WONDERLAND

WONDERLAND

WONDE

RLAND

ROCHELLE STEINER

with contributions by

GIULIANA BRUNO

BEATRIZ COLOMINA

TERENCE RILEY

MARGIE RUDDICK

THE SAINT LOUIS ART MUSEUM

Published on the occasion of the exhibition
WONDERLAND
The Saint Louis Art Museum
July 1 – September 24, 2000

Wonderland has been made possible by
The Andy Warhol Foundation for the Visual Arts, Inc.
and Enterprise Rent-A-Car Foundation,
with additional assistance from McCarthy Construction
Company and Millman Lumber Co.

© The Saint Louis Art Museum 2000
Library of Congress Cataloguing in Publication Data
Steiner, Rochelle
Wonderland/Rochelle Steiner: with contributions by
Giuliana Bruno, Beatriz Colomina, Terence Riley, Margie Ruddick
p. cm.
 Published to accompany an exhibition held at
The Saint Louis Art Museum
1. Contemporary art 2. Installation art 3. Architecture
4. Landscape I. Steiner, Rochelle II. Bruno, Giuliana
III. Colomina, Beatriz IV. Riley, Terence V. Ruddick, Margie
VI. Cardiff, Janet VII. Eliasson, Olafur VIII. Fernández, Teresita
IX. Hendee, Stephen X. Klaila, Bill XI. Atelier van Lieshout
XII. Neto, Ernesto XIII. Rist, Pipilotti XIV. Schneider, Gregor
XV. Steinkamp, Jennifer XVI. Loock, Ulrich

Editor **Mary Ann Steiner**
Design **Abbott Miller/Pentagram**
Printing **Strine Printing Company**

LCC 99-69191
ISBN 0-89178-082-3

Printed in the U.S.A.

Available through
D.A.P./Distributed Art Publishers
155 Sixth Avenue, 2nd Floor
New York, New York 10013
Tel: (212) 627-1999
Fax: (212) 627-9484

FOREWORD

Sometimes visitors come to museums with a precise destination or a specific expectation in mind: they may want to revisit a favorite gallery or explore a new exhibition. But another great pleasure is to wander through the galleries, moving from room to room, open to anything that might elicit interest, appreciation, pleasure, or awe. Our inclination to wander, and the sense of wonder that so often results, is the subject of *Wonderland*. This exhibition comprises ten unique works of art by ten contemporary artists. They give us experiences of unexpected spaces inside predictable spaces, landscapes within walls, and architecture outside them, and they inspire us to think with open minds about things we have not seen before. We thank them for their willingness to present their creative work in this innovative exhibition.

We are especially grateful for the generous support of The Andy Warhol Foundation for the Visual Arts, Inc., which has made the exhibition possible. Their willingness to support *Wonderland* even before the artists had created their installations is a tribute to their vision for the possibilities of contemporary art. Enterprise Rent-A-Car Foundation embraced this opportunity to provide assistance as well, and we thank them for seeing an innovative exhibition as a way to engage new and different audiences. McCarthy Construction Company and Millman Lumber Co. have generously provided construction equipment and building materials for the exhibition, and we are most grateful for their support.

While most of the works of art were created specifically for this exhibition and this art museum's building, Pipilotti Rist's *Ever Is Over All* dates from 1997 and is in the collection of the Donald L. Bryant, Jr. Family Trust. We thank the Bryants for lending their piece as well as their support throughout the development of the exhibition. Gregor Schneider's *Totally Isolated Guest Room, ur 12,* which dates from 1995, is in the collection of Dr. Thomas Waldschmidt, and we are grateful for his willingness to lend it to *Wonderland*. We also appreciate the cooperative spirit of our neighbor institutions with whom we are collaborating on this project: Forest Park, the Saint Louis Zoo, and the Bi-State Development Agency for their support of those works of art outside the Museum building.

We have been very fortunate to engage catalogue authors who bring a range of discourse and an excellence of scholarship to the task of interpreting this work and placing it in context. Giuliana Bruno, Professor of Visual and Environmental Studies at Harvard University; Beatriz Colomina, Associate Professor of Architecture at Princeton University; Terence Riley, Chief Curator of Architecture and Design at The Museum of Modern Art in New York; and Margie Ruddick, landscape architect, provide serious discussions of the major themes of art, architecture, and landscape at the beginning of the twenty-first century.

This endeavor would not have been possible without the vision of Rochelle Steiner, Assistant Curator of Contemporary Art, who organized the exhibition. From the beginning she understood the importance of providing the artists the encouragement and freedom to create these wonderful spaces in our Museum.

Brent R. Benjamin
Director

won.der.land *n*. an imaginary land or place full of wonders, or a real place like this

This exhibition takes as its premise the idea that inspiration, curiosity, and marvel ("wonder") may be derived from various types of spaces and environments ("land"). *Wonderland* is comprised of works of art that define and transform spaces, and encourage our active engagement with and within them. The ten artists participating in the exhibition—Janet Cardiff, Olafur Eliasson, Teresita Fernández, Stephen Hendee, Bill Klaila, Atelier van Lieshout, Ernesto Neto, Pipilotti Rist, Gregor Schneider, and Jennifer Steinkamp—have created works of art whose constructed or alternate realities inspire, and in some cases rely on, our involvement with them. Some of the pieces reference architectural spaces, with structures resembling intricate cathedrals or domestic interiors; others take as their subjects natural settings, including simulated landscapes and representations of gardens. Many of the installations provoke an array of sensory responses beyond visual pleasure. These artists situate us within environments that range in tone from beautiful to playful to disorienting, and affect our perceptions through shifts of sight, sound, physical orientation, and mental state.

Even before these ten artists were chosen, *Wonderland* was conceived as an exhibition of contemporary art that would engage people in unexpected ways. This was pursued through the selection of artists who encourage interplay between their pieces and viewers, and by a choice of artworks that inspire wonder, adventure, and the pleasure of movement. We set out to create a "wonderland" through which individuals would travel and become engaged with provocative artist-created spaces as active participants rather than as stationary, passive spectators. In other words, this exhibition explores the possibility that subject-object relations between viewers and works of art might not be fixed positions, but rather complex and multi-directional sets of relations. Early on we pondered what it would be like to build a conveyer belt or "people mover" through the exhibition, literally setting viewers in motion and transporting them to, through, and between the works of art. While this proved to be a fleeting fantasy—and is as flawed philosophically as it is practically—the thought contains an important kernel that is embedded in *Wonderland*: the notion of a mobile viewer. This exhibition has been designed as a journey—physical, mental, as well as conceptual—through and within works of art. In essence, it is rooted in the belief that to wander is to wonder.

Because a "wonderland" is a subjective place, an exhibition with this title could have included art that makes reference to Lewis Carroll's *Alice in Wonderland* or uses "the looking glass" as a metaphor. A "wonderland" comprised of spectacular contemporary art produced in digital media or installations of stunningly intricate accumulations of objects, both found and fabricated, also would have been possible. Our vision of *Wonderland* derives from the word itself: it is focused on the ways spaces create wonder, and at the same time are places in which viewers are free to wander. Although numerous artists were considered, these ten emerged, in part, because of the strong physicality of their work. Even in those pieces in which space is virtual, the visitor's role is primarily physical. It is for this reason that Web-based art is not included in *Wonderland*: although cyberspace is structured as "sites" and "communities," our experiences of them are neither bodily nor encouraging of mobile viewership. This should not be interpreted as a luddite position, but rather as an interest in exploring the role of the body within contemporary art.

Today, when Internet access to museums is often substituted for direct experiences of art, it is interesting to find artists making work that depends on physical inhabitation and sensory responses. It is also significant that artists are constructing large-scale pieces when space—or more specifically the lack thereof—is a fundamental human concern. We seem to have run out of room within our homes, schools, hospitals, and communities, within urban as well as suburban settings. As a culture we search for new frontiers in outer space as much as cyberspace. At a time when museums, including The Saint Louis Art Museum, are overflowing, this exhibition affords us the luxury of being situated within unique environments and allowing our imaginations to be stimulated by our surroundings.

Parallel to the exhibition, this publication provides another place in which to explore the themes of journey and spatial constructions. From multiple vantage points it brings together thoughts about installation art, architecture, landscape, and the origins of multimedia technology. The book is meant not only to serve as a permanent document of these singular artist-created spaces, but also to provide new and interdisciplinary ways of thinking about the world in which we live.

Divided into three sections, the book begins with "Spaces for Wonder," which traces the phenomenon of wonder from antiquity through art and contemporary culture, to the work included in *Wonderland*. The second section is dedicated to the artists in the exhibition: it is comprised of interviews with each of them, images of their previous projects, and biographic and bibliographic information. Bringing the artists' voices into the publication provides insightful glimpses into their art and ideas.

The third section of the catalogue widens the scope of the discussion beyond these ten artists to consider some of the broader cultural topics that their work raises. Four writers examine the main themes of the exhibition—the journey through space, landscape, and architecture—from their own disciplines and perspectives. Terence Riley, Chief Curator of Architecture and Design at The Museum of Modern Art in New York, adds an important perspective on installation art, comparing it to the fundamental aspects of architecture in "Heterotopia: Displacing Architecture." Beatriz Colomina, Associate Professor of Architecture at Princeton University, analyzes the confluence of space, information, and technology in "Enclosed by Images: The Eameses' Multi-Screen Architecture." She not only addresses the way the Eameses responded to these issues in the 1950s, but also draws parallels between their projects and our experiences in contemporary culture. Giuliana Bruno, Professor of Visual and Environmental Studies at Harvard University, maps the development of the mobile viewer in relation to the picturesque in the 17th, 18th, and 19th centuries. Her text, "Haptic Journeys," analyzes notions of landscape and travel by considering the ways gardens, parks, and historical sites have been conceived, traversed, and documented. "Tom's Garden" by landscape architect Margie Ruddick looks at space from a personal point of view. Using the example of her neighbor's garden, she examines the way we design, utilize, and interpret our surroundings.

One of the challenges posed by works of art made on site for a specific exhibition is their documentation. Photography of the pieces in *Wonderland* was accomplished right after the exhibition opened and is included in the book's unique boxed format. By transforming the book into a container for images of spaces, it becomes another place for exploration.

Rochelle Steiner
Assistant Curator of Contemporary Art

ACKNOWLEDGMENTS

An enterprise as huge and heterogeneous as *Wonderland* has many lessons about space and relationships. These acknowledgments are the space in which I can express my gratitude and recognize the many relationships—between people and between ideas—that have been formed and renewed through this project. I have been fortunate to work with many talented collaborators and dedicated colleagues: in some cases, our paths crossed briefly at fortuitous moments; in others, we have been companions through the long course of this project.

At the center of *Wonderland* are the artists, who have created extraordinary works of art. Most have made new pieces for the exhibition, and all have been deeply involved in the floor plan, construction, and installation at the Museum. It has been a unique opportunity to work with these ten extremely talented artists, and I have benefited from our ongoing discussions. My most sincere thanks to each of them who, in expanding our ideas about art and about wonder, made this show possible.

Some of the artists completed their pieces for *Wonderland* with collaboration or input from others. Janet Cardiff worked closely with George Bures Miller to produce *Taking Pictures*. Joep van Lieshout regularly works within the collaborative enterprise of Atelier van Lieshout in Rotterdam; Wouter Louman, Margreet Bulthuis, and Yolanda Witlox engineered, fabricated, and constructed *Pioneer Set*. The hypnotic soundtrack for Pipilotti Rist's *Ever Is Over All* was created by Anders Guggisberg. Jennifer Steinkamp invited Andrew Bucksbarg to compose the mesmerizing music for *X-Room*. Olafur Eliasson was assisted by Martin Müller, Marianne Krogh, Einer Thorstein of Kingdomes, and Bo Ewald of Ewald & Rasmussen in the design and construction of *The drop factory. A short story on your self-ref and rep.* We appreciate all these individuals involved in the creation of unique works of art.

Some of the artists were supported by studio assistants whose attention to numerous details, large and small, was most helpful. Deep gratitude is due to Henriette Bretton, Pat Kalt, Rian van Rijsbergen, Pius Tschumi, and Ineke van Tuinen. We are also extremely thankful to the artists' gallerists and their staffs for assisting with *Wonderland*: Tanya Bonakdar, Marc Jancou, Ethan Sklar, and Kelly Calanni at Bonakdar Jancou Gallery; Tim Neuger, Burkhard Riemschneider, Jochen Volz, and Lioba Scherzer at neugerriemschneider; the late Marcantonio Vilaça, Karla Meneghel Ferraz de Camargo, and Fabize Moinhos at Galeria Camargo Vilaça; Luis Campaña, Miks Kalmanis, and Vera Gliem at Luis Campaña Galerie; Sadie Coles at Sadie Coles HQ; Lawrence Lurhing, Roland Augustine, and Michele Maccarone at Luhring Augustine; Ursula Hauser, Iwan Wirth, Cornelia Providoli, Claudia Friedli, and Rahel Sprecher at Galerie Hauser & Wirth; Randy Sommer and Robert Gunderman at ACME.; Jeffrey Deitch, Courtney Cooney, Elizabeth Iarrapino, and Amalia Dayan at Deitch Projects; Bronwyn Keenan at Bronwyn Keenan Gallery; Mark Moore, Cliff Benjamin, and Christopher Ford at Mark Moore Gallery.

The Donald L. Bryant, Jr. Family Trust lent its important piece by Pipilotti Rist to this exhibition. I am appreciative for the Bryants' ongoing support and commitment to contemporary art at The Saint Louis Art Museum. Dr. Thomas Waldschmidt generously lent his piece by Gregor Schneider and we are most appreciative to have been able to include it.

Wonderland benefited from the interest and support of institutional neighbors, who became our partners in realizing various art works: Dan McGuire, Director of the Department of Parks, Recreation and Forestry, and Forest Park Manager Anabeth Calkins were enthusiastic collaborators for the outdoor pieces by Atelier van Lieshout and Janet Cardiff. Charles Hoessle, Director of the Saint Louis Zoo, and Alice Seyfried, Supervisor of their Children's Zoo, generously provided and cared for the farm animals in Atelier van Lieshout's *Pioneer Set*.

I am indebted to Giuliana Bruno, Beatriz Colomina, Terence Riley, and Margie Ruddick for their intellectual generosity and contributions not only in the form of texts, but also in discussions of key themes and suggestions about the book. Ulrich Loock kindly allowed us to reprint portions of his interview with Gregor Schneider.

J. Abbott Miller of Pentagram designed this unique catalogue. Assisted by Roy Brooks, Scott Devendorf, and Elizabeth Glickfeld from his staff, he created a book that echoes the themes in the exhibition and translates them to print. John Porter of Pentagram kept the vision of the book intact while managing countless production details. I am grateful for the breadth of their creativity and diligence.

At The Saint Louis Art Museum numerous individuals have been involved with *Wonderland*. First and foremost I would like to thank Brent R. Benjamin, Director, who has offered strong support for one of the most ambitious exhibitions of contemporary art in the Museum's history. James D. Burke, Director Emeritus, provided early institutional commitment to an exhibition of this scale. Sidney Goldstein, Associate Director; Rick Simoncelli, Assistant Director; and Cornelia Homburg, Curator of Modern Art, lent guidance and direction throughout the project's development.

The exhibition came together with the devotion and professionalism of Jeanette Fausz, Director of Exhibitions, who coordinated a multi-layered endeavor. We relied on Dan Esarey, Building Operations Manager, and his staff to manage the construction of the works of art on site. Larry Herberholt, Engineering Operations Manager, and his engineering staff were helpful in the electrical and lighting needs of these diverse installations. The vision of Jeff Wamhoff, Exhibition Designer, is reflected in the layout of the exhibition, and Jon Cournoyer, Senior Graphic Designer, produced the beautiful graphics for the show and brochure. Diane Mallow, Associate Registrar, managed the shipping of many difficult pieces. Michael Sullivan, Superintendent of Protection Services, and his staff created a safe environment for art and visitors. Kate Guerra, Audio-Visual Technician, assisted artists on their installations.

This publication has been a labor of love on the part of Mary Ann Steiner, Director of Publications, to whom I am extremely grateful. Her intellectual curiosity augmented my own and added substantially to each of the texts that appears in the following pages. Kate Weigand, Publications Assistant, sought out and secured the images for the essays and provided an essential and steady link among the curator, editor, authors, and designers. Patricia Woods, Photography Manager, coordinated the on-site photography of the work in the exhibition.

I have had the good fortune to work with four exceptional research assistants. Melissa Brookhart helped lay the early conceptual groundwork with a sense of art historical rigor. Kate Weigand followed the careers of numerous artists who were considered for the show. Jessica Halonen worked closely with me to develop the exhibition and added her own spirited insights. Most recently, Jennifer Dorsey's attention to detail has been instrumental in tracking endless bits of information in the final stages of the exhibition and the catalogue.

Jim Weidman, Director of Development, and Judy Wilson, Assistant Director of Development, worked to raise funds for Wonderland, and I am grateful for their successes. Judy Graves, Director of Finance, was sensitive to the nontraditional financial considerations involved in working with living artists and the production of installation work.

Kay Porter, Director of Community Relations, assisted by Brian Adkisson, coordinated the publicity and promotion for Wonderland. Together they generated much enthusiasm for the exhibition. Susan Patterson, Manager of Information Services, organized information about the exhibition on the Museum's Web site, and Cathryn Goodwin, Information Resources Coordinator, sought out a system for archiving information about the artists and their pieces. Stephanie Sigala, Marianne Cavanaugh, Davina Harrison, Julie Lombard, and Clare Vasquez in the Museum's library provided important research assistance and interlibrary loans during the writing of this catalogue. Mary Susman, Development Activities Coordinator, and Carole Bartnett, Special Events Assistant, coordinated the events for the opening weekend and welcomed our patrons and guests. In the curatorial department, Administrative Assistants Susan Shillito and Carol Kickham offered valuable and much appreciated help.

In St. Louis we are fortunate to have a number of patrons of contemporary art, whose cheerful enthusiasm has been a constant source of encouragement. Anabeth Calkins and John Weil, co-presidents of the Museum's Contemporary Art Society, have lent endless support during their four-year tenure and have taken a keen interest in Wonderland. In addition, I am thankful to Roxanne Frank, Jan Greenberg, Nancy Kranzberg, and Amy Whitelaw for their help with the opening festivities and for their love of contemporary art.

During the development of Wonderland I have benefitted from discussions with colleagues and friends who have helped frame this project, given advice on technical details, and offered personal encouragement. I would like to express special thanks to John Alexander, Elizabeth Armstrong, Francesco Bonami, Adam Brooks, Connie Butler, Amada Cruz, Siri Engberg, Ann Goldstein, Diana Guerrero-Maciá, Madeleine Grynsztejn, Kathy Halbreich, Yoshiko Isshiki, Camilla Jackson, Marge Jacobson, Helen Kornblum, Beth Levanti, Deborah Littlejohn, Judy Mann, Monica Manzutto, Cara McCarty, Sabina Ott, Santiago Piedrafita, Chris Rauhoff, Christiane Schneider, Junko Shimada, Diana Thater, the late Jay Tobler, Lilian Tone, Jill Vetter, Kirsten Weiner, Rita Wells, and Ron Wiener.

The untimely deaths of Marcantonio Vilaça and Jay Tobler before this project was completed were losses to the field of contemporary art and reminders of the importance of good friends and colleagues in such an enterprise. Many thanks to everyone who has traveled any part of this journey with me. R.S.

The most beautiful experience we can have is the mysterious. It is the fundamental emotion which stands at the cradle of true art and true science. Whoever does not know it can no longer wonder, no longer marvel, is as good as dead, and his eyes are dimmed. ALBERT EINSTEIN

ROCHELLE STEINER

SPACES FOR WONDER

Since ancient times individuals have been inspired by the Wonders of the World. A list of seven key monuments is thought to have appeared first in a poem attributed to the Greek poet Antipater in the 2nd century B.C. "I have gazed on the walls of impregnable Babylon, along which chariots may race, and on the Zeus by the banks of the Alphaeus. I have seen the Hanging Gardens and the Colossus of Helios, the great man-made mountains of the lofty pyramids, and the gigantic tomb of Maussollos. But when I saw the sacred house of Artemis that towers to the clouds, the others were placed in the shade, for the sun himself has never looked upon its equal outside Olympus."[1] From that time forward, interest in the world's wonders increased, and the contents of the list were debated. Despite the popularity of these monuments, there was no fixed canon for approximately 1000 years, when the Walls of Babylon was replaced by the Pharos (Lighthouse) of Alexandria. In modern times, subsequent lists of wonders have been assembled, chronicling what are considered to be natural and modern wonders. They include some of the world's greatest sites, such as Niagara Falls and the Eiffel Tower, places that attract millions of tourists annually who travel in search of something extraordinary.

Antipater's poem, which is written in the first person, indicates that he saw—and thus traveled to—the Wonders of the Ancient World. All were places that Greek citizens actually could have visited and, with the exception of the Hanging Gardens of Babylon whose location approximates present-day Iraq, they were all near the Mediterranean Sea. Significantly, in Greek such monuments were originally called *theamata* or "things to be seen," rather than *thaumata* or "wonders." However, over time the "sights" of the ancient world came to be wondered at, and so *theamata* became *thaumata*.[2] The compilation of a list of Wonders represented a firsthand survey of the world in terms of its outstanding human creations. The monuments were celebrated for their impressive majesty, beauty, size, and attention to detail—aspects at which humankind marveled and which contributed to their classification as wonders.

By the height of the Roman Empire, the Seven Wonders were already beginning to erode and disintegrate.[3] As they could no longer be enjoyed in person, the list was used in later centuries to historicize the great achievements of previous civilizations rather than to

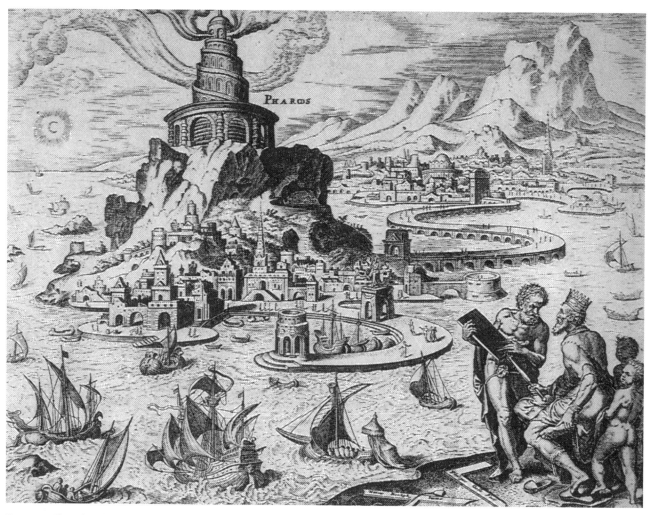

Maerten van Heemskerck's idea of the Pharos of Alexandria, from Peter A. Clayton and Martin J. Price, *The Seven Wonders of the Ancient World*, Routledge, 1988

promote places that could be visited and viewed. Nevertheless, although six of the seven Wonders of the Ancient World have not survived intact to modern times, we continue to marvel at the oldest—the Great Pyramid of Egypt—still standing approximately 4500 years after it was built. Travelers fortunate enough to visit it and the smaller surrounding pyramids describe their remarkable beauty, and they marvel at the unbelievable feat of their construction. Their mathematical and geometrical perfection, the brilliance of their engineering, and their ability to withstand time are truly thought provoking. Neither their mystery nor their stature can be re-created through photographs, literary accounts, Web sites, or models: our awe requires a journey to actually see and physically experience them.

The long-term maintenance of lists of the world's wonders probably belongs to a human impulse towards exploring and knowing the world as completely as possible. Pliny the Elder

(A.D. 23–79), the Roman thinker known for his vast *Natural History*, is credited with compiling voluminous documentation of facts in his attempt to create a complete inventory of the world. Amassing and recording as much information as possible from the sources available to him, he deliberately chose not to distinguish "what counts more from what counts little . . . the true from the false, the plausible from the incredible, the documented from the fanciful, the useful from the useless."[4] Inclusive rather than discriminating, Pliny recorded both the mundane facts and the exotic wonders of the world. Nonetheless, in his *Natural History*, the rare and exceptional separated themselves from natural regularity; but rather than being designated marginal or secondary, they took on a status of precious and miraculous. In fact, in Pliny's view, "they were preserved as extraordinary phenomena, worthy of wonder."[5] The exceptions served as evidence that "nature is capable of stupefying productions," and recording them enabled them to be preserved.[6]

Pliny's influence extended to the Renaissance, when a similar interest in exploring and cataloguing the world prevailed and a focus on the extraordinary flourished. The 16th and 17th centuries in Europe sometimes have been called the Age of the Marvelous because it was a time of intense fascination with "those things or events that were unusual, unexpected, exotic, extraordinary, or rare. The word marvel (*meraviglia* in Italian, *merveille* in French, *Wunder* in German) was widely applied to anything that lay outside the ordinary, especially when it had the capacity to excite the particular emotional responses of wonder, surprise, astonishment, or admiration."[7] Much of what was deemed marvelous by Western cultures was discovered through exploration of the world: expeditions in search of new lands and their riches produced many treasures that were collected and sometimes represented in Renaissance art.

Exploring the world led to mapping and classifying it, as well as compiling and accounting for the various bits of information and objects found near and far. Atlases and maps were ways of "collecting the 'entire world' in a manageable format."[8] Large collections of rare objects were another. *Wunderkammern*—"cabinets of curiosities"—were designed to display items that were considered unique, odd, or unfamiliar for both private and public viewing. They not only reflected the intellectual and geographical spirit of exploration; they also marked the origins of modern museums, which were born out of encyclopedic collecting patterns.[9] Artifacts of antiquity were eagerly gathered by collectors, and the figurines and mummies of ancient Egypt were particularly valued. Objects, and at times people, were brought back from far-off places and displayed in the *Wunderkammern*, allowing the public to marvel at what could be found in the Americas, Africa, Southeast Asia, and the Far East. Polar bears, cassowaries, and dodos that seemed as fantastic as the unicorns and basilisks of mythology were put on public display in "raree-shows," and often, after their demise, found their way into museums.[10] Europeans exoticized and commodified the world, turning others and their objects into celebrated treasures.

According to art historian Joy Kenseth, in the Renaissance, objects and phenomena that had the power to cause wonder, surprise, and astonishment fell into three categories: the supernatural, the natural, and the artificial.[11] Those that were deemed supernatural were in the range of the miraculous, whether the "fabulous events described by Homer"

or the "sublime workings of God." This included acts of divine intervention as well as religious relics collected by churches and early museums.[12] Interestingly, relics were not only wonders to behold but also destinations to visit: they were and continue to be sacred objects to which believers travel in order to benefit from their divine powers. Likewise, the sites of religious and miraculous apparitions, like the grotto of the Virgin Mary in Lourdes, France, are places to which hundreds of thousands of people travel annually. Pilgrimages to witness such miracles with one's own eyes are not unlike journeys to the Wonders of the World in ancient times or to the Pyramids and other spectacular sites today: wonder is bound to travel from one's own part of the world to another. Through journeys we seek out what is thought to be exceptional.

Natural wonders (naturalia) included "examples of God's ingenuity" in the realm of animal, botanical, and geological specimens, as well as cases of "nature erring"—things that were unusually large or small, extremely rare, exotic, abnormally or grotesquely shaped, or spectacularly beautiful.[13] Natural wonders also included phenomena such as rainbows, earthquakes, and volcanic eruptions. In addition there were wonders from distant lands, including the Brazilian toucan, the bird of paradise from New Guinea, as well as exotic fruits and plants. People native to remote lands aroused the greatest curiosity, especially Indians from North America and people from the Canary Islands who were completely covered with hair.[14]

While natural wonders revealed God's "divine handiwork," artificial wonders (artificialia) demonstrated the ingenuity of man. According to Kenseth, artists and architects had the capacity, by means of technical skills and imaginative powers, to advance God's creative work by fashioning exceptional, unusual, and surprising objects. Such objects included "not only paintings, sculpture, architecture, prints, and decorative objects, but also automata, mechanical and scientific equipment . . . , fountain displays and topiary art, spectacular apparati (both religious and secular), ethnographic artifacts, and pyrotechnic exhibitions."[15]

Such intriguing objects made their way into Renaissance Wunderkammern, which were typically packed from floor to ceiling and end to end with treasures. Heterogeneity was one of the most common aspects of 16th- and 17th-century collections and museums, and a beholder could encounter a stunning diversity of things that represented the most extraordinary natural phenomena and manmade objects past and present.[16] The curiosities provoked a sense of surprise and marvel, responses at the very core of wonder. Wunderkammern inspired interest in remote parts of the world, a fascination fueled by idealized visions of exoticism. For collectors, the contents of their cabinets represented journeys taken and valuables acquired: their holdings were indexes of their worldliness and success. By providing a semblance of access to regions outside the immediate surroundings, these objects connected individuals with worlds separated from them either by time or geographical distance.[17] However, unlike the Wonders of the Ancient World or religious relics sought in pilgrimages, the objects in Wunderkammern were surrogates for travel, representing places held in one's memory or imagination. They delivered the idea of another place to an individual situated comfortably at home, and provided a location for unique "souvenirs" to be collected and displayed.

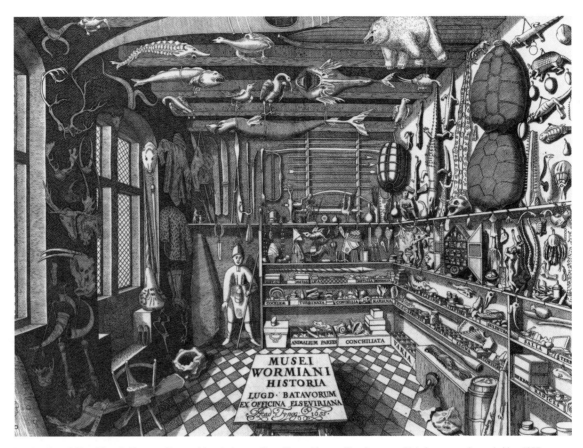

Interior view of Olaus Worm's Museum. Engraved frontispiece to Olaus Worm, *Museum Wormianum seu historia rerum rariorum*, Leiden 1655.
Ernst Mayr Library of the Museum of Comparitive Zoology, Harvard University; ©President and Fellows of Harvard College

With the rise of science and its rational approach to the study of nature in the mid-17th century, the Age of the Marvelous began to decline. Since nature was acknowledged to be governed by general law, it was no longer necessary to accumulate extraordinary examples to obtain a complete understanding of the world; instead, the common or familiar object sufficed for the purposes of study. As a result, much of the wonder was left out of the observation of the physical world.[18] Paradoxically, the decline of the *Wunderkammern* was also, in part, a result of their popular success: as "cabinets of curiosity" proliferated throughout Europe, the objects in them lost their capacity to excite.[19] Rarities became so abundant that they were no longer viewed with the same sense of uniqueness or unexpected wonder. The tension between the marvelous and the mundane appears historically throughout Western culture and became a defining theme in 20th-century art, especially in the work of Marcel Duchamp. Though at first seen as a unique gesture through which Duchamp transformed a urinal into a work of art entitled *Fountain* (1917), everyday objects have come to play a prevalent role in modern and contemporary art, from Andy Warhol's Pop imagery to the meticulously handcrafted objects by Peter Fischli and David Weiss that simulate familiar, found objects.

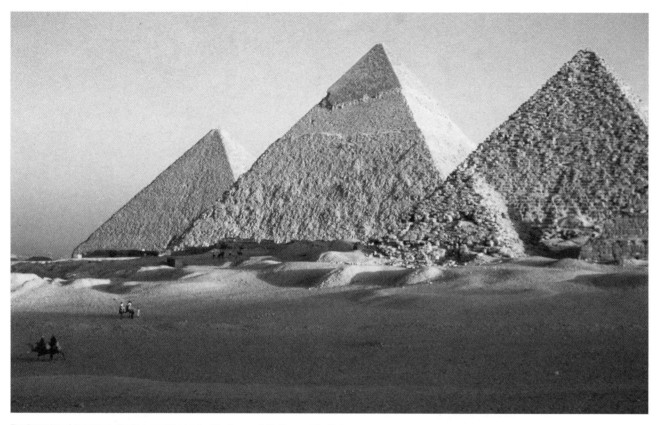

The Pyramids of Mycerinus, Chefren, and Cheops by Wim Swaan. Getty Research Institute,
Research Library, Wim Swaan Photograph Collection

The pursuit of wonder continued to a lesser extent in the early 18th century and enjoyed small revivals in the 19th century;[20] however, the types of extraordinary objects that inspired awe in the Renaissance have seldom since provided the same degree of curiosity. Today, when the majority of the earth and portions of outer space have been explored and mapped, the discovery of new objects from unfamiliar terrain is not a common goal. And since the middle of the 20th century, the presentation of such objects as oddities has been understood as politically problematic, demonstrating an ethnocentric and culturally biased view of the world. The Museum of Jurassic Technology in Los Angeles is a rare example of a modern-day "curiosity cabinet" dedicated to unique and marvelous objects. It has refocused attention to the topic of wonder through the exhibition of a wide assortment of unusual artifacts, including a scale model of Noah's Ark, fruit stones carved with tiny landscapes, recordings of the sounds made by beetles, and miniature sculptures displayed in the eyes of needles. The objects on view there provoke a sense of wonder, which by definition refers not only to marvel but also to disbelief. As critic and cultural historian Lawrence Weschler writes, "The visitor . . . continually finds himself shimmering between wondering *at* (the marvels of nature) and wondering *whether* (any of this could possibly be true)."[21] Though the Museum of Jurassic Technology has roots in 16th- and 17th-century

Wunderkammern, it also can be compared to such contemporary phenomena as *Ripley's Believe It or Not!,* which promotes itself as "the World's Most Unusual Museum" and features rarities from ritual objects used at voodoo ceremonies to optical illusions. Though more of a tourist attraction than a traditional museum, *Ripley's* arouses our disbelief in the face of such artifacts and phenomena and hearkens back to notions of wonder prevalent in the Renaissance.

Despite the decline of attention to the world's unique marvels, in 1649 René Descartes elevated wonder to the highest level of importance. During the Enlightenment it was not only objects and phenomena that fell prey to categorization, but also thoughts and emotions that were analyzed and prioritized. Descartes wrote:

> When our first encounter with some object surprises us and we find it novel, or very different from what we formerly knew or from what we supposed it ought to be, this causes us to wonder and to be astonished at it. Since all this may happen before we know whether or not the object is beneficial to us, I regard wonder as the first of all the passions. It has no opposite, for, if the object before us has no characteristics that surprise us, we are not moved by it at all and we consider it without passion.[22]

It is significant that the philosopher shifted attention away from objects thought to be wonders, and instead defined wonder as an emotional response resulting from an encounter between a person (i.e., the subject who views and/or experiences something marvelous) and an object (i.e., the object of the encounter).

As much as Descartes privileged wonder, his enthusiasm for delight was tempered by a strong commitment to knowledge. He warned against excessive frivolity, suggesting:

> [it] makes us fix our attention solely on the first image of the objects before us without acquiring any further knowledge about them . . . [and] prolongs the troubles of those afflicted with blind curiosity, i.e., those who seek out rarities simply in order to wonder at them and not in order to know them, for gradually they become so full of wonder that things of no importance are no less apt to arrest their attention than those whose investigation is more useful.[23]

By linking wonder to knowledge, Descartes proposes that marvel is the best first step towards learning. In other words, curiosity and wonder should inspire education, not oppose it. Such a relationship between extraordinary effects and intellectual rigor is apparent in the Pyramids, which are not only wonders on a sensory level, but also marvels to scholars who seek to discover their mathematical and engineering secrets. Similarly, the works of art included in *Wonderland* demonstrate a union of sensuous effects and conceptual underpinnings. Ideally, the novelty of the pieces produces a moment of inspiration leading towards an investigation of contemporary art.

We are trying to build visions that people can experience with their whole bodies, because virtual worlds cannot replace the need for sensual perception. PIPILOTTI RIST

Wonderland invites us to journey into ten unique works of art by Janet Cardiff, Olafur Eliasson, Teresita Fernández, Stephen Hendee, Bill Klaila, Atelier van Lieshout, Ernesto Neto,

Pipilotti Rist, Gregor Schneider, and Jennifer Steinkamp that are situated within The Saint Louis Art Museum and surrounding Forest Park. Like the heterogeneity amongst the contents of Renaissance "curiosity cabinets," *Wonderland* brings together diverse approaches to art: different types of spaces—some architectural, others organic; some fabricated, others virtual—are superimposed within and outside the Museum's building. And like the Wonders of the Ancient World, which except for the Pyramids are no longer standing, *Wonderland* introduces us to ephemeral and transitory environments—often as impermanent as the exhibition itself. We wander in, around, and through the spatial transformations and in doing so are transported beyond our ordinary mental and physical frames of reference. We are encouraged to move without a destination to discover the unexpected, to risk losing ourselves within works of art, and to open ourselves up to the possibility of wonder.

While each of the pieces in *Wonderland* provides us with a constructed environment and allows for our movement within it, some more prominently emphasize our journey through alternate realities, while others focus attention on space itself. These spaces are inspired largely by architecture or landscape, or the intersection of the two. Physical movement is a strong component of Janet Cardiff's and Bill Klaila's work, and these two artists use sound to define space and mobilize visitors. Cardiff literally invites us to take a walk. Using the sound of her voice and other audio effects—recorded, mixed, and played on personal CD players known as Discmans—she leads us along a predetermined and site-specific path through The Saint Louis Art Museum and surrounding Forest Park. Her *Taking Pictures* (2000) makes use of binaural audio recording, a technique in which two small stereo microphones are placed at ear-width distance to achieve a lifelike, three-dimensional reproduction that we perceive as the actual sounds of a given site. She fills this constructed space with auditory signifiers of activity and people, including herself as our guide. Descriptions, narration, sound effects, and ambient sound transport us to a virtual environment that simulates as well as diverges from the actual place we find ourselves walking in. By providing us with photographs of the site taken earlier, we also experience a shift in time between what is represented in the image and the present.

The power of sound to create and define space is equally important in Bill Klaila's work, which we experience by physically traversing it. Entering the darkened room of *Virtual Bog* (2000), we feel as though we are walking into a marsh at night. The sounds of insects, frogs, nocturnal birds, and other audio effects transport us from the gallery into a "natural" setting—from inside the Museum to the external world. As we move further into the space, we find ourselves walking across a pressure-sensitive floor, onto which a computer-generated image of a bog is projected. The noises of sloshing through mud and water are synchronized to our footsteps, and visual "ripples" and "splashes" appear simultaneously in the electronic water. Responding to our movements in real time, the piece maps our journey through the space.

The pleasure of movement is a strong theme in Pipilotti Rist's work as well, but while Cardiff and Klaila move us physically, Rist moves us via visual and audio identification. In *Ever Is Over All* (1997), she uses camera movement and a mesmerizing soundtrack to lead

us into her double video projection. We follow the image of a woman on a carefree stroll through the streets of Zurich and are enticed by the image of a swirling, larger-than-life Technicolor garden. The woman hums a catchy tune, and we are led to identify with her as she travels through a seemingly parallel universe and performs surprising actions. *Ever Is Over All* presents us with two different settings—one urban, the other natural—which are offered as points of departure for our pleasure and exploration: we are invited to journey into realms beyond the expected and immerse ourselves in their wonders.

Teresita Fernández and Olafur Eliasson encourage us to explore space by focusing on aspects of landscape and the natural world. Though diverse in their practices, they create, represent, and simulate conditions that remind us that "nature"—gardens, water effects, and parks—are human creations. In *Landscape (Projected)* (1997), Fernández reinterprets the image of a formal garden by constructing a space that is vibrant green in color and includes a labyrinth-inspired pattern reminiscent of a hedge. From the ceiling an oculus projects what appears to be daylight into the room, and a faint looping soundtrack subtly recalls a rotating water sprinkler. Together these elements create the illusion of a landscape. But as much as Fernández's space signifies a form of nature, the piece is also architectural in its structure, collapsing internal and external space in a rectangular, six-sided room. Standing within it, we are projected beyond the walls, into an alternate, albeit conceptual, reality.

Eliasson, too, contains his "natural" effects within an architectural structure. *The drop factory. A short story on your self-ref and rep* (2000) is a large-scale geodesic dome standing approximately 20 feet tall in the center of the Museum's Sculpture Hall. It is a space within a space, a structure modeled after those used for outdoor exploration that has been transformed and situated within the Beaux-Arts building. The dome houses the Museum's fountain as well as a water and light effect the artist has devised. Strobe lights seem to freeze individual droplets of water in mid-air, as if suspended in defiance of gravity. By fashioning the inside surface of the dome with mirrored panels, Eliasson creates a kaleidoscope of reflections that place us within the multiplied effects. While we are looking in awe at them, the piece seems to be "looking" back at us and turning us into its subjects.

Unlike Eliasson and Fernández, who bring nature into the Museum, Atelier van Lieshout prefers to insert its architectural constructions into the landscape. *Pioneer Set* (2000) is a simple farm for self-sufficient living that includes a farmhouse, chicken coop, rabbit hutch, and stable and is inhabited by farm animals. Set in Forest Park just beyond the Museum's grounds, the piece calls attention to the cultivated "wilderness" of the urban park. By constructing the stable and farmhouse in the same dimensions, Atelier van Lieshout draws an equation between the animals and the humans that occupy these spaces. The shift in scale leads to unexpected whimsy; like many of the works in the exhibition, this piece delivers the commonplace in uncommon surroundings.

Gregor Schneider's architectural dwelling is focused internally rather than externally. Since 1985 he has continually built rooms within rooms and fabricated architectural structures onto existing structures, all within the confines of his private home in Rheydt, Germany. Though the exterior facade of the house remains untouched, he has successively

constructed and reconstructed the interior: rooms, passageways, false corridors, doors opening up to nowhere, and dead ends are interconnected and layered within a complicated and evolving labyrinthine structure. These spaces are then cut out of their original location, deconstructed, shipped to museums and galleries, and reconstructed for exhibitions. In *Wonderland* we enter into Schneider's small and spare *Totally Isolated Guest Room, ur 12* (1995), moved mentally by way of the container that physically surrounds us. Within it we are relocated from the exhibition space to his home.

While Atelier van Lieshout and Schneider build structures that may function for human use, Hendee adopts the language of architecture to fabricate colossal works of art that resemble would-be, futuristic cathedrals. Working with the low-tech materials of foam board, fluorescent lights, and gaffer's tape, he is able to transform light and planes into intricate spaces. In *Abandon.exe* (2000) Hendee constructs a three-dimensional representation of the virtual environment that underlies the structure of the World Wide Web. The ephemeral nature of his work, which is destroyed when it is deinstalled at the end of the exhibition, calls attention to the material temporality of the contemporary culture—both physical and virtual—in which we live.

Architectural considerations also inspire the work of Ernesto Neto and Jennifer Steinkamp, both of whom transform space by means of mesmerizing sensory effects. Neto's womb-like rooms of off-white polyamide fabric and spices envelop viewers within a transparent haze that challenges our perceptions of space and depth. In *It happens when the body is the anatomy of time* (2000), the nylon material is stretched and anchored horizontally over our heads, producing a cloud-like ceiling from which dramatic, sculptural, spice-filled "columns" are suspended. Pulled toward the floor by the force of gravity, they are reminiscent of stalactites that have become elongated over time. The vibrantly colored and aromatic spices seep out of the porous fabric, creating a wonderous scented and sensuous environment.

Steinkamp manipulates space as well as our physical and psychological orientation within it through computer-generated video projections and accompanying soundtracks. For *Wonderland* she has devised *X-Room* (2000), whose narrow, crisscrossing corridors call attention to our physical presence within the space. At the ends of each of the corridors are thin areas of 3-D computer animation, and as the images move we feel that the architecture is also in motion. The result is an altered state, which the artist describes as a "waking dream experiential space."[24] In both Steinkamp's and Neto's work, the architectural space is made corporeal, in turn heightening our awareness of our own sensations.

These ten pieces are different from one another in terms of the types of environments they present, yet they share spatial qualities apparent in installation art, contemporary sculpture, architecture, and landscape design. As we wander through the constructed spaces and explore the artists' fabricated realities, we find ourselves contained within unique three-dimensional worlds. The parameters of the environments may be defined physically by walls, as in Schneider's guest room and Hendee's controlled architectural setting, or demarcated by conceptual boundaries, such as the audio path of Cardiff's "Walk." Still in other pieces, like Fernández's "landscape," we find ourselves at the inter-

section of physical and mental spaces—with our bodies firmly planted in the room, but our imaginations projected to a place beyond its architectural limits. Moving via sight, sound, smell, touch, intellect, and wonder, we become a part of these surroundings. We are not only engaged by these works of art but subsumed within them.

> That's why I don't do paintings. You can't be inside a painting
> and I want people to be absorbed into a physical kind of mass.
> I want to be absorbed. ANN HAMILTON

Issues of spatiality, especially as they are manifested in room-sized works of art, have been closely identified with the artistic category known as installation, or alternately installation art. Although its roots stretch back to the beginning of the 20th century and can be seen in Dada, Futurism, Constructivism, and the Bauhaus, since the 1960s the term has encompassed a variety of practices from the curatorial activity of arranging and exhibiting art objects, to strategies for art making that combine aspects of sculpture, architecture, and performance and often integrate video and audio components as well as other nontraditional and mixed media. Rather than presenting a single object, installations tend to set up relationships between multiple elements, found or fabricated, as well as between those elements and the context in which they are shown. This type of work also involves the construction of three-dimensional environments in which viewers are transformed from passive spectators into active participants. Far-reaching and inclusive, installation eludes formal definition, and the term has been applied to such markedly different practices as Cady Noland's accumulation and grouping of mass-produced objects like beer cans, shopping carts, walkers, and parts of erector sets; Fred Wilson's examinations and reinstallations of the contents of museum collections; and Ann Hamilton's elaborate, theatrical settings in which spectators are interwoven into three-dimensional narratives.

As an art form, installation reached its apex in the early 1990s, but the core of these diverse practices is located in the social, political, and museological critiques of earlier decades.[25] This includes numerous and interconnected shifts, both actual and theoretical, between the artist and museum or gallery, and between the work of art and its viewers. Brian O'Doherty (a.k.a. artist Patrick Ireland) was among the earliest critics to begin to lay out the conditions that would come to define installation in his seminal series of essays, "Inside the White Cube," originally published in *Artforum* in 1976.[26] There he referred to Kurt Schwitter's *Merzbau* (1923) as "the first example of a 'gallery' as a chamber of transformation,"[27] and considered Marcel Duchamp's *1,200 Bags of Coal* at the *International Exposition of Surrealism* in Paris in 1938 as "the first time an artist subsumed an entire gallery in a single gesture."[28] Duchamp suspended 1,200 bags from the ceiling and placed a "stove"—a makeshift brazier made from an old barrel filled with a light bulb—in the center of the floor.[29] In doing so, he transformed the space by placing seemingly heavy items on the ceiling and the light source on the floor, and opened up the possibility of using parts of the room other than the four walls as viable exhibition space.

By utilizing the entire gallery as the space of his art, Duchamp not only integrated the architecture into the piece, but also incorporated into it the work of fellow artists on display

Marcel Duchamp, *1,200 Bags of Coal*, in the *International Exhibition of Surrealism*, Paris, 1938;
© 2000 Artists Rights Society (ARS), New York/ADAGP, Paris/Estate of Marcel Duchamp

in the exhibition. In this sense he co-opted the exhibition as a whole: his *1,200 Bags of Coal* was comprised of the container it was contained within. The way Duchamp used the gallery space as an element in his work rather than merely as a backdrop or setting was important for the development of installation. According to O'Doherty:

> By exposing the effect of context on art, of the container on the contained, Duchamp recognized an area of art that hadn't yet been invented. This invention of context initiated a series of gestures which "develop" the idea of a gallery space as a single unit, suitable for manipulation as an esthetic counter. From this moment on, there is a seepage of energy from art to its surroundings.[30]

Like *1,200 Bags of Coal*, Duchamp's *Mile of String* (1942), which he created four years later for the *First Papers of Surrealism* exhibition in New York, was also installed around and amongst works of art by other artists.[31] With string meandering in a maze-like pattern from floor to ceiling and wall to wall, Duchamp literally connected everything in the room: the other art works, the larger context of the exhibition, and the viewers who entered the space were all ensnared within the piece. We can imagine that traversing *Mile of String*, with webs of string hung throughout the gallery, must have posed a physical challenge to visitors wishing to see the other art included in the exhibition. Just as entering the earlier *1,200 Bags of Coal* must have been a disorienting experience, Duchamp's gesture in *Mile of String*

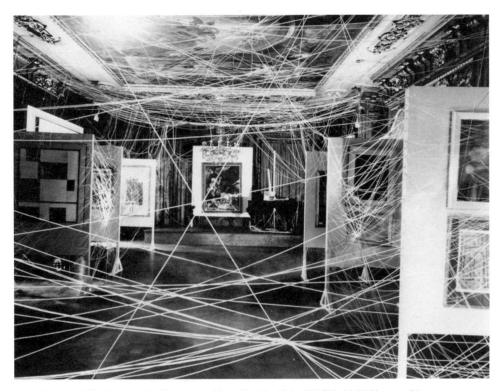

Marcel Duchamp, *Mile of String*, in the *First Papers of Surrealism*, New York, 1942; Philadelphia Museum of Art: Marcel Duchamp Archive, Gift of Jacqueline, Paul and Peter Matisse in memory of their mother, Alexina Duchamp; © 2000 Artists Rights Society (ARS), New York/ADAGP, Paris/Estate of Marcel Duchamp

again disrupted the social space of art and viewership. Whether people navigated their way through these spaces or were deterred by the unexpectedness of the surroundings, their presence, reactions, and mobility—or lack thereof—were crucial to the ideas of installation that would follow.

Investigations of the physical spaces and conceptual contexts of the museum or gallery are at the root of much of the art and criticism of the 1960s, 70s, and 80s, and the ideas that emerged in those decades are embedded in today's artistic theory and practice.[32] Artists, curators, and critics analyzed these spaces which, with their typically spare white walls and regularized cubic shape, had become known as the "white cube." Accepted within Modernism as neutral terrain, this type of space was thought to be removed from the world outside the gallery.[33] However, as O'Doherty argued,

> With post-modernism, the gallery space is no longer "neutral." The wall becomes a membrane through which esthetic and commercial values osmotically exchange. As this molecular shudder in the white walls becomes perceptible, there is a further inversion of context. The walls assimilate, the art discharges. . . . The white wall's apparent neutrality is an illusion.[34]

O'Doherty suggested that the walls of the art gallery, previously considered to be separate from the paintings hung upon them or sculptures enclosed by them, had become a part of

the works they contained: he exposed the "white cube" for having developed its own cultural, social, and economic currency, which in turn was affecting the significance and experience of the art it housed.[35]

A number of artists have turned their attention to the ideology of such containers, creating pieces that examine the structures and underpinnings of museums and galleries. These wide-ranging endeavors include Claes Oldenburg's *Mouse Museum* (1965–77), a modern-day "curiosity cabinet" in the shape of a mouse and filled with found, altered, and fabricated objects. Here a self-contained, artist-conceived environment is built within the parameters of a museum, situated within the very structures it echoes. Investigations into museums also include Hans Haacke's institutional critiques, which uncover and expose the social politics and economic motivations behind the scenes of various cultural institutions, private donors, and corporate patrons. Similarly, Louise Lawler "frames" art as well as private collectors, galleries, museums, and auction houses with photographs and texts that call attention to the support systems that contextualize and lend value to works of art.[36]

In addition to exploring the art world in a self-reflexive manner within the confines of museums and galleries, during the 1960s artists also broke out of the boundaries of these institutions, creating events and tableaux that challenged the traditional parameters of what art might be and the contexts in which it was typically presented. For example, beginning in 1960 Ben Vautier created *Le magasin* (The Shop), a Fluxus mixed-media "gallery" in which he displayed and sold an array of objects. Conceived of as "living sculpture," it included the artist on view in the shop window, surrounded by objects of daily life such as a bed, table, chairs, television, cooking utensils.[37] Shortly after, Oldenburg embarked on a similar project in New York City's East Village: from December 1, 1960 through January 31, 1961, *The Store* was a "gallery-studio-performance-environment" made to resemble the commercial enterprise of a shop.[38] It offered for sale a variety of "consumer goods," including hamburgers, pies, shoes, clothing, and jewelry, all of which were crafted out of plaster and painted by the artist.[39] Like Vautier's *Le magasin,* Oldenburg's *The Store* reflected a transformation of the art object as well as the role of the artist and viewers. Both pieces anticipated some of the qualities that would develop in installation work: the creation of environments; the display of objects with relationships to one another and to the overall space; a performative quality on the part of the artist; and the incorporation of viewers as participants in activities.

Oldenburg was one of a number of artists—along with Jim Dine, Red Grooms, Allan Kaprow, and Robert Whitman—who pioneered Happenings in New York. Initially presented in gallery spaces and later in the outdoors, they were environmental performances devoid of traditional narrative structure; these pieces typically involved the spatial arrangement of objects or props and the engagement of viewers who participated in innovative ways.[40] Kaprow, who is credited with the first named Happening in 1959, acted as a strong advocate of the developing art form, which was indebted to the action paintings of Jackson Pollock and the experimental sound work of John Cage. Originally called "action-collages," Kaprow did these pieces "as rapidly as possible by grasping up great hunks of varied matter: tinfoil, straw, canvas, photos, newspaper, etc." and combining them together within

Claes Oldenburg, *Mouse Museum*, 1965–77 (exterior view).
Museum of Modern Art Ludwig Foundation Vienna

Claes Oldenburg, *Mouse Museum*, 1965–77 (interior view).
Museum of Modern Art Ludwig Foundation Vienna

a gallery space.[41] Soon afterwards he "introduced flashing lights and thicker hunks of matter. These parts projected further and further from the walls and into the room, and included more and more audible elements: sounds of ringing buzzers, bells, toys, etc."[42] By incorporating sound elements he not only added sensory aspects to the work, but also moved from creating assemblages of objects toward complete environments, filling the space and engaging viewers within the setting. As Kaprow has recalled about his early work:

> When you opened the door, you found yourself in the midst of an entire Environment. . . .
> I immediately saw that every visitor to the Environment was part of it. . . . And so I gave
> him opportunities like moving something, turning switches on—just a few things.
> Increasingly during 1957 and 1958, this suggested a more "scored" responsibility for
> the visitor. I offered him more and more to do until there developed the Happening.[43]

Kaprow drew strong connections between this type of performative work and the "overall" or "drip" paintings of Jackson Pollock, a relationship that was explored in *Out of Actions: between performance and the object, 1949–1979*, an exhibition organized by Paul Schimmel at The Museum of Contemporary Art, Los Angeles. Kaprow proposed that Pollock's "mural-scale paintings . . . ceased to become paintings and became *environments*. . . . Pollock's choice of great sizes resulted in our being confronted, assaulted, sucked in."[44] Kaprow further suggested that "[t]he space of these creations is not *clearly* palpable as such. One can become entangled in the web to some extent, and by moving in and out of the skein of lines and splashings, *can* experience a kind of spatial extension."[45] Responding to the physicality and spatiality of Pollock's working method, which had become legendary through Hans Namuth's widely circulated photographs of the artist at work, Kaprow identified a link between Pollock's paintings and the three-dimensional environments that artists of successive generations would come to make. As he wrote in his 1958 manifesto, "The Legacy of Jackson Pollock," published in *ARTnews*:

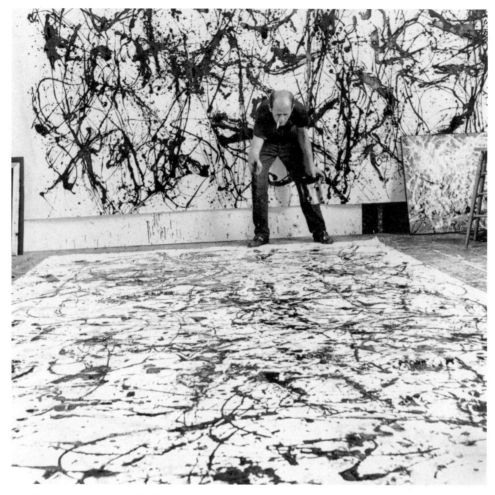

Hans Namuth, *Jackson Pollock*, 1950. National Portrait Gallery, Smithsonian Institution. Gift from the Estate of Hans Namuth

> Pollock, as I see him, left us at the point where we must become preoccupied with and even dazzled by the space and objects of our everyday life, either our bodies, clothes, rooms, or, if need be, the vastness of Forty-Second Street. Not satisfied with the *suggestion* through paint of our other senses, we shall utilize the specific substances of sight, sound, movements, people, odors, touch.[46]

Kaprow's writing placed Happenings within Pollock's legacy, but the influence of Cage enabled them to move beyond two-dimensional painting. The layered audio and visual elements, simultaneous yet often unrelated actions, and the incorporation of individuals into Happenings recall Cage's mixed-media experiments at Black Mountain College in the early 1950s.[47] However, while Cage encouraged audience members to participate and create chance occurrences as a way to "to relinquish authorial control," Kaprow used audience members as "props through which [his] vision was executed."[48]

For example, in *Yard* . . . Kaprow created an allover field of used tires in the tight confines of the backyard of a Manhattan townhouse; the work existed as an entity only

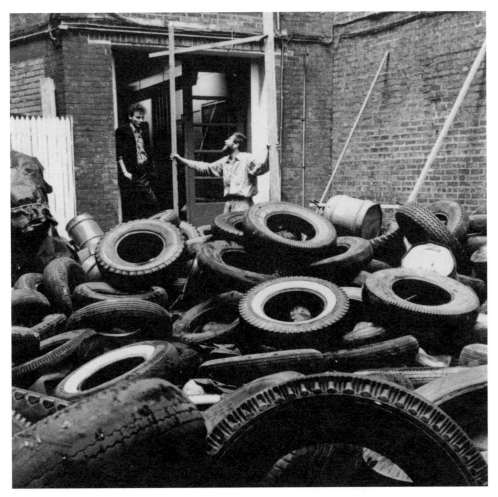

Allan Kaprow, *Yard*, 1961. Photo courtesy Getty Research Institute, Research Library. Photo by Robert McElroy

when audience members activated it by walking through the piece. Although these audience members were encouraged to believe that they were playing, Kaprow had in fact established very controlled parameters within which they had to act.[49]

In breaking away from the two-dimensional realm of painting and its static conditions, artists not only reconsidered the forms art would take but also the ways viewers could participate in their work. As evident in the comparison between Cage and Kaprow, these roles ranged from open-ended and self-defined on the part of viewers, to predetermined and mediated on the part of artists. Along with other performance-based work including Fluxus, Gutai, Nouveau Realismé, and Viennese Actionism initiated throughout the world in the post-war period, Happenings were one of many significant pivot points around which such transformations occurred.

In addition to the changes that resulted from the intersection of painting and performance, the expansion of sculpture towards site-specific endeavors, the construction of three-dimensional spaces, and the use of new media in the 1960s and 1970s likewise manifested

substantial changes in the forms of art objects and the roles of art audiences. Viewers were likely to feel confronted and frustrated by Bruce Nauman's psychologically altering videos, rooms, and corridors; and they were made to feel self-conscious when images of themselves were reflected in the mirrors and videos of Dan Graham's spaces. Influenced by tenets of Eastern philosophy, Light and Space artists such as Robert Irwin and James Turrell explored individual perception in environmental works, inspiring and at times overwhelming viewers with optical effects and illusions. Likewise, members of Experiments in Art and Technology (E.A.T.), a collaborative group of artists and engineers, used technology to encourage unique audience participation in art. Their engagement of the human body in surprising spaces and their use of new media was achieved most vividly in *The Pavilion* at Expo '70 in Osaka, Japan.

Some of the conceptual groundwork behind the significant developments in space and viewership in the mid-20th century also can be seen in Minimalism, which changed the look of sculpture as well as the way viewers related to it. In "Notes on Sculpture," a three-part article published in *Artforum* in 1966–67, artist Robert Morris attempted to define a new kind of sculpture, enumerating distinctions between it and painting and outlining the role of its viewer. Concentrating on the size of the work, Morris suggested:

> The awareness of scale is a function of the comparison made between [the] constant [of] one's body size, and the object. Space between the subject and the object is implied in such a comparison. In this sense space does not exist for intimate objects. A larger object includes more of the space around itself than does a smaller one. It is necessary literally to keep one's distance from large objects in order to take the whole of any one view into one's field of vision. The smaller the object the closer one approaches it and, therefore, it has correspondingly less of a spatial field in which to exist for the viewer. . . . However, it is just this distance between object and subject which creates a more extended situation, for physical participation becomes necessary.[50]

According to Morris, the near-human size of Minimal sculpture resulted in "extended situations" that engaged viewers differently than previous works of art had.[51] Instead of accepting the long-standing belief that meaning is inherent and located within a work of art, he began to move toward an understanding of sculpture as a set of relations between objects and viewers, suggesting that "the expanded situation hardly indicates a lack of interest in the object itself. But the concerns now are for more control of and/or cooperation of the entire situation. . . . The object itself has not become less important. It has merely become less *self*-important."[52]

While Morris's considerations are limited to a view of space as a physical entity, his proposal nonetheless can be seen within the context of a more wide-scale refocusing of attention away from the Modernist ideal of an object's autonomy. A few years later Conceptual artists would assert that their work, whether or not it was material, was surrounded by both physical and mental spaces,[53] and a decade after that O'Doherty would expound upon the parameters of a work of art in his analysis of the "white cube." Similar topics were being addressed in other fields of study: in 1971 literary and cultural theorist Roland Barthes identified what he saw as a shift "from work to text," or a passage from

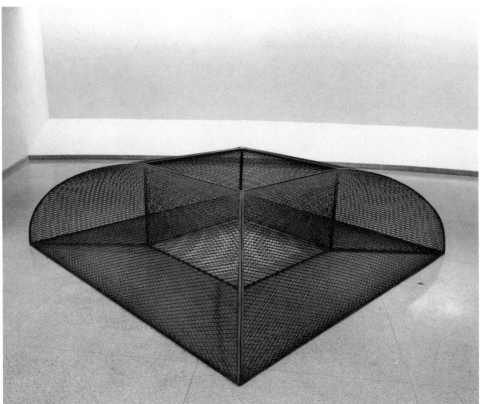

Robert Morris, *Untitled (Quarter-Round Mesh)*, 1967. Solomon R. Guggenheim Museum, New York, Panza Collection 1991. Photograph by David Heald © The Solomon R. Guggenheim Foundation, New York; © 2000 Robert Morris/Artists Rights Society (ARS), New York

Bruce Nauman in his *Green Light Corridor* in 1971; © 2000 Bruce Nauman/Artists Rights Society (ARS), New York

autonomy to an awareness of context. He proposed the movement of meaning from an inherent and embedded position within a "work," to the production of meaning through a network surrounding it or "text."[54] Although Barthes was referring to literary texts in his essay "From Work to Text," the notion of a set of conditions or "*social* space"[55] also applied to his interpretation of cultural productions including visual art, film, fashion, and advertising.[56]

Writing in support of the purity of Modernist painting, art critic Michael Fried rejected Minimalism, which he termed "literalist art," in his monumental essay "Art and Objecthood" published in *Artforum* in 1967. He attacked the new form of sculpture because of the way it transformed the viewer, which he referred to as the "beholder," and because it relied on an audience to encounter the work. He argued: "the largeness of the piece . . . *distances* the beholder—not just physically but psychically. It is, one might say, precisely this distancing that *makes* the beholder a subject and the piece in question an object."[57] Fried understood— and feared—not only that the viewer was interacting with the work and becoming its subject, but also that "literalist art" was dependent upon audiences to give it meaning. Viewers were no longer passive observers of art works that held universal truths, but rather active

interpreters—or subjects—of "situations" that they defined through their presence. This reversal and art's reliance on the "beholder" led Fried to compare Minimalism to theater, which he considered to be the most impure art form due to its mixture of genres and elements, both visual and verbal, as well as its need for an audience:

> For theater *has* an audience—it *exists for* one—in a way the other arts do not; in fact, this more than anything else is what modernist sensibility finds intolerable in theater generally. Here it should be remarked that literalist art, too, possesses an audience, though a somewhat special one: that the beholder is confronted by literalist work within a situation which he experiences as *his* means that there is an important sense in which the work in question exists for him *alone*, even if he is not actually alone with the work at the time. . . . Someone has merely to enter the room in which a literalist work has been placed to *become* that beholder, that audience of one—almost as though the work in question has been *waiting for* him. And inasmuch as literalist work *depends on* the beholder, is *incomplete* without him, it *has* been [waiting for him]. And once he is in the room the work refuses, obstinately, to let him alone—which is to say, it refuses to stop confronting him, distancing him, isolating him. (Such isolation is not solitude any more than such confrontation is communion.)[58]

What happens when you get there depends not only on what the artist has prepared for you, but also on how curious and demanding you are as you plunge into their world. ROBERT STORR

In a recent article entitled "No Stage, No Actors, But It's Theater (and Art)" published in *The New York Times*, curator Robert Storr asserts that Fried's rejection of Minimalism's "theatricality" paradoxically outlined the conditions that would come to define installation art. In Storr's discussion of what he calls "complete immersion environments," exemplified by the work of artists Ann Hamilton, Ilya Kabakov, and Robert Wilson, he suggests that installation "aspires to the condition of theater" and might be equally if not more "impure" because of its combinations of media and physical inclusion of viewers.[59] According to Storr, "installations of this type are 'walk in' worlds complete in every relevant detail,"[60] presenting life-size, set-like tableaux. "The experience they provide is much like wandering onstage and picking up loose pages from a script, overhearing bits of recorded dialogue and trying to figure out what the setting is, what actions have might [*sic*] taken place there and what actions might still be taken."[61] Perhaps more like scenes than environments, as viewers enter into this type of art they find themselves *in media res*, sliding into the position of subject in the midst of three-dimensional narratives laid out before them. He also pointed to similarities between such environments and theater in their temporality: they are often impermanent creations, lasting no longer than the length of an exhibition.

The "complete immersion environments" Storr describes are but one type of installation art, a range of which was featured in the 1991 exhibition *Dis*locations that he curated at The Museum of Modern Art. As one of the earliest exhibitions of installation art in a U.S. museum, the show aimed to represent the diversity of installation being produced at the time through the formal, poetic, and social practices of Louise Bourgeois, Chris Burden,

Ilya Kabakov, *The Bridge*, 1991, from the exhibition *Dis*locations at The Museum of Modern Art, New York in 1991;
© 2000 Ilya Kabakov/Artists Rights Society (ARS), New York. Photo © Scott Frances/Esto. All rights reserved

Sophie Calle, David Hammons, Ilya Kabakov, Bruce Nauman, and Adrian Piper. Using different strategies, media, and themes, these artists presented socially and politically inspired topics in the form of large-scale sculptural pieces, videos shown on monitors and projected on walls, assemblages of found and constructed objects, as well as combinations of photos and texts. Each "require[d] that the individual viewer physically and psychologically enter into a space conceived in the image of instability or mystery or aggravated ambiguity."[62] Through an unconventional exhibition scheme, challenging art forms, and politically charged subject matter, *Dis*locations kept audiences at a distance, reinforcing the separation between viewer and art work that both earlier and later endeavors tried to overturn. Working from the premise that "art is both a vehicle and a destination, within the museum as a protected and protective domain in which the transportation takes place,"[63] *Dis*locations laid out a journey that fit the definition of the exhibition's title—putting

viewers out of place, dismantling their expectations, and disrupting artistic conventions. The show began with unpainted walls as if the installation were in progress, giving the impression that visitors had taken a turn into some place behind the scenes. A similar device structured the catalogue, which rearranged parts of the book from their expected locations: the table of contents appears on the last rather than first page, and images are in the front rather than the back of the book. These transgressive curatorial strategies echoed the museological critique then at the forefront of much installation work.

Another exhibition, *Performance Anxiety,* curated by Amada Cruz at the Museum of Contemporary Art in Chicago in 1997, set out to actively involve viewers in installations. This show turned museum visitors into participants by engaging them in architecturally determined spaces and in the activities and conditions of the works of art. It included viewers donning elf costumes in Paul McCarthy's *Santa's Theater* (1997); wearing headsets and joining a community of listeners in pieces from Charles Long's *Amorphous Body Center* (1995), which is an ongoing collaboration with the pop band Stereolab; and using supplied musical instruments to perform and record songs in Rirkrit Tiravanija's *Untitled 1996–1997 (Studio No. 6),* 1997. The result was a challenge to viewers to abandon their typically passive roles and become the subjects of art works, even if it resulted in self-consciousness or "performance anxiety."[64] While such shifts in the viewer's role in art have been underway since the late 1950s, the theoretical framework for analyzing the transformation of passive spectators into active participants echoes feminist film theory since the 1970s. Laura Mulvey, among others, addressed the gendered positions of subjects and objects of the gaze. Also relevant are architectural theories focused on the representation and social inscription of space as well as the ways we are situated within it.[65]

Over the last ten years the category of installation has become increasingly integrated into the mainstream of contemporary art. Though this type of art continues to be difficult to collect, it is nevertheless being shown with increasing frequency. Much of the conceptual and political terrain that was initially at stake has become embedded as framework: museological critique, world and identity politics, and the position of viewers tend to be preconditions rather than battlegrounds. At the beginning of the 21st century, the social, political, and economic conditions in which we live are remarkably different from those just a decade ago, and so too are art and the terms we use to describe it. As curator Connie Butler rightly points out, most artists who construct and alter space no longer label themselves "installation artists,"[66] although this is not to say that the number of artists transforming space and engaging viewers in constructed environments has diminished. In fact, quite the opposite is true. The loosening of the term is not a sign of the form's demise, nor is it unique to installation: today it is common for painters, sculptors, as well as photographers to likewise identify themselves more generally as "artists," perhaps part of a continuing rejection of the ideal of Modernist purity amongst artistic disciplines and genres. Butler further suggests that "since the 1960s . . . there has been a revolution in our understanding of the social inscription of space, architecture, and exhibition design,"[67] a revolution that is not only reflected in, but also the result of, what we know to be installation.

Consider the suggestive confusion between wonder and wander—
as if getting lost and digression were at the root of amazement,
of change, even of knowledge. BRUCE HAINLEY

The artists in *Wonderland* abandon the security of traditional art forms and call on us to give up more comfortable roles as passive spectators in order to become actively engaged in art. While this in and of itself is not radical, the ways they mobilize us and construct spaces that provide opportunities for discovery is different. Ranging from contemplative to surprising, amusing to dramatic, each piece envelops us in surroundings that heighten our awareness of ourselves, our bodies, and our senses. Instead of exploring the confines of the museum or breaking out of its boundaries as artists of earlier generations have done, those participating in *Wonderland* situate themselves within the context, though ever expanded, of the art museum. Drawing us in, they transport us elsewhere, as if we were being taken on journeys to other places. By letting our minds wander within their work, we wonder; and by allowing our bodies to wander through their spaces, we find ourselves in a wonderland.

Throughout history people have traveled great distances to seek out wonders. We go elsewhere to find things beyond compare, and we search for sites that are truly awe-inspiring. Of course there are also spaces closer to home that provoke wonder: museums, gardens, amusement parks, and even casinos and shopping malls are examples of places that transport us from everyday realities and introduce us to unexpected pleasures. They are worlds unto themselves, diversions from the mundane and refuges from the banal. Fittingly, The Saint Louis Art Museum positions itself as a world apart, with the inscription "Art Still Has Truth Take Refuge There" carved above its entrance. Like the *Wunderkammern* of previous centuries, museums are collections of wonders, comprised of treasures that can transport us, mentally, to the cultures and eras from which they originate. As we wonder about them, we wander, journeying in our minds through space and time.

In the late 20th century the development of Virtual Reality resulted in the simulation of sites and situations, allowing us to travel, virtually, to different places. Long before such technological developments, World's Fairs and Expositions of the 19th and 20th centuries involved the re-creation of various parts of the world in other locations. These events invoked both physical and mental travel: visitors journeyed geographically to them, and once there they were "moved" to distant parts of the world through an array of representations. Often individual pavilions were constructed to display the art and innovations of exhibiting countries and were designed in accordance with the region's indigenous architecture, an attempt to make visitors feel as though they really had been relocated. Perhaps the most popular destination that provides simulated world travel is "It's a Small World," which first appeared at the 1964 World's Fair in New York and in 1966 was reconstructed at Disneyland in California. It welcomes visitors on an "around-the-world" tour by boat through symbolic representations, however stereotypical, of places and cultures from across the globe. The world and all its "variety" is conveniently brought to us, in this case made easy by the premise of its smallness. The experience affords us the novelty of visiting multiple locations while being physically situated in one.[68]

Japanese Imperial Garden in St. Louis World's Fair, 1904. Photo courtesy the Missouri Historical Society Library

The drive to resituate parts of the world is also apparent in Disneyland's re-creation of natural sites and architectural structures. The Matterhorn, the amusement park's icy mountain ride, is fashioned after the alpine mountain of the same name located at the Italian-Swiss border. Likewise, its fantastic signature castle is modeled after the Neuschwanstein castle in Bavaria. Significantly, Disneyland's "foreign sites" are juxtaposed with representations of the most common parts of the United States: the amusement park's entrance leads visitors down Main Street, USA, complete with the quaint architecture and little shops associated with middle America. Though perhaps more familiar to Americans than the Matterhorn, pristine small towns are actually scarce in this country, and the setting allows park visitors to travel, through nostalgia, to another place and time outside their typical frames of reference.[69]

Recently some of the world's greatest monuments and architectural wonders have been re-created in Las Vegas: the Eiffel Tower from Paris, Egypt's Pyramids and Sphinx, and the Manhattan skyline are among the places one can visit in the state of Nevada. While it is impossible to completely reproduce the wonders of other places, travelers nonetheless marvel at these transformations of space. Signature characteristics of the city of Venice, Italy—including replicas of St. Mark's Square and the Grand Canal, along with gondolas and singing gondoliers—also have been imported in Las Vegas, with symbols of the Italian cityscape brought to the Venetian Hotel. Although "traveling" to "Venice" without passport or lire does not produce an authentic Italian experience, it nonetheless allows individuals to move beyond their ordinary surroundings. The endeavor relocates the

Catherine Wagner, *Storybook Land; Fantasyland, Disneyland, Anaheim, California*, 1995. Collection Centre Canadien d'Architecture/Canadian Centre for Architecture, Montréal; © Catherine Wagner, CCA, Disney

quintessential city of water to the great American desert, a jarring collision of cultures, climates, and tourist destinations.

The transportation of one place to another creates a disjunction between what we expect in a space and what we actually find there. Such movements or shifts pique curiosity, and the gap or "empty space" between our expectations and reality is fertile ground for inspiration and marvel. This is the experience of entering a room and finding ourselves in the "garden" of Teresita Fernández's *Landscape (Projected)*, or walking in Forest Park and finding ourselves in the "farm" of Atelier van Lieshout's *Pioneer Set.* We are surprised along the route of Janet Cardiff's *Taking Pictures* when her audio recordings and photographs diverge from the reality of the physical world around us. Wonder is akin to discovering one thing while looking for another. In those moments we become aware of

The Venetian Hotel, Las Vegas. Photo © Ron Mesaros

ourselves and our senses, and we are transformed into the subjects of spaces and experiences. Wandering through Bill Klaila's *Virtual Bog*, we perceive ourselves in the visual and auditory effects in his electronic waterscape as they are produced by our movements. Beckoned into Gregor Schneider's room, we assume the role of his guest and sense what it might be like to visit his home. Standing within Olafur Eliasson's dome, reflected endlessly in its mirrored surfaces, we not only see images of ourselves, but also watch ourselves become the subject of a work that seems to "look" back at us.

Within The Saint Louis Art Museum we find ourselves in *Wonderland*, a place temporarily transformed by ten surprising and provocative environments. By inviting the construction of works of art inside and outside its building—by allowing spaces to be built within its space—the Museum has opened itself up to being altered by the wonders of contemporary art. The artists in their turn have given us opportunities to play roles within their work—specifically, to become the subjects of their spaces. But once the invitation has been extended, their art comes to depend on our active engagement: they rely on us to become mobile viewers, wandering mentally and physically about their work. *Wonderland* and its artists propose that we participate in a journey and allow ourselves the pleasure of not necessarily knowing where we're going or what we're going to find along the way. They ask us to open ourselves to wonder.

NOTES

1 Peter A. Clayton and Martin J. Price, *The Seven Wonders of the Ancient World* (London: Routledge, 1988), p. 12. The roots of the list of Wonders began in the middle of the 5th century B.C. in the *Histories* of Herodotus, who has been called the father of history. Subsequently, Callimachus of Cyrene (305–240 B.C.) wrote *A collection of wonders in lands throughout the world*, though the text itself did not survive.

2 Ibid., p. 4. In her contribution to this catalogue, Giuliana Bruno illuminates the slippage between "sightseeing" and "siteseeing" in the 17th, 18th, and 19th centuries.

3 Ibid., 160.

4 Gian Biagio Conte, *Genres and Readers: Lucretius, Love Elegy, Pliny's Encyclopedia,* trans. Glenn W. Most (Baltimore: The Johns Hopkins University Press, 1994), p. 72.

5 Ibid., p. 86.

6 Ibid., p. 87.

7 Joy Kenseth, "The Age of the Marvelous: An Introduction," *The Age of the Marvelous,* ed. Joy Kenseth (Hanover: Hood Museum of Art, Dartmouth College, 1991), p. 25.

8 James A. Welu, "Strange New Worlds: Mapping the Heavens and Earth's Great Extent," *The Age of the Marvelous,* p. 106. Giuliana Bruno also discusses maps and atlases in her essay in *Wonderland.*

9 For discussions of *Wunderkammern,* see Oliver Impey and Arthur MacGregor eds., *The Origins of Museums: The Cabinet of Curiosities in Sixteenth- and Seventeenth-Century Europe* (Oxford: Clarendon Press, 1985) and Kenseth, "A World of Wonders in One Closet Shut," *The Age of the Marvelous.*

10 Impey and MacGregor, "Introduction," *The Origins of Museums*, p. 2.

11 Kenseth, "The Age of the Marvelous," p. 31.

12 Ibid., pp. 31–2.

13 Ibid., p. 33.

14 Ibid., pp. 33–6.

15 Ibid., p. 39.

16 For fuller discussion, see Kenseth, "The Age of the Marvelous," pp. 40–52.

17 Kenseth, "A World of Wonders in One Closet Shut," pp. 90–1.

18 Kenseth, "The Age of the Marvelous," p. 54, and Kenseth, "A World of Wonders in One Closet Shut," p. 97.

19 Kenseth, "The Age of the Marvelous," p. 54.

20 See Kenseth, "A World of Wonders in One Closet Shut," p. 98 and Lawrence Weschler, *Mr. Wilson's Cabinet of Wonder* (New York: Vintage Books, 1995), p. 139.

21 Weschler, op. cit., p. 60.

22 John Cottingham, Robert Stoothoff, and Dugald Murdoch, trans. *The Philosophical Writings of Descartes* (Cambridge: Cambridge University Press, 1985), vol. 1, p. 350. Quoted in Kenseth, "The Age of the Marvelous: An Introduction," p. 25.

23 Cottingham et al, op. cit., p. 354–6.

24 Correspondence with the artist, September 8, 1999.

25 For a survey of installation, see Nicolas de Oliveira, Nicola Oxley, and Michael Petry, *Installation Art* (Washington, D.C.: Smithsonian Institution Press, 1994). The authors divide installation into the somewhat arbitrary and overlapping categories of site, media, museum, and architecture and attempt to build a chronology. See also Anne Farrell, ed., *Blurring the Boundaries*: *Installation Art, 1969–1996* (San Diego: Museum of Contemporary Art, 1997), which provides an overview of installation as it has been extensively exhibited and collected by the Museum of Contemporary Art, San Diego.

26 Brian O'Doherty's essays were first reprinted in *Inside the White Cube: The Ideology of the Gallery Space* (Santa Monica: Lapis Press, 1976) and subsequent reprintings were issued in 1981, 1986, and 1999. The following citations are from the original version in *Artforum*.

27 O'Doherty, "Inside the White Cube, Part II, The Eye and The Spectator," *Artforum* (April 1976), p. 30.

28 O'Doherty, "Inside the White Cube, Part III, Context as Content," *Artforum* (November 1976), p. 40.

29 See Arturo Schwarz, *The Complete Works of Marcel Duchamp*, vol. 2 (New York: Delano Greenidge Editions, 1997), pp. 747–8. The bags, which were empty, had previously been used to transport coal.

30 O'Doherty, "Inside the White Cube, Part III," p. 40.

31 See Schwarz, op. cit., p. 767. Duchamp bought 16 miles of string, but used only one mile in the piece.

32 See Craig Owens, "From Work to Frame, or Is There Life After 'The Death of the Author'?" *Implosion*: *a postmodern perspective* (Stockholm: Moderna Museet, 1987), pp. 207–11. This text was reprinted in Craig Owens, *Beyond Recognition: Representation, Power, and Culture,* ed. Scott Bryson, Barbara Kruger, Lynne Tillman, and Jane Weinstock (Berkeley: University of California Press, 1992).

33 It is worth noting that museum and gallery spaces that constitute the "white cube" are not necessarily white nor perfect cubes.

34 O'Doherty, op. cit., p. 42.

35 While the gallery's walls were becoming part of the work in terms of artists' considerations of the contexts and spaces of exhibiting art, during this period artists were also embedding their works of art into and onto gallery walls. Sol LeWitt's wall drawings and Lawrence Weiner's removals of sections of walls and his texts painted directly onto the walls are examples of this.

36 The work of Oldenburg, Haake, and Lawler, among many others who address artists' relationships to museums, were the subject of *The Museum as Muse: Artists Reflect,* a large-scale exhibition at The Museum of Modern Art in 1999. See Kynaston McShine, *The Museum as Muse: Artists Reflect* (New York: The Museum of Modern Art, 1999).

37 Paul Schimmel, *Out of Actions: between performance and the object, 1949–1979* (Los Angeles: The Museum of Contemporary Art and New York: Thames and Hudson, Ltd., 1998), pp. 71–2. See also Owen F. Smith, "Fluxus: A Brief History," *In The Spirit of Fluxus* (Minneapolis: Walker Art Center, 1993).

38 Schimmel, op. cit., p. 68.

39 While Oldenburg's work has roots in Happenings, it is also part of the origins of Pop Art with which it would come to be most closely associated. For a discussion of the early phases of Pop Art and the way it related to both Happenings and Abstract Expressionism, see Schimmel, *Hand-Painted Pop: American Art in Transition, 1955–62* (Los Angeles: The Museum of Contemporary Art and New York: Rizzoli International, 1992).

40 See Schimmel, *Out of Actions,* pp. 58–9.

41 Ibid., p. 59. Originally cited in Adrian Henri, "Allan Kaprow," *Total Art: Environments, Happenings, and Performance* (New York: Oxford Univerisity Press, 1974).

42 Schimmel, *Out of Actions,* p. 59.

43 Ibid., p. 61.

44 Alan Kaprow, "The Legacy of Jackson Pollock," *ARTnews* (October 1958), p. 56.

45 Ibid.

46 Ibid. It is fitting that Pollock's studio was re-created within the 1998 exhibition of his work at The Museum of Modern Art as a space for visitors to enter. I am grateful to Connie Butler for pointing this out to me.

47 Schimmel, *Out of Actions,* p. 21.

48 Ibid., p. 63.

49 Ibid.

50 Robert Morris, "Notes on Sculpture: Part 2," *Artforum* (October 1966), p. 21. Parts 1 and 2 of this text were first anthologized in Gregory Battcock, ed. *Minimal Art: A Critical Anthology* (Berkeley: University of California Press, 1968), which was reissued in 1995. Citations here are for original publication in *Artforum*.

51 Morris, op. cit., p. 21.

52 Morris, op. cit., p. 23. In addition to scale, in these texts Morris also developed his ideas about the gestalt. See also Robert Morris, *The Mind/Body Problem* (New York: The Solomon R. Guggenheim Foundation, 1994), pp. 172–4.

53 A symposium entitled "Art without Space" held on radio network WBAI-FM in New York in 1969 addressed what was proposed to be the lack of physical space occupied by Conceptual art, which typically took the form of ideas rather than objects. The moderator, Seth Siegelaub, set out to consider the "nature of the art whose primary existence in the world does not relate to space, not to its exhibition space, not to its exhibition in the space, not to its imposing things on the walls." The artists participating in the discussion disagreed with this proposition. Lawerence Weiner asserted that "anything that exists has a certain space around it, even an idea exists within a certain space." See Roselee Goldberg, "Space as Praxis," *Studio International* (September 1975), p. 130.

54 Roland Barthes, "From Work to Text," *Image-Music-Text*, trans. Stephen Heath (New York: The Noonday Press, 1977), pp. 155–64.

55 Ibid., p. 164.

56 See Roland Barthes, *Mythologies,* trans. Annette Lavers (New York: Hill and Wang, 1972); *Empire of Signs,* trans. Richard Howard (New York: Hill and Wang, 1982); and *The Fashion System,* trans. Matthew Ward and Richard Howard (New York: Hill and Wang, 1983).

57 Michael Fried, "Art and Objecthood," *Artforum* (Summer 1967), p. 15. This text was anthologized in Gregory Battcock, op. cit., which shows slight textual differences. It also should be noted that the quotation was originally written by Morris: "It is, one might say, precisely this distancing that *makes* the beholder a subject and the piece in question. . . an object," with the ellipses for emphasis.

58 Fried, op. cit., p. 21. In the first publication of this text in *Artforum*, the words "waiting for him" were omitted from the sentence: "And inasmuch as literalist work *depends on* the beholder, is *incomplete* without him, it *has* been waiting for him." They appear in the reprinted version of the text as anthologized in Battcock, op. cit., p. 140.

59 Robert Storr, "No Stage, No Actors, But It's Theater (and Art)," *The New York Times* (November 28, 1999), sec. 2, p. 48.

60 Ibid.

61 Ibid.

62 Robert Storr, *Dislocations* (New York: The Museum of Modern Art, 1991), p. 33.

63 Ibid., p. 19.

64 The artists included in *Performance Anxiety* were Angela Bulloch, Willie Cole, Renee Green, Charles Long, Paul McCarthy, Cai Guo Qiang, Julia Scher, Jim Shaw, and Rirkrit Tiravanija. See Amada Cruz, *Performance Anxiety* (Chicago: Museum of Contemporary Art, 1997).

65 Both film and architectural theory are vast fields of study that can be only briefly mentioned here. For further discussion see, respectively, Laura Mulvey, *Visual and Other Pleasures* (Bloomington: Indiana University Press, 1989) and Beatriz Colomina, ed., *Sexuality & Space* (New York: Princeton Architectural Press, 1992) as well as Giuliana Bruno's essay in this volume, "Haptic Journeys," n. 55.

66 Connie Butler, "Still Life with Chair Caning," *Period Room and Other Projects: Amy Hauft* (Glenside, Pennsylvania: Beaver College Art Gallery), p. 68.

67 Ibid., p. 67.

68 The pageant-like approach to nationality is exemplified in large-scale international art exhibitions, which have become increasingly abundant in the last decade. The Venice, Istanbul, São Paulo, and Johannesburg biennials, among others, not only provide curators and art enthusiasts with destinations across the globe, but also aim to include work by artists from diverse regions of the world.

69 Time travel is equally prevalent in Disneyland's thematic sections: "Frontierland" and "Tomorrowland" transport visitors to the past and the future respectively. The other sections of the park, "Adventureland" and "Fantasyland," are dedicated to types of experiences.

JANET
CARDIFF

OLAFUR
ELIASSON

TERESITA
FERNÁNDEZ

STEPHEN
HENDEE

BILL
KLAILA

ATELIER
VAN LIESHOUT

ERNESTO
NETO

PIPILOTTI
RIST

GREGOR
SCHNEIDER

JENNIFER
STEINKAMP

JANET CARDIFF

INTERVIEW

Let's start by talking about how sound developed as an element in your work. As an undergraduate, I did painting and printmaking, and I also was working with photography. Later, my husband George went to art college and concentrated in multimedia, which gave him access to sound labs, equipment, and things like that. I started to use some of that equipment and was influenced by what was going on in his school. One of my first installations was mostly printmaking but also had a video playing and sound components. Once I started letting go of the visual material, the sound was able to develop more substantially. *Whispering Room* was the first complete sound piece. There were just 16 bare speakers, and out of each speaker came a woman's voice in short two-minute excerpts from a story. The speaker stands were arranged throughout the room, and they were very anthropomorphic because you'd hear voices coming from them, as if you had walked up to speaking bodies.

At that point I was very interested in how you could understand a narrative three-dimensionally—how you could walk through a story and experience it in different directions and, as a result, interpret it in different ways. You might come in at the end of a sentence or the end of a little excerpt; or you might come in when a woman ripped her skirt getting into the car and think there's some sort of dangerous, violent scene going on; or you might come in where two women are talking about having a cup of coffee. I was interested in cubist narrative, and I was trying to think about how to tell a story from past, present, and future points of view simultaneously. I was trying to make the narrative physical.

This seems to be closely related to your audio "Walks," which literally move people through a story while guiding them physically through a space. How did the "Walks" develop? I had a residency at the Banff Centre that gave me the opportunity to use tons of different equipment. One day I was out with a mini-recorder, recording the names off grave sites. I happened to rewind the tape and play it back through the headphones while I was in the same site, and I heard my footsteps and my voice talking about the exact place where I was standing. And all of a sudden I realized this made for a very peculiar experience. It was so strange to hear the recorded footsteps and voice talking about what was right in front of me. I knew I had to use it. A few weeks later I made my first "Walk," called *Forest Walk.*

Janet Cardiff, *Walk Muenster*, 1997; installation view at *Skulptur Projekt in Münster 1997*, Münster, Germany; courtesy the artist; photo by George Bures Miller

Some people have drawn relationships between your work and the acoustic guides that museums use to orient their visitors. Is this a connection you are actively pursuing? It was only after I had done a few of these sound pieces and started to be included in museum exhibitions that the connection was made. I started getting grouped with Sophie Calle, Andrea Fraser, and Vito Acconci, but they really are interested in deconstructing the museum and exploring how we get information about art. I am more interested in the experiential aspect of recorded sound.

Are you interested in radio programs and the way they tell stories through sound? And do you see a relationship between the narrative structure of your work and film? I like radio plays. They're an interesting way of telling stories. One of my favorite movies, *Sorry Wrong Number*, was written first for the radio. I have been asked quite often to do things for radio, but it has never really worked for me because that form of storytelling generally is not based on spatial or three-dimensional sound. My work is more related to film, especially in terms of the way going into a theater takes you away from reality. You don't have to think about yourself or your problems or your life; you are taken to another place. In some ways your work does that too because it re-situates us in an alternate reality, but it is unlike film in that you do not physically enter into a confined space, completely blocked off from the world outside. Instead, you sort of suspend us between the real world and the audio world. I love playing off the layers of reality. It is magical. In the "Walks," the real world becomes the cinematic set influenced by the soundtrack.

I know you record most of your sounds on site, but do you also use prerecorded sounds? Yes, but I rely mostly on what I record myself because then I'm able to use recording techniques that create a more spatial experience. Can you describe those techniques a bit? I record in a very old technique called binaural. Basically it means hearing with two ears. It has been around since audio recording began. What I do is place the microphones on a dummy head that I carry with me so that when I'm recording, the sound waves jump back and forth and echo back onto the microphones in the same way they do with our ears. When you wear the headset, it presents you with the sounds in the same positions as they were recorded. It replicates the sound the way our ears hear it. So that's why you can hear three-dimensional sound in my pieces.

At first it makes you very aware of what's around you. It operates in the same way as blind people who tap their canes to figure out where they are within a space based on the types of sounds they hear. We all have the skill to interpret sounds in this way, but most people haven't developed it. By manipulating different types of sounds, I can alter someone's perceptions of a space. For example, if I want to make a room sound bigger, I will add reverb to it until it sounds like the noises are bouncing off a surface farther away.

There are other ways I use sound to heighten the sense of the space. If you are walking in a space and you hear some other person's footsteps, it heightens your experience. It is like having a hearing aid on. With the headset, everything you hear is a bit exaggerated, so it is hard to tell what's real and what's recorded. It's a weird morphing of the space around you and the virtual space of the recording. If I cut the volume down, you will realize how much of your understanding of the space has been based on the fabrication of sounds. So there are these formal techniques that I use to control your sense of the space. I am interested in the way you use sound to transport the viewer. You not only move people physically by having them walk, but also mentally by having them imagine other locations. The content of the pieces moves you to other places and times. For example, if you hear a soundscape with sea gulls in the background, you are immediately transported in your mind to the sea. Sometimes I will cut to other places, like walking around my house. You can start to imagine that space. Memory and imagination are triggered very effectively by sound.

Your narratives often focus on such topics as memory and time. Is this a consistent thread between your pieces, or are you starting each anew with a different focus? I definitely think that there is a connection. Most of the stories are about the same thing. I remember being at an artist's talk once, and the artist said that he thought every artist has just one question that he or she is obsessed with. My stories have a main text that varies from piece to piece, but their subtexts are usually about time, space, and coping with reality in a personal way.

Are you one of the characters in your stories? I become a character similar to the way Cindy Sherman takes on different roles in her photographs. At the same time it's not just me, but also the participants who take on different roles as they become part of the stories.

Janet Cardiff, *In Real Time*, 1999; installation at *Carnegie International 1999/2000*, Carnegie Museum of Art, Pittsburgh; courtesy the artist and Galerie Barbara Weiss, Berlin; photo by Richard A. Stoner

Janet Cardiff, *Walk Muenster*, 1997; installation view at *Skulptur Projekt in Münster 1997*, Münster, Germany; courtesy the artist; photo by George Bures Miller

them; the headsets are almost types of prosthetic devices. Many people—perhaps more women than men because of the dominant female voice—say it is like hearing voices inside their heads, almost like their own thoughts and memories rather than actors telling stories.

What I am really trying to do is to use people's memories like a reference. I will try to write a line in such a way that it won't be really specific, but open enough that people can include themselves in it. I also try to combine different types of sound; for example, if I say I am walking down a hallway, I might add the sound of a door opening beside me to help you visualize the setting. People always ask me when I'm going to start making films. The difficulty for me with film is that I would be giving visual imagery instead of letting people create it themselves.

You incorporated images into your piece for *Carnegie International 1999/2000.* What do you think this brought to your work, and what did it take away? I learned so much by doing the Pittsburgh piece and using digital video cameras. I found that using imagery became an interesting comment on our culture right now and our belief that media—especially video—is real. You can forget where the reality begins and ends in the audio pieces too, but it happened in a different way in the video. There people could see the way the fabricated reality on the screen and the actual space either lined up or was out of sync. People were more involved in that piece, but at the same time they were much more like zombies following the pictures. Maybe this is because we are programmed to zone out in front of media images, particularly anything on a screen. We tend to give ourselves over to the television and to film and become very passive.

That is true, but I also noticed that the video verified the reality in such a way that the sound portion became more ghostlike. One of the problems was that some people's visual sense overrode their sense of the audio. They didn't listen and were not as tuned in to my voice and the story.

Having kids listen to my work is very interesting because I think they are still much more sound-oriented than we are. An adult sitting in a chair listening to a tape of three-dimensional sounds of someone walking by will know that the activity is just on the tape, so they won't turn their head and look for the person walking by. But a child listening to it will turn right around and look for the source of the sounds. For children, hearing is dominant to their other senses. They haven't yet been taken over by sight.

Your piece in *Wonderland* will include photographs that people will view as they walk along your route. Again, that will be an addition of a visual cue. How do you think this will affect the sound element? I have noticed that the photographs do not take away from the voice as much as the video does. What I'm planning to do is have people look at a particular picture and then line it up with the reality that they see in the Park in front of them. It will appear as if the character I'm presenting in the piece took the photos. I think this will further complicate the layers of reality.

Can you talk a bit about the way you approach a site and how you connect a narrative to a specific location? I start with the physical site and look around

Would you say there is some degree to which you are manipulating audiences? There are multiple levels of manipulation. There is manipulation of the listener who agrees to participate: people really like to be told what to do, it's very reassuring for them. Then there is the manipulation that comes through the emotional part of the story and allows me to draw people in and form a connection; it is similar to film. I will use dramatic or scary music to manipulate a situation—to make it scarier or lend impact. But I think every aspect of our culture is about a certain degree of manipulation. I think my techniques are honest and straightforward so that the audience doesn't feel manipulated. It's more their choice to participate.

I am making a connection with the listeners through my voice. The Walkman becomes a kind of surrogate that unites me with

Janet Cardiff, *Louisiana Walk #14*, 1996; installation view at Louisiana Museum of Modern Art, Humlebaek, Denmark; courtesy the artist; photo by George Bures Miller

the location to see what appeals to me in terms of space and possible stories. I think about textures and relationships as well as the formal aspects of the space. I try to expose people to different types of spaces, so I like those that allow me to bring the outside world inside or play off of particular architecture. I am curious about the way the viewer, who is more accurately a listener in most of your pieces, interacts with and in some cases even activates your work. I didn't set out to do that deliberately, but I became more interested in including the viewer when I produced an installation called *To Touch* and noticed that it became something of a performance. In that piece you walked into a small gallery that had an old wooden carpenter's table in it. In the surface I hid sensors that were connected to various soundtracks. When people touched the table, they activated different sounds and voices. People would "play" that piece like a DJ, and it even created an audience in the sense that others would observe the action. There is a performative aspect to the "Walks" as well, but there is no audience. I am very interested in the development of the audience throughout Modernism, from Dada and Futursim through Fluxus. Does your interest in the audience parallel the ideas that developed in film theory, especially the analysis of the positions of spectators in cinematic space that arose out of feminist film theory? Yes. I have made two pieces that deliberately present miniature theaters as a way to think about spectatorship. They both use the binaural recording technique to make it seem that there is someone next to you in the theater talking to you, involving you. The story you hear beside you and the story on the stage or screen begin to merge. You become part of the central action. We've talked about the way you create a space through sound, but your work also affects our sense of time, which is suspended or altered in your "Walks."

People are always surprised that my pieces are only 15 minutes in length. They seem to feel that a long time has passed as they move through the narrative. Part of this is due to the subject matter, which typically has to do with memory. By using images, as I did for the *Carnegie International* and will for *Wonderland*, there is a visible time shift between when I made the video or photo and when it is viewed. Different types of sounds also alter your sense of time, like if you hear someone walking around you and you are scared, your adrenaline is pushed up and time seems to slow down. I would assume that people also lose track of time as they get lost in the work. I know you don't set out to get people lost physically, but I would assume you are trying to get them to lose themselves in the work metaphorically. Yes. The tendency is that people forget about themselves and get lost in the characters, or in the footsteps, or in the surroundings. It's very trance-like because of the amount of concentration necessary. I don't intentionally try to get people physically lost, but I think it is an interesting effect. The fear of getting lost makes you think about why our society is so concerned with being right. People are very concerned about doing the right thing, and they get really upset with themselves if they think they have lost their way. I've noticed that Americans are the worst at following the directions in my pieces. I wonder if that has anything to do with the fact that, as a culture, we don't walk very much. We are used to being in cars and to a lesser degree riding in forms of public transportation. I think that is part of it, but we are also bombarded with so many media voices that we don't actually listen. It is easy to dismiss the TV or radio; we easily filter out their sounds. My work presents a physical sound and a bodily experience, and we just aren't used to it. Our ears are not trained very well.

People have different levels of appreciation for the various senses. Some people are very smell-oriented; some are more tactile. I know that I am very sound-oriented. I have often wondered how your physical environment growing up determines which sense will take over. I grew up in a very quiet area on a farm. I try to compare that to a child growing up in the city where you have to be able to focus so much on one sound within many—for example, you need to listen to the sounds of cars going by in order to safely cross the street. Sound affects us constantly and we rely on it much more than we realize. Interview with Janet Cardiff by Rochelle Steiner

JANET CARDIFF

Born Brussels, Ontario, Canada, 1957
BFA, Queen's University, Kingston, Ontario, Canada, 1980
MFA, University of Alberta, Edmonton, Alberta, Canada, 1983
Lives and works in Lethbridge, Alberta, Canada

WORK IN WONDERLAND

Taking Pictures, 2000
CD, Discman, headset
Courtesy the artist

SELECT SOLO EXHIBITIONS

2000 *Sleep Talking*, Kunstraum München, Munich, Germany

1999 *London Walk*, Artangel, London, England

Side Street Project (collaboration with George Bures Miller), Los Angeles, California

1997 *The Dark Pool* (collaboration with George Bures Miller), Morris Healy, New York, New York

Playhouse, Gallery Barbara Weiss, Berlin, Germany

The Empty Room, Raum Aktueller Kunst, Vienna, Austria

1996 *To Touch*, Gallerie Optica, Montreal, Quebec, Canada

1995 *The Dark Pool* (collaboration with George Bures Miller), Western Front Gallery, Vancouver, British Columbia, Canada

The Road, Eastern Edge Gallery, St. John's, Newfoundland, Canada

The Dark Pool (collaboration with George Bures Miller), Walter Phillips Gallery, Banff Centre, Alberta, Canada

1994 *To Touch*, The Power Plant, Toronto, Ontario, Canada

To Touch, The Southern Alberta Art Gallery, Lethbridge, Alberta, Canada

SELECT GROUP EXHIBITIONS

2000 *The Grange Project*, Art Gallery of Ontario, Toronto, Ontario, Canada

1999 *Carnegie International 1999/2000*, Carnegie Museum of Art, Pittsburgh, Pennsylvania

The Museum as Muse: Artists Reflect, The Museum of Modern Art, New York, New York

The Passion and the Wave, 6th International Istanbul Biennial, Turkey

Talk Show, Von-der-Heydt-Museum, Wuppertal, Germany

Divine Comedy, Fort Asperen, Netherlands

Musiques en Scene, Musée d'Art Contemporain, Lyon, France

1998 *XXIV Bienal de São Paulo*, Brazil

Places in Gothenburg, Kulturnämnden, Gothenburg, Sweden

Wanås '98, The Wanås Foundation, Knislinge, Sweden

La Ville, le Jardin, la Mémoire, Accademia di Francia, Villa Medici, Rome, Italy

New Work: Words and Images, Miami Art Museum, Florida

Voices (collaboration with George Bures Miller), Witte de With, Rotterdam, Netherlands (traveled to: Le Fresnoy, Tourcoing, France; Fundació Joan Miró, Barcelona, Spain)

1997 *Present Tense: Nine Artists in the Nineties*, San Francisco Museum of Modern Art, California

Skulptur Projekt in Münster 1997, Westfälisches Landesmuseum für Kunst und Kulturgeschichte, Münster, Germany

Ear as Eye, Los Angeles Contemporary Exhibitions, California

1996 *NowHere*, Louisiana Museum of Modern Art, Humlebaek, Denmark

Alberta Biennial for Contemporary Art, Edmonton Art Gallery, The Glenbow Museum, Calgary, Alberta, Canada

1995 *A Night at the Show*, Fields Zürich, Switzerland

Think Big, Erindale College, Toronto, Ontario, Canada

SELECT BIBLIOGRAPHY

BOOKS AND CATALOGUES

2000 Janet Cardiff and Kitty Scott. *Janet Cardiff: The Missing Voice (Case Study B).* London: Artangel.

1999 N. Fulya Erdemci and Paolo Colombo, eds. *6th International Istanbul Biennial: The Passion and the Wave*. Istanbul: Istanbul Foundation for Culture and Arts, pp. 58–61 (exhibition catalogue).

Kynaston McShine, ed. *The Museum as Muse: Artists Reflect*. New York: The Museum of Modern Art (exhibition catalogue).

Carnegie International 1999/2000. Vol. 1. Pittsburgh: Carnegie Museum of Art, pp. 20–1, 125 (exhibition catalogue).

1998 C. Borgström-Fälth, et al, eds. *Places in Gothenburg*. Gothenburg: Cultural Board (exhibition catalogue).

Sylvie Fortin. "Journeys Through Memory Gardens and Other Impossible Homecomings." *La Ville, le Jardin, la Mémoire.* Rome: Académie de France à Rome (exhibition catalogue).

Ivo Mesquita. "Antropofagia: art history as a ready-made-in-waiting." *XXIV Bienal de São Paulo: Roteiros, Roteiros. . . .* São Paulo: A Fundação (exhibition catalogue).

Christopher Phillips. *Voices*. Rotterdam: Witte de With; Barcelona: Miro Foundation; Tourcoing: Le Fresnoy (exhibition catalogue).

Marika Wachtmeister. *Wanås 1998*. Knislinge: The Wanås Foundation (exhibition catalogue).

1997 Klaus Bussman, Kasper König, and Florian Matzner, eds. *Sculpture. Projects in Münster 1997.* Münster: Westfälisches Landesmuseum (exhibition catalogue).

John Weber. *Present Tense: Nine Artists in the Nineties*. San Francisco: San Francisco Museum of Modern Art (exhibition catalogue).

1996 Laura Cottingham, ed. *NowHere*. Humlebaek: Louisiana Museum of Modern Art (exhibition catalogue).

1995 Catherine Crowstone. *The Dark Pool*. Banff: Walter Phillips Gallery, Banff Centre (exhibition brochure).

ARTICLES AND REVIEWS

1999 Gary Michael Dault. "Janet Cardiff." *Canadian Art Magazine*, Spring, pp. 40–5.

Sherry Gaché. "Miami: Janet Cardiff." *Sculpture*, January–February, p. 61.

Barry Schwabsky. "Report from Sweden." *Art in America,* January, pp. 57–9.

1998 Andy Grundberg. "Present Tense: Nine Artists in the Nineties." *Artforum*, February, p. 87.

1997 David Garneau. "Janet Cardiff and George Bures Miller, Glenbow Museum, Calgary." *Art/Text*, Issue 57, pp. 93–4.

Claudia Wahjudi. "Krimi ohne Leiche, Alles Theater: Janet Cardiff." *Zitty* (Berlin), December, p. 64.

1996 Harald Fricke. "NowHere, Louisiana Museum." *Artforum*, November, p. 95, 127.

Valerie Lamontagne. "Louise Wilson and Janet Cardiff." *Parachute*, Summer, pp. 46–8.

1995 Jim Drobnick. "Mock Excursions and Twisted Itineraries, Tour Guide Performances." *Parachute*, October–December, p. 35.

Laura Marks. "Janet Cardiff." *Artforum*, March, p. 96.

WEBSITE
http://www.abbeymedia.com/Janweb/index.html

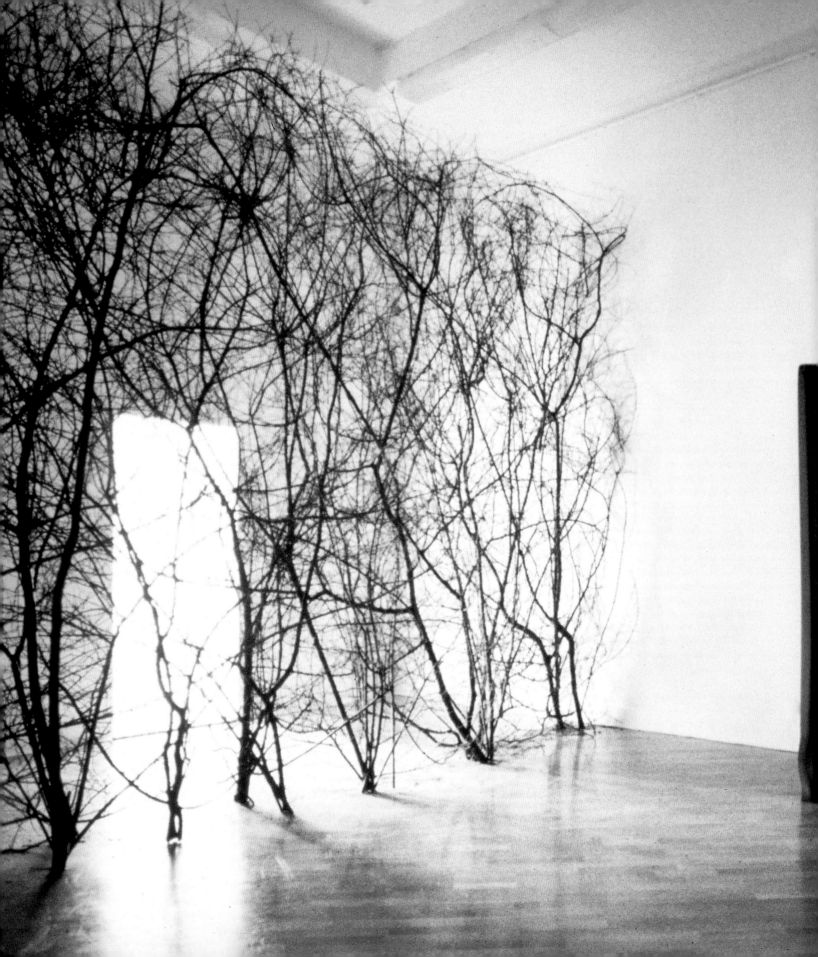

OLAFUR ELIASSON

INTERVIEW

A few years ago we were talking about your work and your role in it, and you told me "I'm not a magician." This has always stuck with me. I guess you meant that the mechanisms you use to create the effects in your work are not hidden. You seem to want us to know how they are made. Yes. The idea of not being a magician is tied to ideas about the naturalness of nature. Some people think that I'm only representing nature, without questioning what the reconstruction means. Saying "I'm not a magician" is like making the reconstruction visible. Showing the machinery that creates the phenomenon makes it completely evident that my work is not natural, but artificial. Often people don't understand the way the mechanics function, but they still know that it's made mechanically; that's enough. Sometimes I'll just put something mechanical in the space, even if it's unrelated to the effect being created; the presence of some mechanical device acts as a reminder. It breaks the illusion. But you know, you can also overdo it, like if you are hanging a painting, you don't have to make the wire behind the painting visible.

Can you talk about your particular interest in water, which is consistent throughout your work? There is not one weighted reason why I keep choosing to work with water. There are different reasons, although one of them certainly is that water is something that everybody knows. It is very familiar, and it is also organic. It is very simple. Because it's liquid, it's full of all kinds of wiggles and qualities that make it not so easy to encapsulate. I sometimes use water metaphorically, as a representation; but sometimes I use it, let's say, more directly, as something to be experienced firsthand. The worst thing would be that I would formalize water to the extent that I would become the "water artist."

Do you approach light in the same way? Yes, light is also very basic. It is totally elementary and democratic. Everybody has access to it, at least the natural type of light that comes from the sun. I am interested in natural phenomena because almost everybody has an opinion about them: everybody has something to say about a rainbow, or a piece of ice, or sand, or moss, or fire. But also you have to remember that the natural world is part of the context I grew up in—I was educated in Denmark and traveled a lot to Sweden and Iceland. I believe I have a notion of space and consciousness that has derived from a Scandinavian background, and it is different from the role nature would play in my life if I were from New York, for instance. There is clearly an autobiographical aspect to my work, though it's not the simplified thing

Olafur Eliasson, *The curious garden*, 1997; installation at Kunsthalle Basel, Switzerland; courtesy neugerriemschneider, Berlin and Bonakdar Jancou Gallery, New York

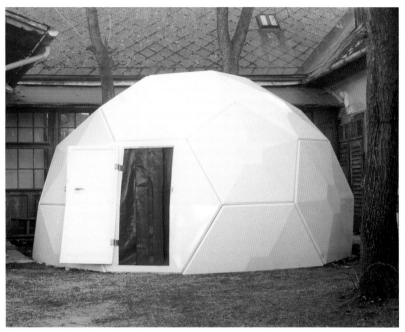

Olafur Eliasson, *By means of a sudden intuitive realization, show me your perception of presence*, 1996 (exterior view); installation in *Sharawadgi*, Felsenvilla, Baden, Austria; courtesy neugerriemschneider, Berlin and Bonakdar Jancou Gallery, New York; photo by Oktavian Trauttmansdorff

some art historians and critics think—that because I am Icelandic I make beautiful natural works of art so people can see how beautiful it is in Iceland. Most writers either address my Scandinavian background or my interest in science. Nobody seems to connect the two any further than that.

The next question that typically arises is whether light and water are nature. I think they each have been cultivated to such an extent that we think of light as the material we need to read a book. And water is most familiar as the material in the toilet. That may be as close as we get to nature within our domesticized spaces or frames of reference. Even if people go out and look at a river, that might not be totally natural, depending on the conditions for the scene. Are they looking at the river through the car window? Do they experience the river more like a picture because they have seen it more often on TV than in reality? Has the river been cultivated because of a reservoir upstream? So is it really a natural thing that they are seeing? It very rarely is a "real" river because normally the landscape has been controlled to such an extent that the questions of what is nature and where does it start, and what is culture and where does it stop, are impossible to answer. It is so hard to use the word nature—maybe it is better to refer to uncultivated areas and cultivated areas and the areas in between. As an artist are you using your work to point to or investigate these spaces in between? Sometimes I am, but I am not particularly interested in the question of what is nature and what is culture. I'm actually interested in what people see as nature and what they see as culture. So you could say I am more interested in the people who are doing the seeing and the social conditions that are based upon spatial understandings. I think you have a choice of being able to say I am going to step out of the car and look at something this way, or I am going to sit in the car and look at it another way. I think it's important to have that sort of liberty, metaphorically at least. The importance of the spectator or the individual who does the seeing seems to be developing more extensively in your recent pieces. I basically start out with the spectator—that's the first element in a piece. Then I try to encompass the situation of the spectator as completely as possible. I consider what kind of movement he will make, what kind of space he will find himself in, what is the time and place of the situation. For me that is a scheme for situating or mapping the conditions of the piece. I don't think that's particularly different from many other artists. I try to leave a piece as open as possible so that the spectator can find a role within it.

This attention to the spectator has been there all along, but recently it has been prioritized. I am moving away from a unified point of view where everything is controlled towards an understanding of physical and mental space in which the subject can move around and the conditions for relating to a work are very open. Hopefully this will create a much more diverse subjectivity where everybody sees things from a slightly different position. I don't think it's that new, but I am interested in the idea that you relate to your surroundings in a specific time and space where things are changing so that you have a new situation every split second. I've been reading about gardens, particularly formal gardens and labyrinths. You can rarely see an entire garden at once; instead you must experience it in parts—or through aerial photographs. This discrepancy between what you see, know, and experience seems to be related to your work. There's always a difference or space between what you know and what you experience. I try to use that in my work, like in the ice skating rink I made in São Paulo. Many Brazilian people know, of course, what ice is, but they don't actually experience it like we do. So when they saw it in my piece, they reacted more strongly than people who had a more experiential understanding of the material. Some people sat down on the ice and thought, "oh, that's great, it's ice!" without realizing that they were going to get wet. This was totally great because there was such a big difference between knowledge and experience. It's not that different from gardens.

I have started to make some gardens in parks, but those pieces are tied to my interest in trying to understand what role these natural spaces play within a society. I don't have any desire to nail down exactly what nature is, which everyone seems to be very concerned with. I somehow think that the parks seem more natural than what we call "nature" because of their context—because they are usually

surrounded by cities. It used to be that the world was filled with small cities within a huge expanse of uncultivated land, and this big area of undomesticated land was called "nature" or the "wilderness." As culture grew, the situation reversed. Now everything is cultivated, and there are only small areas that are still wilderness. And these small natural areas seem strange, almost unnatural; because they are so rare they almost appear mutant.

Consider this idea in terms of the cloning of sheep that is being discussed because of biotechnology. Let's say you have ten perfect sheep all alike and suddenly you get one sheep which is a mistake because it has three legs. Is that natural? Is it a mutant? Is there some kind of failure? In some sense, the three-legged sheep is an example of nature, because nature is where unpredictable things happen. But of course we consider it to be unnatural because a weird-looking sheep doesn't fit our expectations. Our sensibility towards little areas of wilderness is not unlike the three-legged sheep. They are natural, but they are rare.

That is why I'm so fascinated by Iceland, because it's so funny looking. It's not like the grand American landscape. Iceland hasn't been domesticated by knowledge or an idealization of nature yet. But as time passes, it is becoming more cultivated. This is also why I am interested in parks and gardens, which are like plateaus of accumulated knowledge of nature.

For some people parks are the only experience of nature they have. Yes, that's right. And this relates to the idea that even the real "nature"—if there could be such a thing—is not so natural. It is

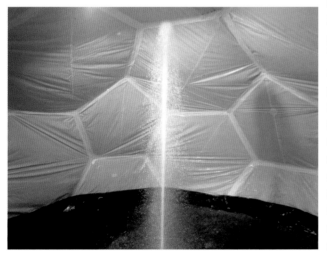

Olafur Eliasson, *By means of a sudden intuitive realization, show me your perception of presence*, 1996 (interior view); installation in *Sharawadgi*, Felsenvilla, Baden, Austria; courtesy neugerriemschneider, Berlin and Bonakdar Jancou Gallery, New York; photo by Oktavian Trauttmansdorff

known through images, and it is changed just by walking through it and leaving our footsteps on it.

Are you attempting to remind people that there is no such thing as an original or "pure" experience? I am thinking about your sunset piece, in which you simulated a sunset over the city of Utrecht. You seem to be calling our attention to a natural phenomenon we all know and have seen, both in reality and in postcards. It is important to understand that I'm not trying to re-create the real experience, and I'm not trying to use my work to point out the loss of real experiences. It is actually about accepting that our vision and knowledge and experiences are totally controlled. *So would you agree that someone could have a "pure" experience of your sunset, even though it's artificial?* Yes. Sometimes I enjoy the pleasure of being totally romantic and playing with these ideas of purity. Then, it's nice to say, oh yes, it's a "pure" experience. But at the same time it never really can be. My work sits at that borderline. Small interventions make you rethink the conditions you find yourself in.

Ever since the Renaissance, since the beginning of perspective, we have been dividing what we know into categories. For example, when we encounter the street we live on, which doesn't have any surprises, we see what's in front of us. But let's say we go to another place where there is some kind of surprise, something unexpected. In that case, what happens is that the spectator sees himself in the situation. There is a metaphysical encounter that cannot be described or commodified as a typical way of seeing. The idea of seeing yourself in a work of art is definitely not something new, but in my case I'm hoping to create some uncertainty and unpredictability that is unexpected.

Everything you've talked about so far has to do with the way we perceive things. Yes. And it also has to do with mathematical or geometrical issues, which were developed to get a hold on nature, land, time, the passing of time. One of the first mathematical interests was in measuring systems that could be used to comprehend our surroundings. Scientific systems are often about visualizing natural phenomena. These things get factored into my work.

Your photographs depict aspects of certain landscapes, mostly in Iceland. This representational quality differs from your sculptures and installations. Exactly. The photos are sort of research into spatial situations in landscape that help me prepare ideas for the installations. There is not a direct correlation—I don't do a cave photo series and then make a cave installation. But in making the cave photos, I realized when I walked into these natural formations that there was a super-intense experience of compressed space that reminded me of standing in a swimming pool without water. So you have a sense of being in a space where you almost can feel the pressure on your body. I might try to realize that experience of space in an installation. *So what are you planning for your piece in* Wonderland*?* Today I really realized the extreme height of the space of the Museum's main hall. I will probably try to take advantage of that, though I don't know exactly how yet. People might know it is a tall space, but they probably haven't really experienced that height, so there might be a way to refocus people's attention to scale through something very immediate. It could even be something as simple as one child's balloon that has flown up onto the ceiling. That simple, tiny thing would get so much attention because it would be

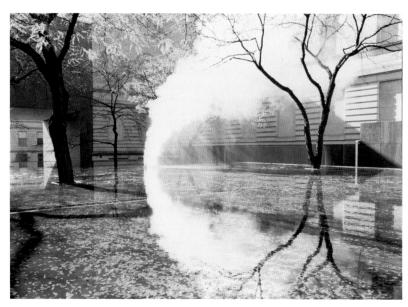

Olafur Eliasson, *Your natural denudation inverted*, 1999; installation at *Carnegie International 1999/2000*, Carnegie Museum of Art, Pittsburgh; courtesy Bonakdar Jancou Gallery, New York and neugerriemschneider, Berlin; photo by Christopher Baker

a total surprise within the scale of the space. I also like the idea of the wonderland as the intersection between the real world and a fabricated world.

In addition to the space, I am interested in looking at time. I have been thinking of building a geodesic dome. For me the dome is about trying to stop time. This, of course, plays with the whole idea of the museum, which can either be a fixed place that is already settled in our mind or something moving, organic, and changing. Inside of the dome you might see mirrors and reflections, with a strobe light that causes all the movement to appear to be frozen in small bits of time.

Most people who are familiar with The Saint Louis Art Museum expect to see a fountain with a sculpture of Neptune on top of it in the center of Sculpture Hall. Are you trying to shift that expectation? It's going to look like Neptune got a new coat in a way. People are going to look straight through the dome and see Neptune standing there. The dome is not transparent, but if you have been to the Museum before you know the fountain is supposed to be there. So you will see straight through the dome to what's on the inside. When you go inside it, I hope you will have a new experience within the space: see Neptune in a new light, see the Museum's building in a new light, see yourself in a new light. You see yourself not only in the mirrors in front of you, but you see yourself scattered all around the building because the inside of the dome is fully coated with mirrors. I always think one can see oneself in my work, but here I am trying to reduce the object to the extent that there is a subject. I am trying to reduce the object by not creating a physical sculpture: I didn't make the Neptune or the fountain, and the dome is just an architectural frame. What's going on inside the dome is experientially based; it is so much about the experience that the spectator or subject becomes the central issue of the piece.

This is why what we see is, in fact, ourselves. In a way you can say that if nobody is in the space, the drops of water there would not be standing still because you would not be there to see them. It is not until somebody walks in and looks at them that the water can appear to be frozen. None of the drops would be moving either if we weren't there to see them. So we can say that the phenomenon that I have created only exists when there are people to see it.

I am thinking about the multiple points of view in your work, and especially in the dome for *Wonderland*, which will be seen from the outside as well as from the inside. It is like layers of representation and experience that begin when the viewer is still at home and decides to go to the museum. Parking the car, crossing the threshold, and entering the museum all create different expectations, so when we go to the museum to have an experience, a so-called "art experience" of some sort, we are already conditioned by what has led up to it. When we look at a piece, we are not only seeing it but also seeing something that is inside ourselves. Are we just fulfilling our expectations of what we are seeing? So are you trying to control the way people experience your work? No, I like to have an openness. I try to keep myself from telling people how to see my work. I can try to push and pull it in different directions by formal decisions—I could paint the dome black, or make Neptune yellow, or do lots of other things that would provoke a response—but I can't put a big text in front of the piece saying how to experience it. That's up to the individual.

Once you told me that you are thinking about the space in between the piece and the viewer. Is that where you would locate perception? Within classical psychology, perception is always limited to the senses. But perception is also a psychological layer of memory and recognition. For example, what you see and do right before you go to the museum has a huge impact on your perception of what you see when you arrive. Perception is much bigger and more intuitive than seeing. When I talk about the space between the piece and the spectator, I am referring to ideas Robert Morris had in the 60s. Ultimately the spectator becomes the piece.

Interview with Olafur Eliasson by Rochelle Steiner

OLAFUR ELIASSON

Born Copenhagen, Denmark, 1967
Royal Academy of Arts, Copenhagen, Denmark, 1995
Lives and works in Berlin, Germany

WORK IN WONDERLAND

*The drop factory. A short story on
your self-ref and rep,* 2000
spatial medium
Courtesy Bonakdar Jancou Gallery, New York
and neugerriemschneider, Berlin

SELECT SOLO EXHIBITIONS

2000 *Your surrounded intuition versus your
 intuitive surroundings,* The Art Institute of
 Chicago, Illinois

 Surroundings surrounded, Neue Galerie am
 Landesmuseum, Joanneum, Graz, Austria

 The curious garden, Irish Museum of Modern
 Art, Dublin, Ireland

1999 Dundee Contemporary Arts, Scotland

 De Appel, Amsterdam, Netherlands

 Frankfurter Kunstverein, Frankfurt, Germany

 Kunstverein Wolfsburg, Germany

 Marc Foxx, Los Angeles, California

 Castello di Rivoli, Turin, Italy

1998 Galerie für Zeitgenössische Kunst, Leipzig,
 Germany

 neugerriemschneider, Berlin, Germany

 Tell me about a miraculous invention, Århus
 Kunstmuseum, Vennelystparken, Denmark

 Bonakdar Jancou Gallery, New York,
 New York

1997 The Reykjavik Municipal Art Museum, Iceland

 Your sunmachine, Marc Foxx, Los Angeles,
 California

 The curious garden, Kunsthalle Basel,
 Switzerland

1996 *Your foresight endured,* Galleria Emi
 Fontana, Milan, Italy

 Your strange certainty still kept, Tanya
 Bonakdar Gallery, New York, New York

 Tell me about a miraculous invention, Galeri
 Andreas Brändström, Stockholm, Sweden

 Kunstmuseet, Malmo, Sweden

1995 *A Description of A Reflection, or A Pleasant
 Exercise Regarding Its Qualities,* neugerriem-
 schneider, Berlin, Germany

 Künstlerhaus Stuttgart, Germany

 Thoka, Kunstverein in Hamburg, Germany

SELECT GROUP EXHIBITIONS

1999 *Carnegie International 1999/2000,* Carnegie
 Museum of Art, Pittsburgh, Pennsylvania

 Landscape: Outside the Frame, MIT List Visual
 Art Center, Cambridge, Massachusetts

 dAPERTutto, XLVIII Biennale di Venezia,
 Venice, Italy

1998 *New Photography 14,* The Museum of Modern
 Art, New York, New York

 XXIV Bienal de São Paulo, Brazil

 Every Day: 11th Biennale of Sydney, Australia

 Berlin/Berlin, Berlin Biennale, Germany

 Something Is Rotten in the State of Denmark,
 Museum Fridericianum, Kassel, Germany

 La Ville, le Jardin, la Mémoire, Accademia di
 Francia, Villa Medici, Rome, Italy

 Mai '98, Kunsthalle Köln, Cologne, Germany

 Nuit blanche, La jeune scène nordique, Musée
 d'Art Moderne de la Ville de Paris, France
 (traveled to: The Reykjavik Municipal Art
 Museum, Iceland; Bergens Billedgalleri,
 Norway; Porin Taidemuseo, Eteläranta,
 Finland; Göteborgs Konstmuseum, Sweden)

 Seamless, De Appel, Amsterdam, Netherlands

 Sightings: New Photographic Art, Institute of
 Contemporary Arts, London, England

1997 *On life, beauty, translations and other
 difficulties,* 5th International Istanbul
 Biennial, Turkey

 Trade Routes, 2nd Johannesburg Biennale,
 South Africa

 *TRUCE: Echoes of Art in an Age of Endless
 Conclusions,* SITE Santa Fe, New Mexico

 New Scandinavian Art, Louisiana Museum
 of Modern Art, Humlebaek, Denmark

 Platser, Public Space Projects,
 Stockholm, Sweden

 Kunsthalle Wien, Vienna, Austria

1996 *Manifesta 1,* Rotterdam, Netherlands

 Glow, New Langton Arts, San Francisco,
 California

 Prospect 96, Frankfurter Kunstverein,
 Frankfurt, Germany

 The Scream, Nordic Fine Arts 1995-96, Arken
 Museum of Modern Art, Ishoj, Denmark

1995 *Campo 95,* XLVI Biennale di Venezia, Venice,
 Italy (traveled to: Sant' Antonino de Susa,
 Turin, Italy; Konstmuseet, Malmo, Sweden)

SELECT BIBLIOGRAPHY

BOOKS AND CATALOGUES

1999 Yilmaz Dziewior. "Olafur Eliasson."
 Art at the Turn of the Millennium. Cologne
 and New York: Taschen, pp. 142-5.

 Harald Szeemann and Cecilia Liveriero
 Lavelli, eds. *La Biennale di Venezia:
 48a esposizione internazionale d'arte:
 dAPERTutto.* Venice: Marsilio, pp. 278-81
 (exhibition catalogue).

 Carnegie International 1999/2000. Vol. 1.
 Pittsburgh: Carnegie Museum of Art,
 pp. 32-3, 102 (exhibition catalogue).

1998 Francesco Bonami. "Olafur Eliasson."
 Cream: Contemporary Art in Culture. London:
 Phaidon Press Ltd., pp. 104-7.

 Simon Grant. "Olafur Eliasson." *Every Day:
 The 11th Biennale of Sydney.* Sydney:
 The Biennale of Sydney Ltd., pp. 90-1
 (exhibition catalogue).

 Marianne Krogh Jensen. "Olafur Eliasson."
 *XXIV Bienal de São Paulo: Representações
 Nacionais.* São Paulo: A Fundação,
 pp. 238-43 (exhibition catalogue).

1997 Francesco Bonami. "Olafur Eliasson." *5th
 International Istanbul Biennial: On life, beauty,
 translations and other difficulties.* Istanbul:
 Istanbul Foundation for Culture and Arts,
 pp. 86-7 (exhibition catalogue).

 Francesco Bonami. *TRUCE: Echoes of Art in
 an Age of Endless Conclusions.* Santa Fe: SITE
 Santa Fe (exhibition catalogue).

 Roxana Marcoci, Diana Murphy, and Eve
 Sinaiko, eds. *New Art.* New York: Harry N.
 Abrams, Inc., p. 51.

 Olafur Eliasson. Kunsthalle Basel. Basel:
 Schwabe & Co. AG. Verlag
 (exhibition catalogue).

ARTIST PUBLICATIONS

1998 Olafur Eliasson. *USERS.* Copenhagen and
 Berlin: Olafur Eliasson.

ARTICLES AND REVIEWS

1998 Daniel Birnbaum. "Openings: Olafur Eliasson."
 Artforum, April, pp. 106-7.

 Christian Haye. "The Iceman Cometh." *Frieze,*
 May, pp. 62-5.

 Jan Winkelmann. "Project: Olafur Eliasson."
 Art/Text, February-April, pp. 44-9.

1996 Christiane Schneider. "Olafur Eliasson."
 Frieze, January-February, p. 77.

 Roberta Smith. "Enter Youth, Quieter and
 Subtler." *The New York Times,* May 17, p. C1.

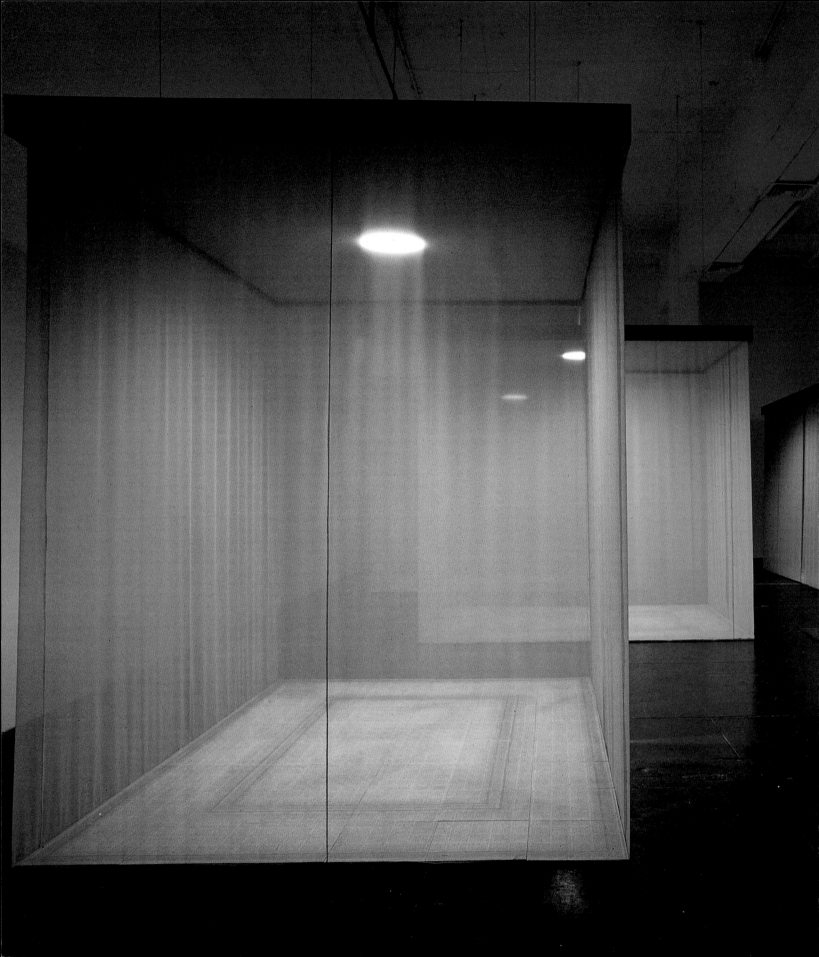

TERESITA FERNÁNDEZ

INTERVIEW

What was your inspiration for *Landscape (Projected)*, **your piece in** *Wonderland?* I have been interested in 17th-century formal gardens for some time. My research was key to the conceptual development of this piece. I wasn't at all interested in using the garden reference as a tableau, or illustrating it in any way. But I chose it as an image because it was the perfect vehicle to look at the significant gestures of the viewer moving through space. It also highlights the collapsing between two and three dimensions, where vistas or framed views become fixed, two-dimensional planes, depending on how you move around the layout for a garden. You occupy these gardens in an imaginary way, because the only way that you can really get a sense of the entire thing is little by little. You never have a sense of it as a whole. So the idea of this shaped, geometric garden is really something that you visualize in your mind's eye. It's only by way of your movement through it that the garden is unraveled.

I was thinking of this piece as an indoor landscape or an outdoor room, and I was trying to collapse the idea not only of inside and outside, but also of a natural reference and an artificial reference. I was trying to combine an interior—in this case not a domestic interior, but a sort of museum or gallery interior—and its opposite—an outdoor landscape. Other references to the garden can be seen in the choice of color and the pattern created by the pipes. The intense yellow-green color looks both natural and synthetic at the same time. The layout of the pipes on the floor suggests the shaped parterre pattern that you would walk around in a formal garden.

It's almost like an inversion of a landscape because the landscape is on the inside rather than the outside of the space. When you look at this piece from the outside it's a rectangular room. It's like you're looking at the exterior of a volume of a building or of a sculpture. But when you're inside, the image is something you identify as outside. The only thing that's dividing those two spaces is a wall and a thin layer of paint. And it's that very thin layer of paint that's interesting to me because it's almost like the room is lined on the inside. The layer of paint is so thin that it's almost not there, yet it completely inverts the whole space. You're actually occupying two different spaces that are shifting all the time. One is near, enclosed, and architectural. The other is imagined, picturesque, distant, and atmospheric. So there is this sort of simultaneity of the space that you're occupying. It almost seems like you're looking out onto a horizon around you—a vista. It's very picturesque. And on the other hand, you're completely aware of what's encapsulating both that image

Teresita Fernández, *Borrowed Landscape (Citron, Cerulean, Violet, Blue, Citron)*, 1998;
installation at ArtPace—A Foundation for Contemporary Art/San Antonio;
courtesy the artist and Deitch Projects, New York; photo by Ansen Seale

Teresita Fernández, *Untitled*, 1996 (detail); installation at Deitch Projects, New York; courtesy the artist and Deitch Projects, New York; photo by Tom Powel

to project the viewer into another place. You can't actually climb those ladders, but they take you on some sort of mental journey. It's really no different than what I'm trying to do in the other pieces. With them, I'm trying to create a journey, that sort of trek, that projection, whatever you want to call it.

Your work, like many pieces in this exhibition, involves an artificial space in which visitors have a very physical or perceptual experience. Are you trying to achieve a specific sensory response from your viewers? The space is overtly artificial and employs artifice as its vocabulary for constructing meaning. The light and air in the room seem almost tangible, thick. It is through this very sensual, physical effect that the viewer is suspended.

The title of the piece is *Landscape (Projected)* and you've just said the viewer is projected into the space. This seems to be an important idea within the piece. I thought of the image of the room as a projection and that's why I put the oculus at the top, almost as though it were a film projector producing the image. This creates the suggestion that the image is made out of light and out of things that aren't tactile, even though, of course, you are very aware that it's pipe and drywall and everything else. I wanted you to be able to suspend your belief in the physical elements and have an experience of the image just hovering. Then, of course, the sound is really, really important in that kind of illusion. Both the sound and the light are circular projections. They are both being projected into the room, and they are both being projected in a circular pattern. The sound is recorded from a sprinkler that's moving in a circular pattern, and the light, of course, is being sort of thrown into the space in the circular pattern, even though it's kind of diffuse and doesn't make a hard circle. And most importantly, the sound of the sprinkler has a rhythm that's almost exactly the same as that of a film projector. So, the projection occurs in many overlapping, superimposed images and layers.

I've done other pieces that I also thought of in very cinematic terms, even though there was no filmic apparatus. I'm interested in the cinematic apparatus on a conceptual level that involves a kind of panning or the viewer moving through the image. In that sense, the viewer functions almost as a moving camera would, creating the image along with the light.

The sound of the sprinkler is very intriguing because it conjures up a certain type of experience with nature that is domestic and often associated with childhood or suburbia. That is a very different type of landscape than a formal garden. I actually don't think people know it's the sound of a sprinkler unless I tell them. It's very subtle and it can sound like a lot of things. It could sound like the repetitive rhythm of a train moving over train tracks or like the ticking of

and the space you're standing in. It's almost like you have two spaces that are superimposed on one another. Enclosure is achieved through surface.

Can you elaborate on the way two- and three-dimensional spaces are collapsed? It's a compression. It's similar to what happens with film. Film is created with a very three-dimensional approach to space, and then it's compressed into something flat. So it's not quite flat and it's not quite three-dimensional. And there's always the sense of scale, too. Gaston Bachelard talks about "intimate intensity," a kind of daydream or projection into an imaginary space that happens without physically moving. It's not unlike the cinematic experience—where you're absorbed in a situation from a static position in a dark theater.

Your ladder pieces, *Untitled (Crawlspace)* and *Hatch Spill*, look very different than the landscape pieces—they are more sculptural than spatial. But they also seem

a clock or something. I chose it because it fit in to the piece conceptually, but it's not that important for the viewer to identify it as a sprinkler sound. I'm really not making a reference to suburbia or to some childhood memory. It's a much more generic, mnemonic device. It's not meant to be nostalgic, and I think that because it's not specific it creates that suspension of belief. Because if it were specific, then it would be a tableau . . . or part of a narrative. Exactly.

Would you say that you're creating an illusion? I've never been interested in tricking the viewer, so I can tell you exactly how the piece is made, or you can read the label and pretty much figure it out. It's not about the trick. The illusion is in the viewer's own construction of it. It's not in the apparatus of the piece, and that's really, really important to my work. The perceptual fine-tuning is a way for me to create a tone—but it's the viewer's psychology that really allows the space to be effective. It's really not at all about how it's put together, which is overt and simple. What makes that kind of glowing, unreal quality is the fact that the viewer completes the circuit of meaning.

Landscape (Projected) is related to your later piece, Borrowed Landscape (Citron, Cerulean, Violet, Blue, Citron), which was made at ArtPace and shown at the Institute of Contemporary Art in Philadelphia. It's as if the paint in Landscape (Projected) was transformed into a fabric curtain. Yes, that's true. What's the same is the idea of the projection and the oculus, and the feeling that the image is not solid but hovering. In both pieces it's as if the images are created by light shining through a transparent film. What's different is the way they are related to landscape. They both relate to the formal gardens, but Borrowed Landscape also touches upon the manipulated aspect of the landscape in the formal garden and how that relates to ornament and gender.

I was really trying to examine my own decision-making process. I started to question this reductive Minimalist approach that I was using as a given. Minimalism functions so differently than it did 35 years ago—it has become a mainstream "look" which we are surrounded by. It has become stylized. That reductive approach has become more stylized than things that we would think of as "ornamental"—worse in fact, because it purports to be pure. Those were all ideas I was thinking about in Borrowed Landscape.

I've always been very interested in the work of Adolph Loos. In Ornament and Crime he talks about decoration as something negative, something that we must do away with, both in relation to our own bodies and to buildings, which really are like bodies. What's most disturbing about his ideas is that he cites "primitives and criminals," who tattoo their bodies, and women, who paint and

Teresita Fernández, *Untitled*, 1996; installation at Deitch Projects, New York; courtesy the artist and Deitch Projects, New York; photo by Tom Powel

ornament their bodies, as being less cultured. I look at his ideas from my feminist point of view, not to reclaim territory as much as to restructure the space that they occupy. I challenge those ideas by creating a space in which surface and the act of looking are exposed.

Can you discuss the role of feminist theory in your work? I think the thing that everyone agrees upon in feminist film theory is that there's a kind of pleasure in the act of looking, and that it is women who are being objectified. It is feminist criticism of both architecture and cinema that brought these things to light and made them an important subject in the first place. The groundwork has been done and I don't feel like I have to stick to one sort of rigid way of looking at something. Many people would say that the position of the viewer in Borrowed Landscape would be a predictable masculine position of looking in and fantasizing, and that what's on the inside of the curtain is occupied by some sort of feminized scene. But it's not that simple.

So are you trying to expand the gendered positions defined by feminist film theory through the positions you create for viewers in your work? What I am trying to do is to overlap them, so that they really start to occupy the same space, where subject and object are simultaneous aspects of the same experience, the same viewer. I've been doing work like this for a while. Because the conceptual basis of my work stems from these ideas about space and gender, it is important for me that it does not just get consumed by the references and become a "sexy" space.

Earlier you used the word "fantasy." What role does this play in your work? I use the

Teresita Fernández, *Hatch Spill*, 1999, *Double Hatch Spill 1*, 1999, and *Double Hatch Spill 2*, 1999; installation at Institute of Contemporary Art, Philadelphia; courtesy the artist; photo by Gregory Benson

I think it's primarily formal and rigid. Or sometimes it's completely atmospheric, which is another kind of formalism. My work and process come from conceptual concerns. There are formal aspects of my work, but I use them as a vehicle for the conceptual part of it. It often gets confused for this whole sort of Light and Space thing, but that's not a starting point for me. One of the main differences is that I'm completely dependent on an image and on a reference. When you say an "image," what do you mean? A recognizable image or a specific reference. Something that the viewer can latch on to emotionally. It's like a mnemonic device that you are invested in. It's very hard to come up with something that is specific, but also ambiguous. The Light and Space artists and the Minimalists were so concerned with stripping the art object of any image or reference. I almost start in the opposite direction, from the reference. I have to find an image that will carry that sense, that tone, that meaning through conceptually. The viewer has to feel emotionally connected to it, and that's where the reference comes in. What links the references you choose? Is there an overarching thematic approach? There's no blanket answer, but all I can say is that it's really hard for me to choose something that will hold. It has to have resonance. I have to be able to find an image that can function almost like a framework onto which I can layer things. Because if not, it becomes a tableau and I'm anti-tableau.

Let's return to the image of the garden in your work. Is it possible to read these spaces as feminized or identified with female leisure activity? Lately I've been interested in the idea of the landscape as being gendered and exoticized—but mostly associated with the "natural," virgin wilderness, which is such a loaded and fascinating metaphor. But in these pieces, the subjects I was interested in were structured landscapes, like Versailles or Vaux-le-Vicomte, for example. These gardens were very much "by a man, for a man"— for the king—and tied into the whole idea of perspective and power. There are, however, other aspects of gardens that I think are interesting in that they deal with secret space or a series of spaces that are not easily or immediately accessible. I'm interested in a sense of searching through a space physically, of having to penetrate a space and move through it. And I think that the secretive place always has a kind of sexual undertone. If you look at gardens historically they are meeting places and private places. Gardens were one of the first places that people thought of as being private or of being able to attain privacy in. They were also very much seen as a place for something to be staged, as a scene where something is going to happen.

Interview with Teresita Fernández by Rochelle Steiner

word "fantasizing" loosely because it could be a kind of visual projection, or it could be a kind of daydream. It's not necessarily sexual, it can be anything. It could also be having your eyes graze the surfaces of these things, which is another kind of fantasizing. It could just be a kind of pleasure of looking. In *Borrowed Landscape* what you're really fantasizing about is yourself on the other side of the curtain. The act of looking becomes very self-contained rather than dualistic. There's usually this assumption that the act of looking or thinking or imagining is about the "other"— about an "other" who is at a disadvantage because they are subject to whatever you want to imagine. But I don't think that's true. I think that the subject of the fantasy, or rather the object of the fantasy, is really yourself. I mean, what you're thinking about is yourself. The work poses something unexpected in that sense. You might think you know what you're looking at, this sort of scene that you've come upon, but what you're really seeing and thinking about is yourself in that space. You become a voyeur, looking at yourself, ensnared in the very act of looking.

As you've explained, your work draws from architecture and film and feminist theories of both. But what about art history? Are you inspired by Light and Space artists, for example? I always have trouble making this sound like I'm not exaggerating, but I really don't feel that connected to the whole Light and Space movement because

TERESITA FERNÁNDEZ

Born Miami, Florida, 1968
BFA, Florida International University,
Miami, Florida, 1990
MFA, Virginia Commonwealth University,
Richmond, Virginia, 1992
Lives and works in New York, New York

WORK IN WONDERLAND

Landscape (Projected), 1997
oculus light, pipes, fabric, sound, paint
Courtesy the artist

SELECT SOLO EXHIBITIONS

2000 Castello di Rivoli, Turin, Italy

1999 *Borrowed Landscape,* Deitch Projects,
 New York, New York

 Teresita Fernández, Institute of Contemporary
 Art, Philadelphia, Pennsylvania

 Teresita Fernández/MATRIX 182 supernova,
 UC Berkeley Art Museum, California

1998 ArtPace, San Antonio, Texas

 Masataka Hayakawa Gallery, Tokyo, Japan

1997 Masataka Hayakawa Gallery, Tokyo, Japan

 The Corcoran Gallery of Art, Washington, D.C.

1996 *Teresita Fernández,* Deitch Projects,
 New York, New York

1995 *Real/More Real,* Museum of Contemporary
 Art, Miami, Florida

SELECT GROUP EXHIBITIONS

2000 *La Ville, le Jardin, la Mémoire,* Accademia
 di Francia, Villa Medici, Rome, Italy

1999 *Luminous Mischief,* Yokohama Portside
 Gallery, Japan

 On Your Own Time, P.S. 1, Long Island City,
 New York

1998 *Threshold,* The Power Plant, Toronto, Ontario,
 Canada

 Seamless, De Appel, Amsterdam,
 Netherlands

 Insertions, Arkipelag/Cultural Capital,
 Stockholm, Sweden

1997 *The Crystal Stopper,* Lehmann Maupin
 Gallery, New York, New York

 X-Site, The Contemporary Museum,
 Baltimore, Maryland

1996 *Enclosures,* The New Museum of
 Contemporary Art, New York, New York

 Container 96, Copenhagen Cultural
 Capital, Denmark

*Defining the Nineties: Consensus-making
in New York, Miami and Los Angeles,*
Museum of Contemporary Art, Miami, Florida

1995 *Selections Spring '95,* The Drawing Center,
 New York, New York

1994 *Fine,* TBA Exhibition Space, Chicago, Illinois

 The New Orleans Triennial, The New Orleans
 Museum of Art, Louisiana

 South Florida Cultural Consortium,
 Boca Raton Museum of Art, Florida

1993 *South Florida Artists Invitational,* Margulies
 Taplin Gallery, Boca Raton, Florida

 Thirty and Under, Ground Level Gallery,
 Miami Beach, Florida

SELECT BIBLIOGRAPHY

BOOKS AND CATALOGUES

1999 Francesco Bonami and Hans-Ulrich Obrist,
 eds. *Sogni/Dreams.* Turin: Fondazione
 Sandretto Re Rebaudengo per l'Arte, p. 41.

 Heidi Zuckerman Jacobson, *Teresita
 Fernández/MATRIX 182 supernova.*
 Berkeley: UC Berkeley Art Museum
 (exhibition brochure).

 La Ville, le Jardin, la Mémoire. Rome:
 Académie de France à Rome, pp. 179–84
 (exhibition catalogue).

 Teresita Fernández (text by Lisa Graziose
 Corrin). Philadelphia: Institute of
 Contemporary Art, University
 of Pennsylvania (exhibition catalogue).

1998 Carlos Basualdo. "Teresita Fernández."
 Cream: Contemporary Art in Culture.
 London: Phaidon Press, Ltd., pp. 116–9.

 Threshold. Toronto: The Power Plant
 (exhibition catalogue).

1996 Bonnie Clearwater, ed. *Defining the Nineties:
 Consensus-making in New York, Miami
 and Los Angeles.* Miami: Museum of
 Contemporary Art (exhibition catalogue).

ARTICLES AND REVIEWS

1999 Jane Harris. "Intimate Immensity." *Art/Text,*
 February–April, pp. 39–41.

 Melissa Ho. "Teresita Fernández: Institute
 of Contemporary Art." *New Art Examiner,*
 July–August, pp. 56–7.

 Yukie Kamiya. "Borrowing Scenery—An
 Interview with Teresita Fernández/Scenari in
 Prestito." *Cross,* no. 2, pp. 116–21.

 Edward Leffingwell. "Teresita Fernández at
 Deitch Projects." *Art in America,* November,
 pp. 138–9.

Anne Wilson Lloyd. "From an Architect of
Desire, Many-Layered Constructions." *The
New York Times,* March 21, Section 2, p. 41.

Charles Moleski. "Reviews: Teresita
Fernández." *Art Papers,* September–October,
pp. 54–5.

Anne Barclay Morgan. "Teresita Fernández:
The Structure of Space." *Sculpture,*
January–February, pp. 8–9.

Roberta Smith. "Teresita Fernández,
Borrowed Landscape." *The New York Times,*
June 4, p. E33.

Sabina Spada. "Teresita Fernández,
Recensoni." *Tema Celeste* (Siracusa),
July–September, p. 85.

Gregory Williams. "Into the Void." *World Art,*
Issue 20, pp. 58–61.

1998 Carlos Basualdo. "Teresita Fernández/
 Quisqueya Henriquez." *Artforum,* March,
 pp. 104–5.

 Jade Dellinger. "Cityscape Florida." *Flash Art,*
 March–April, pp. 69–72.

 Adam J. Lerner. "Teresita Fernández and
 Quisqueya Henriquez." *Art Papers,*
 March–April, p. 50.

 Anne Barclay Morgan. "Paths to Success:
 Recently 'Emerged' Artists." *Sculpture,*
 July–August, pp. 48–53.

 Sarah Tanguy. "X-Site 9." *Sculpture,*
 March, pp. 60–2.

1997 Monica Amor. "Teresita Fernández at
 Deitch Projects." *Art Nexus,* January–March,
 pp. 142–3.

 Jan Avgikos. "The Crystal Stopper."
 Artforum, September, p. 124.

 Owen Drolet. "Teresita Fernández." *Flash Art,*
 March–April, p. 111.

 Felicia Feaster. "Enclosures." *Art Papers,*
 March–April, p. 63.

 Cary Lovelace. "Weighing in on Feminism."
 ARTnews, May, pp. 140–5.

 Margaret Sundell. "The Crystal Stopper."
 Art Nexus, July–September, pp. 115–6.

1995 Carol Damian. "Teresita Fernández and
 Quisqueya Henriquez." *Art Nexus,*
 October–December, pp. 124–5.

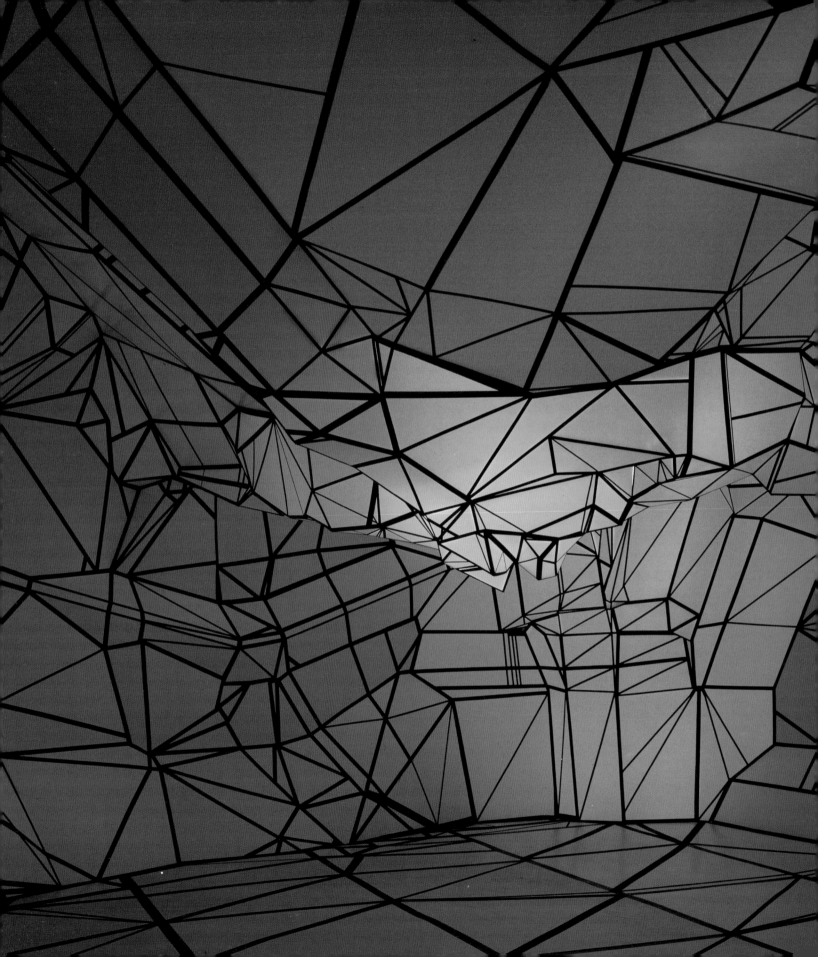

STEPHEN HENDEE

INTERVIEW

Let's begin by talking about one of your recent installations, *Shadow Proxy,* at Mark Moore Gallery in Santa Monica. There were two interlocking tunnels, one being a light space and the other a dark space. Could you take me through the piece? One tunnel branches off the other, the idea being that the smaller one is a "shadow" of the larger space—not in a literal sense, but more in a metaphoric sense. It's based on the notion that somehow there could be a shadow of the virtual world. It's lit up, and it's very disorienting. I've been trying to figure out ways in which I can create a dynamic, psychological space so that you don't feel like you're just sort of swimming around in a fish bowl with other people. I want you to have the ability to explore, and I wanted this very simple black space to be like an enigmatic and mysterious shadow. One of the most interesting interpretations that I've heard of my work is that somehow the installations are simulations of the virtual world. A simulation of a virtual world is a very peculiar place to consider. It would be something like an illusion of an illusion, which would be a very alienating place. When I'm in one of my installations, even if there are others in there with me, I don't necessarily feel like I am with people. I don't feel like I'm a part of this world.

Do you set out to create spaces that disorient your viewers? I think each piece ends up being different in terms of its level of orientation or disorientation. The spaces might be alienating because they have to do with chaos, which is a natural phenomenon but something people are not accustomed to. I'm interested in the way architectural environments compete with natural organic spaces. For example, glass buildings somehow allow the world to exist inside, while creating a thing that incorporates an organic level or proximity to nature. I think people have the feeling when they're in my installations that they are in nature. It's similar to the way it feels to be in a forest or to be in a place where there is natural rock. You are distracted by the complexity and the chaos of nature. It's difficult for me to quantify exactly how all that works together. But ultimately I am trying to figure out a way of confusing people just enough so that they forget that they are in a gallery. I want to distract people away from the context and create a new one within it. I can do this by obscuring the architecture of the rooms I work in. Because people aren't used to the type of space I create, they may also think it's like a cinematic space from a movie or some kind of projection. Sometimes this seems to be the quickest reference.

Stephen Hendee, *Vaulted,* 1998; installation at Marie Walsh Sharpe Foundation, New York; courtesy the artist and Mark Moore Gallery, Santa Monica; photo by the artist

Do you mean people think your work is influenced by movie sets? Or do you mean they are cinematic in scale and light quality? Or are you pointing to some other connection to film? Viewers that I have talked with refer to it being like the set from a science fiction movie. The closest a lot of people get to hyper-reality is film, unless they are spiritually minded, take drugs, or are insane. Hopefully the spaces are detailed enough to warrant the kind of attention that is given to a film or an altered state of consciousness. My job within the environment is to configure or program the space so that viewers can either retrieve any latent narrative or make their own. There have been readings of your work in relation to pop culture, science fiction, and futuristic imagery, including comparisons to *Star Trek, Blade Runner,* and *2001.* Are you drawing specifically from pop culture or is that just something that you feel is being read into the work? Well, I've read a lot of science fiction and I've been interested in those narratives for quite a while. It definitely has had an effect on me. I actually worked on a project at the Yerba Buena Center for the Arts in San Francisco that was a retrospective of the work of Syd Mead, who is the set designer for *Blade Runner* and *Tron.* I was asked to rebuild a set from *Blade Runner,* and that was a great experience.

How did you come to work with the materials of foam board and tape? I started working with brown cardboard when I was in graduate school, and I was using it because I didn't have any money. After a while I discovered that I could get white cardboard, and then I began to experiment with white foam board. Foam board is a very structural material, light and easy to work with. It illuminates in a way that no other material does. When I discovered this, it ended up completely transforming the way I work. I had worked in steel for a long time and actually made steel objects that lit up. I was using the steel because I thought the permanence was important. But then I ended up throwing out all my steel sculptures, so it was a fallacy.

The introduction of the lighting elements seems to have been a turning point, but they are not as obvious as some of the other materials you use. How does the lighting add to the perceptual ambiguity of your work? I think it's a by-product of using fluorescent lighting in combination with the foam board and tape. The sheen on the foam board creates a flat plane and a confusion in the viewer's mind. Between that and the geometric forms, it can create a fog of persistence of vision: you see a flash of something and it causes an afterimage. It has to do with the primitive light-sensitive cells of the eye, the portions of your eyes that you use when you are looking at things at night. It's like the effect of seeing colors when you close your eyes. A similar thing happens when people watch TV, because your eyes see the TV in much that same way. I don't think that you're using the normal set of daytime cells within your eyes, so to speak.

Do you want people to know how your work is constructed, or do you want them to be met with an illusion? If it has been done correctly and everything is clean, and if I've worked hard enough on the illusion of it, then people really don't understand how it's built, and it's a mystery to them.

What would you say is the relationship between your work and the Light and Space artists, such as James Turrell and Robert Irwin? I think that their ideas of spaces are primarily abstract, whereas the field of information that I'm drawing from is much

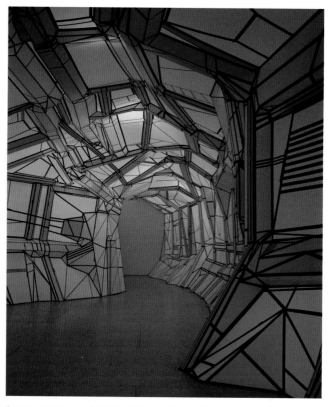

Stephen Hendee, *Inertial Field*, 1998; installation at Bronwyn Keenan Gallery, New York; courtesy the artist and Mark Moore Gallery, Santa Monica; photo by the artist

wider. I think that what they were doing is really important and definitely inspiring, but I've inadvertently come to working in this way through a series of mistakes with these materials. They are much more methodical and much more directed toward their means. The way they affect their viewers is something I find really inspiring. I just think that I arrived at my work through a different route. To see their work, you have to be in a special place and a special time. I would really love to see James Turrell's *Roden Crater* and Walter DeMaria's *Lightning Field.*

The people who've inspired me are people who, for one reason or another, I've worked with. For example, Kenji Yanobe, Glen Seator, and Janine Antoni are all artists I've worked with, and through my direct experiences with them, I was able to see something about their work that I could adhere to my own. And how did you come to work with them? Just through jobs. I worked with Kenji Yanobe through the Yerba Buena Center for the Arts, and I worked with Glen Seator and Janine Antoni briefly through Capp Street Project. They just needed someone extra and I had experience. The

considerations that they put into their work are things that help me understand my own relationship to really complex installations.

I'm interested in the ephemeral nature of your constructions. I find it interesting that work that is so architectural and structural in its references would end up being so impermanent. Is that some sort of comment on the current state of architecture? I think that contemporary architecture has much more to do with data than with permanence. Currently, data is the most valuable thing in the world. It is one of the most flexible resources, and it isn't even natural. It is this understanding which is promoting a change in how we view the state of buildings and how we live and work in them. As the complexity of data and the systems that use them multiply, become cheaper and more useful for rudimentary tasks, these systems will disappear into the fabric of our lives. They will have to, because I know a lot of people who are knocking their heads against the blatant ubiquity of technological devices and hating the overwhelming presence they create.

Your work seems to have a connection to computer models and computerized architectural diagrams. Do you map out your spaces in advance with this type of technology? The power of the computer in relationship to architecture is kind of a myth. You could spend a lot of time making a computer-generated version of one of my pieces, but you'd spend just as much time as it would take to build it and take photos of it. It would be the same amount of time and money. To tell you the truth, I enjoy building things. I enjoy the discovery process of being in space and developing these things. The computer is great for certain things, and I will be using it to

make permanent versions of my work. But for the most part I work organically. I do make drawings that are in scale. The drawings are often preparatory in the sense that they help me work out my ideas of how I want to build forms, and they work almost like land photos of the sites. So, while I don't necessarily make specific drawings of the pieces themselves, I feel like I do prepare for them in a number of different ways, and I have objectives. Some pieces require a lot more planning than others.

For the Q-Artifacts project with applied mathematician Robert Phillips there was some computer work. I was allowed access to files from a prototype quantum computing device project that had failed. The program that was being run on the computer was called Qandam-M and was an Artificial Intelligence program used by the military to quantify multi-phasic, multiple platform, battlefield simulations. The declassified files that I worked with were incoherent on every level of output and deemed secure. What I was able to cull from the project were fractured wire-frame constructions that were then presented as an environment with text from Phillips, who was working as a manager for the Qandam-M project.

When you're developing an installation, how do you usually start? Do you respond to the existing space? It's different every time. Sometimes I'll work with a title. Sometimes I'll work with a narrative that I believe is being actualized by the piece, but isn't necessarily apparent to the viewer. Sometimes the space will be enigmatic enough for me to feel the challenge, or sometimes the time constraints are challenge enough to develop something. As the pieces are developed, often I will discover things I wouldn't have expected at the beginning and try to take advantage of them if I find them early enough. Spaces themselves may lend a specific psychological referent just because of their shape or the dynamics of their space. In Wonderland it is exciting to think about people going from one space to another or people moving in various directions through the installation. This is different from a piece that's more of a cave where people sort of pool around and then leave out the same door.

So do you set out to achieve a specific viewer response? Do you have predetermined types of illusions that you try to create, or are the effects also spontaneous like the building of the piece itself? The various things that I develop from piece to piece are spontaneous. Sometimes I have theories about ways in which I can change elements and I try to actualize them.

Vaulted, your piece at the Marie Walsh Sharpe Foundation in New York, was structured like a cave. The piece at Bronwyn Keenan's gallery in New York, Inertial Field, was more of a corridor, with elements that resembled a cathedral. For me it felt like stained glass. As we've discussed, Shadow Proxy is a double tunnel. Are there other sorts of shapes or forms that you would like to explore? Or does it depend on the shape of the space you're working in? I think it depends on how much time I have. And what if time isn't a factor? Are there certain shapes or forms that are either natural or mathematical or virtual that are intriguing to you, that you feel should be explored? Well, I'm really interested in caves. I did spelunking in the Sierras and those caves have an enormous amount of elasticity. There are really interesting caves that are kind of double-bell shaped where there's a vaulted ceiling and a pool

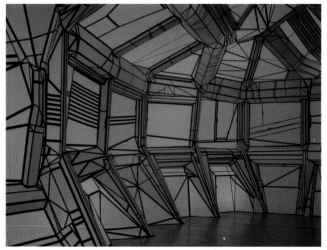

Stephen Hendee, *Inertial Field*, 1998; installation at Bronwyn Keenan Gallery, New York; courtesy the artist and Mark Moore Gallery, Santa Monica; photo by the artist

of water, and that creates another mirrored structure underneath it. I think what I really want to do is work with elevated walkways within a space so that you actually have a space that's above you and below you simultaneously—so as you walk around inside the space you are confined by a pathway, but at the same time you feel like you are completely surrounded.

The other direction that I'm interested in is developing spaces that people never see, except in the form of large format photographic light boxes. These I can develop in my own space and on my own time, and they become a different form of simulated model. That's the other direction besides doing more permanent work.

Do you see your photographic work in relation to the work of James Casebere and Thomas Demand? Yes, I think about James Casebere and even Michael Ashkin. These people have been developing models, and I think it's a parallel track to some kinds of installation work.

When I first saw your work it made me think of Sol LeWitt and the idea of drawing in space. Is he an influence on you? What about Jean Dubuffet's sculpture, which your work also resembles? While it's encouraging on some level that viewers find a connection between my work and that of Jean Dubuffet and Sol LeWitt, the route to my work has developed out of an investigation of subject matter and a material process that circumstantially has an echo to this other work. I find a level of resonance in Sol LeWitt's most recent cinder block scale models. When his structures break into a space which seems to be describing an organically complex level of order, they achieve for me a heroic stature, a description of what we as humans currently champion, our own form of nature.

We've talked about a lot of different threads that weave in and out of your work, including pop culture, film, science fiction, mathematics, computers, architecture, and art history. Is there prevalence of one versus the other? How do you situate yourself within these larger cultural topics? I'm willing to admit that all of these are important elements of the work, and I draw from all of them as equally as possible. I've been working to develop all these things simultaneously. Specifically I look at the architecture of Frank Gehry and Peter Eisenman, both of whose work I only discovered recently.

Do you think that there is some kind of larger phenomenon right now that's pushing people to think about architecture, or more generally about space? Well, I think, if anything, the practice of installation art has a great deal to do with that shift. Artists tend to be ahead of the curve when it comes to foreseeing how social spaces or social interactions are going to happen. The change of the millennium is a really good excuse to redefine things.

I was talking with Teresita Fernández about this at one point. She felt that people are looking for an art form to rally behind in the new time period, and she was saying that she felt architecture very well could be that new art form much in the way that photography was in the last century. And it's interesting that photography as well as film are like architecture in terms of their ability to control space. Her observation was very astute; I think we're going through a larger change because our relationship to information is changing. We don't necessarily have to be in the middle of a city to do what we do. We can be anywhere. The systems by which we receive

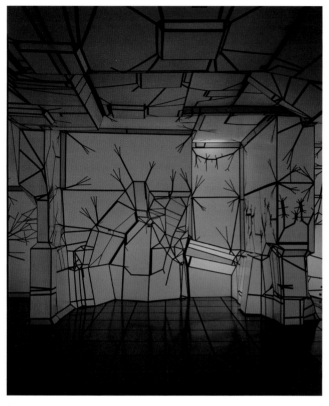

Stephen Hendee, *SuperThrive*, 2000; installation at Rice University Art Gallery, Houston; courtesy the artist and Mark Moore Gallery, Santa Monica; photo by Sergio Fernandez

information are becoming faster. The notion of what it is to go somewhere and do something is completely changing in relation to technological advances.

The things I am investigating have to do with sociology and understanding our relationship to technology and how we're evolving through a technological period. I guess I'm interested in the history of how our motivations are changed by technology. So, in some sense, you could see these spaces as projections of a kind of future that isn't necessarily dystopian or utopian. If anything, they are describing a future that is like the present we have. The future is neither negative nor positive.

Interview with Stephen Hendee by Rochelle Steiner

STEPHEN HENDEE

Born Santa Monica, California, 1968
School of The Art Institute of Chicago,
Illinois, 1986–87
Skowhegan School of Painting and Sculpture,
Maine, 1989
BFA, San Francisco Art Institute, California, 1990
MFA, Stanford University, Palo Alto, California, 1993
Lives and works in Newark, New Jersey

WORK IN WONDERLAND

Abandon.exe, 2000
mixed media
Courtesy the artist and Mark Moore Gallery,
Santa Monica

SELECT SOLO EXHIBITIONS

2000 *SuperThrive,* Rice University Art Gallery,
Houston, Texas

Black Ice, Southeastern Center for
Contemporary Art (SECCA), Winston-Salem,
North Carolina

1999 *Shadow Proxy,* Mark Moore Gallery,
Santa Monica, California

1998 *Inertial Field,* Bronwyn Keenan Gallery,
New York, New York

1994 Refusalon, San Francisco, California

SELECT GROUP EXHIBITIONS

1999 *Threshold: Invoking the Domestic in
Contemporary Art,* John Michael Kohler
Arts Center, Sheboygan, Wisconsin

Generation Z, P.S. 1, Long Island City,
New York

Drawing, Mark Moore Gallery, Santa Monica,
California

Re-Structure, Grinnell College Art Gallery,
Iowa

some*when,* Bakalar Gallery, Massachusetts
College of Art, Boston, Massachusetts

Built, Mark Moore Gallery, Santa Monica,
California

1998 *Seeing & Believing: Naomi Fox, Neil Grimmer,
Stephen Hendee, David Lindberg,* Sculpture
Center, New York, New York

Fading Millennium, Gallery 16, San Francisco,
California

Sub-Techs: Post-Digital Sculpture, The Lab,
San Francisco, California

Creative Village, Locomotive Factory, Berlin,
Germany

Encyclopedia 1999, Turner & Runyon Gallery,
Dallas, Texas

1997 *Bay Area Now,* Yerba Buena Center for the
Arts, San Francisco, California

Real World, New Langton Arts, San Francisco,
California

Tokyo 97, Kirin Corporate Headquarters,
Tokyo, Japan

Microcosmic Cryptozoic, Here Gallery,
New York, New York

1996 *Inter-Galacti,* Four Walls, San Francisco,
California

1995 *I Own the Future and It Costs a Lot,* Gallery
Paule Anglim, San Francisco, California

SELECT BIBLIOGRAPHY

ARTICLES AND REVIEWS

1999 Christopher Miles. "Art in the Back:
Exhibitionism." *Flaunt,* March, p. 150.

Kristina Newhouse. "Stephen
Hendee/Shadow Proxy at Mark Moore
Gallery." *Sculpture,* June, pp. 65–6.

David Pagel. "Cyber-Maze/Stephen Hendee
at Mark Moore Gallery." *Los Angeles Times,*
February 12, p. F30.

Charlene Roth. "Stephen Hendee at Mark
Moore Gallery." *Artweek,* March, p. 22.

Sarah Schmerler. "Generation ZZZZZZ."
Time Out New York, May 20–27, p. 78.

Rebecca Sonkin. "Move over Generation X.
'Generation Z' Has Arrived at P.S. 1." *Queens
Chronicle,* April 18, p. 19.

Sue Spaid. "Neo-Arcadia: Faux-Natural
Wonders." *L.A. Weekly,* February 12–18,
p. 66.

1998 Kenneth Baker. "Sub-Techs at the Lab."
San Francisco Chronicle, April 16, p. C13.

Howard Halle. "Stephen Hendee, *Inertial
Field*/Bronwyn Keenan." *Time Out New York,*
September 17–24, p. 85.

Glen Helfand. "Sub-Techs." *The San Francisco
Bay Guardian,* April 15, p. 102.

Paul D. Miller. "The Q-Artifacts: Part II."
Artbyte, June–July, pp. 42–5.

Elizabeth Pepin. "Three Museums That Don't
Suck." *Juxtapoz,* Summer, pp. 32–7.

Robert L. Phillips. "The Q-Artifacts: Part I."
Artbyte, June–July, pp. 38–41.

Daniel Pinchbeck. "Something Old, New,
Borrowed . . . And Blue?" *The Art Newspaper,*
September, p. 59.

Roberta Smith. "Art in Review: Stephen
Hendee at Bronwyn Keenan." *The New York
Times,* September 18, p. B33.

Darcey Steinke. "Living in Oblivion." *Spin,*
October, p. 71.

Mark Van Proyen. "'Fading Millennium' at
Gallery 16." *Artweek,* April, p. 19.

1997 Jason Forrest. "Bay Area Now." *Art Papers,*
November–December, p. 39.

Roberto Friedman. *Bay Area Reporter,*
February 20, p. 46.

Glen Helfand. "Real World." *San Francisco
Bay Guardian,* January 29–February 4, p. 31.

Glen Helfand. "Real World." *San Francisco
Focus,* February, p. 22.

1996 Glen Helfand. "Night and Day." *SF Weekly,*
January 15–21, p. 18.

1995 David Bonetti. "Gallery Reviews: Paule
Anglim." *San Francisco Examiner,* July 14,
p. C17.

BILL KLAILA

INTERVIEW

In terms of your interactive environments, you've made *Virtual Brook, Virtual Cave,* and now, for *Wonderland*, *Virtual Bog*. How did this group of works develop? So far I've been interested in shallow bodies of water that people readily move through and dip their feet into. *Virtual Brook* utilized an interactive floor that created sound. It was really direct: I could detect with sensors where and when a person stepped, and create an audio effect accordingly. It worked well because people would just walk in the space and suddenly things—sounds—started happening. People were surprised by it. The piece was installed in an old, run-down soap factory, and it suddenly seemed as if you were walking through a brook. It was very appealing. Within the brook, some parts sounded muddier, and others sounded just like water. One of the most important aspects of my work is the idea that your environment is reacting or responding to you.

With *Virtual Brook* I realized that people instinctively looked at their feet to see where the sound was coming from. So with the *Virtual Cave* I projected images onto the floor where they were walking. In addition to the sounds of splashes, it seemed as if there were waves emanating from their feet. *Virtual Cave* had constant sound as well as interactive sound. I wanted to have some ambient sound that would remind people of being in a cave, for example wind swirling around, in addition to the splashes from footsteps.

In both pieces the viewer becomes a creator, activating the body of water as they walk. The piece with sound alone is very effective, but the added visual component turns the visitor's movements into images. There is a direct correlation between one's footsteps and the ripples in the water, almost like making a map of the journey. Yes, wherever you move, the image will change to make it look like you're wading there. If there are multiple people in the piece, the ripples will interact and bounce off each other, just like real water.

Did you study the properties of water and the way it moves? I had the benefit of finding a very short computer program someone wrote that did something close to what I wanted. That was the core, and then I adapted the program from there. Simulating a natural phenomenon like water waves is very hard to do on a computer, and it has only been in the last few years or so that computers powerful enough for real time simulations have been available to people other than scientists.

Do you go out into nature and record the sounds of specific places? Sometimes I use actual sounds, but often I'll find the sounds of footsteps in water or splashing

Bill Klaila, *Virtual Cave*, 1998; installation at The Minneapolis Institute of Arts (re-created in artist's studio); courtesy the artist; photo by the artist

Bill Klaila, *Virtual Cave*, 1998; installation at The Minneapolis Institute of Arts
(re-created in artist's studio); courtesy the artist; photo by the artist

in a bathtub that have been prerecorded for sound effects. It's a real splash, but it's not my splash. I'm not interested in letting someone walk through part of my life, but rather in shifting perceptions.

It's important to remember that there is no prerecorded video in *Virtual Cave*. The visual portion is not a recording on film. A lot of people see the projected image and assume it's a tape loop being projected from the ceiling, but it's not a video. A computer is hooked directly to the projector, which functions in the same way a computer monitor would. The software tools are the same ones that people use to develop games. A lot of tools are available now because games are so popular, and I adapt them to the pieces, however possible. For example, I may be able to dial into the piece in *Wonderland* from Minneapolis via modem and be "in there," too, from another place. My experience is going to be more of maintenance, but there's no reason why this couldn't be some sort of an environment that people could dial into on the Internet. That technology already exists; there are some games or environments or cities you can visit on the Internet. You assign yourself what's called an "avitar." It's how others "see" you. You pick a character—you can make your own or you can pick from a catalogue. So, when someone else dials in, they'll see that picture and they can talk to you. It's live. You can ask where they are from and all that stuff. People create these environments. I went into one that was a swimming pool, a virtual pool, with a bartender even. Another one was like a futuristic city. One was a place you could go to, get property, and build on it. It's kind of interesting.

One of the fundamental differences between this type of Internet activity and your installations is that here in the Museum people are physically inside the space, and physically inside the piece. I'm interested in the role of the visitor's body in your work, and the physical and sensory journey people take within it. It really helps if your senses are engaged in it, which is very hard if you are looking at a computer screen. I could have people put on a suit of some kind with a Virtual Reality hood, and I could simulate the experience of walking through water, except they wouldn't be moving through the piece. With pure Virtual Reality, one's physical movements within the suit or helmet are controlled. I like it that you're really walking around in *Virtual Brook* and *Virtual Cave*, and that there are other people in there with you. One thing I ask myself when I'm about to make a piece is whether it's going to alienate people. I want the work to be accessible to everyone, and not everyone wants to put on a Virtual Reality suit or boots or hood. Does that accessibility also carry over into your choice of imagery? I hadn't thought about the old elitism attitude, but I guess the idea of accessibility comes from my background in the arts which is rooted in Abstract Expressionism. A lot of criticism about that is that it's elitist. When I was in grad school I was making more traditional still-life paintings, which were considered to be kind of "out of line," and a lot of pressure was put on me to make things confrontational and more abstract.

Your work, especially the audio portion, "moves" viewers to another place—to a natural setting outside the gallery. Is this something you're actively trying to achieve? I've liked doing things that shift my reality, like traveling or even going to amusement parks—places where things are happening to you. Mostly this idea comes from travel and spending time overseas where I learned about different cultures. That's jarring. I like the idea of being able to make people suddenly have to rethink where they are. For example, with *Virtual Brook*, which made you feel like you were walking through water by means of sounds alone, there was a disorientation. People were walking around the gallery and all of a sudden they were in a brook. I'm not trying to disorient people, but to transport them—that would be a better word. I'm not trying to shock people, in fact the opposite. These experiences should be pleasant or amusing for viewers. How will your piece for *Wonderland* differ from your previous environments? There will be waves, but since there is more space than in either of the earlier pieces I'll be able to simulate more things. For example, I'm thinking about a sound element leading up to the sound and image area that might simulate a bog or swamp. The sounds will be muddy, with ambient sounds of bugs and other aspects of nature. It has to be something that has distinct and interesting sounds when you walk across it.

What other types of settings are you interested in creating? I like the natural elements. Fire is something I'm interested in. I'm also interested in creating a virtual lawn. What attracts you to

lawns? Well, the fact that they are mundane, and yet a lot of this sophisticated technology goes into creating a backyard that seems natural. It's similar to water because it's so common, and yet many water settings are totally artificial.

Would you say that you are trying to create realistic spaces? To what extent are you trying to simulate the natural world? I'm interested in what things I can do to make my work more real, like adding some odor or something to involve or engage more of the senses. I'm planning to make a new piece that is only going to be an odor. It wouldn't be computer generated, but something that would give off a certain scent when people walk by.

But at the same time, I like the idea that this is a virtual space or place. Creating everything electronically has a big appeal to me. I'm interested in recreating the world, not just bringing natural elements into the piece. My work is a representation, like a painting of a landscape, but in a different form. There's a degree of illusion happening in the work. It's completely generated by computer, by electronics. It's all bits and bytes and there's nothing that we can call real. Yet it appears like you're standing in or walking through water, or it sounds like you're in a cave or in a brook. It would be easier to have logs lying around, I guess, to make people think they were in the woods. But I like that nothing really is there. The closer it gets to the sense of a real brook, the happier I get because it's totally computer generated, and it's completely virtual. There's nothing real or natural in it.

Does your work operate with the same technology associated with Virtual Reality? My idea of Virtual Reality is creating through sensation something that's actually not there at all. People know about that from more sophisticated computer games and flight "sims." They have those in amusement parks now, where you can ride through a bloodstream, for example. The computer equipment around you fools you into thinking that you're flying through liquid. The real Virtual Reality applications that intrigue me are used to take people into places where it would be absolutely inhospitable; they can send down sensors into a burning mine or something like that. Virtual Reality glasses are allowing people to enter environments in which they would be instantly killed, for example.

Is this used mostly for entertainment purposes? The part that most people know about is, but there's an industrial part that's not. It's used in things like mining, surgery, and on Mars with the Rover. There is a stigma whenever you do anything with computers and electronics, people just think "Disney," and I found myself defending that a lot early on. But people have grown more accepting of it now that many different forms of technology are common tools. I don't want to make a ride through a bloodstream

Bill Klaila, *Virtual Cave*, 1998; installation at The Minneapolis Institute of Arts (re-created in artist's studio); courtesy the artist; photo by the artist

or anything like that. My work is more about creating a place, not trying to create little fish nibbling at your feet.

It is interesting that you were making paintings of landscapes before you began your three-dimensional, computer-generated installations. I grew up in a very rural environment, and from an early age I liked to be outside, and travel, and redraw the landscape. Between the painted landscapes and the computer-generated work there was an intermediary stage when I was making still lifes of electrical appliances. This developed into creating electronic appliances that were interactive and then to making interactive sculptural environments.

Were you attempting to transform your two-dimensional still lifes into three-dimensional installations and invite viewers to walk into your landscapes? I was always interested in dimensionality. The paintings I made were really thick with parts that stuck out about two or three inches. Then I started integrating objects into them so they would become even thicker. As I incorporated more and more objects, the projects got bigger and bigger because I was interested in the idea of walking inside the works of art.

What kinds of appliances were you working with? Common household appliances were the inspiration. The sculptures were robotic appliances that would react to viewers and do some things. I also situated the robots within an environment, but at that point the environment itself was not responsive. Now, of course, the whole setting is both responsive, because of the sensors under your feet, and engaging, in the sense that you're immersed inside the piece. I want viewers to know right away that the room is responding to them.

Are you inspired by particular artists? People like Bill Viola, he's an obvious one, and artists who make installations you walk inside of and in which things happen to you.

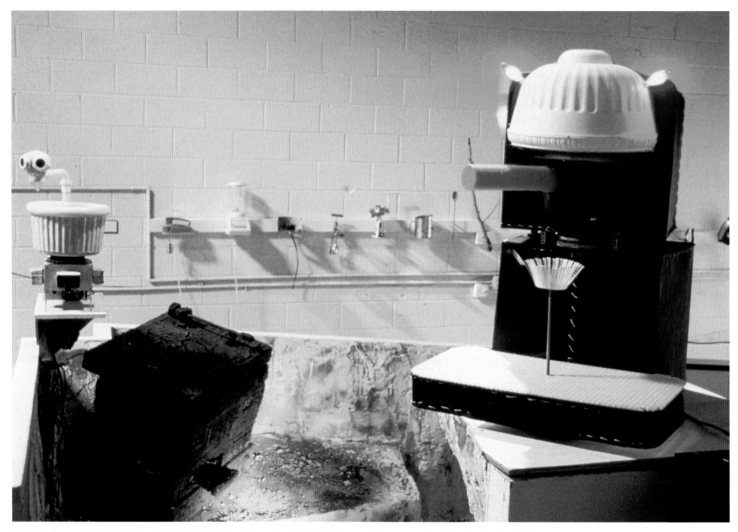

Bill Klaila, *Espresso Mini*, 1991–96; installation in *Art in Space*, Intermedia Arts Gallery, Minneapolis; courtesy the artist; photo by Warwick Green

One of my art history teachers had a theory that all artists are trying to build other worlds. I think she was right, and I guess I took her a bit literally.

Liz Phillips made the first environment that I saw that I really, really liked. You would walk into a room with sensors and electronic music, and the computer tracked where you walked and played different music depending on how fast you moved or what you were doing. If there were more people, the music would be more complex. I thought it was great to just walk around in this room and hear all this stuff happen— every time you turned, something would change. So, I arranged to work with her a little so I could learn some things. But some of the other people who did electronics, like James Seawright, seemed more caught up with the gadgetry of it, and I'm not very interested in that. Back in the late '80s he was showing a lot of electronic things. You'd walk near them and they'd start flipping numbers or whatever. It was like whirring machinery. They were kind of cool, but they were just gadgets.

I haven't seen a lot of people who make environments that are really interactive and responsive to viewers. The Keinholtz environments interest me. They aren't electronic, but you enter into them. Whether they're electronic or not, I am engaged by immersive environments. I like the sensations they create.

Interview with Bill Klaila by Rochelle Steiner

BILL KLAILA

Born Syracuse, New York, 1951
BFA, Syracuse University, New York, 1973
MFA, University of Texas at Austin, 1986
Lives and works in Minneapolis, Minnesota

WORK IN WONDERLAND

Virtual Bog, 2000
hardboard, metal, conductive rubber,
computers, graphics and sound software,
data projectors, surround sound system
Courtesy the artist

SELECT GROUP EXHIBITIONS

1998 *Common Objects/Obsessive Forms,*
Minnesota Artists Exhibition Program,
Minneapolis Institute of Arts, Minnesota

1997 Intermedia Arts, Minneapolis, Minnesota

1996 *Rooms,* No Name Exhibitions, Minneapolis,
Minnesota

Evolution, Art in Space, Intermedia Arts,
Minneapolis, Minnesota

1991 Stendhal Gallery, New York, New York

1989 *Fetishes,* 157 Hudson, New York, New York

1988 *Twenty Men Artists,* The Tunnel, New York,
New York

Ugh, World Tour, Limelight, New York,
New York

East Village, Deep Ellum Exchange, Theatre
Gallery, Dallas, Texas

Alphabet City Art, 2B Space, New York,
New York

Solstice Show, 2B Space, New York, New York

SELECT BIBLIOGRAPHY

ARTICLES AND REVIEWS

1999 Judy Arginteanu. "Art of the Obsessive."
Saint Paul Pioneer Press, January 4, p. C1–2.

Cynde Randall. *Common Objects/Obsessive
Forms.* Minneapolis: Minneapolis Institute of
Arts (exhibition brochure).

1998 Anne Galloway. "Common Obsessions."
Twin Cities Revue, December 17, p. 21.

1996 Diane Hellekson. "Soap on a Shoe String:
Big and risky new show at the Soap
Factory makes building's survival seem
even more important." *Twin Cities Reader*
(Minneapolis), August 7–13, p. 17.

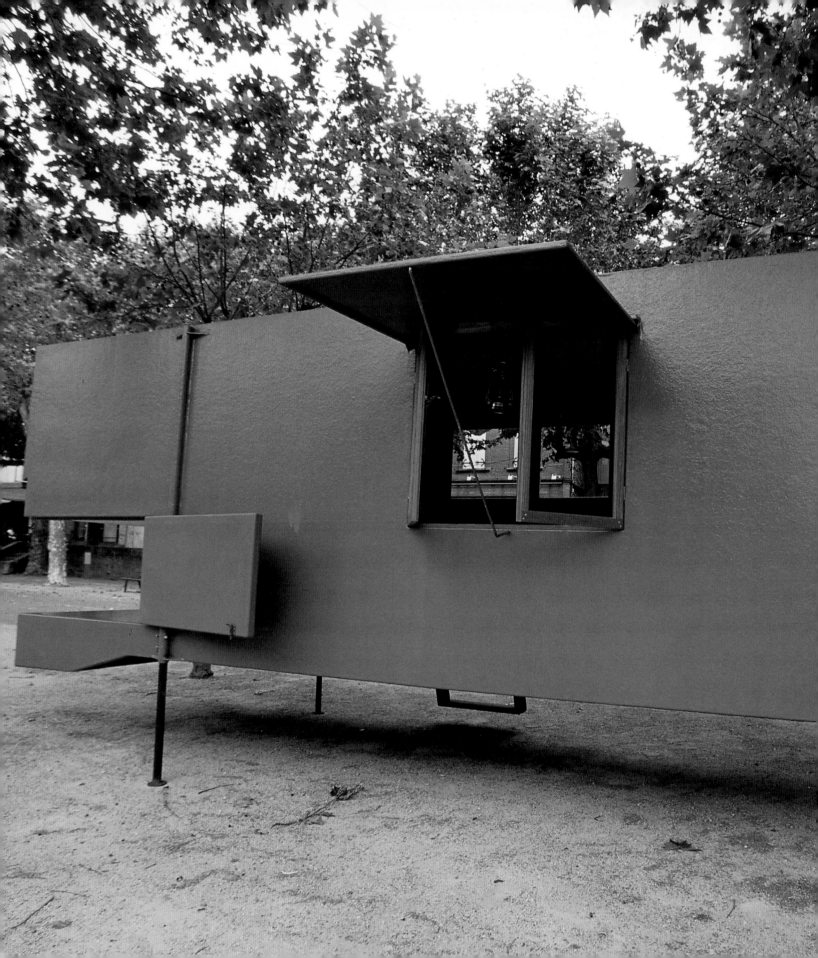

Tell me about *Pioneer Set,* **which you are creating for** *Wonderland.* It will be a prefabricated farm and equipment with which individuals or groups can travel into the world. After arriving at a certain location, they can set up the farm and live self-sufficiently. *Pioneer Set* will be built in such a way that it can function indefinitely without any need for extensions or repairs. It consists of a big container, a farmhouse, a stable, a chicken coop, and a rabbit hutch, with tools, fencing, and animals. The well-being of the animals is a very important part of the design. Plants, humans, and animals are all of equal importance in this piece. It's like a closed circle.

How realistically do you want this piece to function? Are you expecting that people actually will begin to live in it? It's probably impossible to make a completely well-functioning farm here in the Park, so we'll have to make a decision about how far to go and how complete to make it. For example, we'll have to decide whether it will include the facilities for butchering animals, which has been a part of my work in the past, and how many agricultural machines to include. The first objective is to make something for survival. The goal is not to create the type of farm that would make a profit or be economically competitive with other farms, but to take a sensible position in the world. I do think it would be very nice if it is used as a farm in some way. If the piece looks like a farm, for me it has to be able to actually be a farm. If it looks like something but isn't able to function in that way, then it's meaningless to me. Some artists create worlds that are imaginary, but in my case the pieces have to function as real things. So *Pioneer Set* needs to be able to function as a real farm whether or not it's used that way in the exhibition.

What do you want visitors to take away from this piece? I want people to be conscious of what it means to be alive, to be part of the world. I think that people nowadays are not at all conscious of the meaning of the world and what life is about, especially in relation to food. I mean, the food we eat, where does it come from? Normally, it is ground up, processed, packaged, put in a box, and wrapped. I think that one of the nice parts of life is knowing what food is, and eating and enjoying it, instead of being part of an artificial society. There are so few people who have ever seen a pig or a chicken. It's really exceptional. We have a zillion chickens in the world, but they all live in industrial farms that look like warehouses. I think more people see monkeys and lions in zoos and on television than they see chickens and pigs on farms.

Atelier van Lieshout, *Autocraat*, 1997; installation in *The Good, The Bad & The Ugly*, Rabastens, France; courtesy Atelier van Lieshout, Rotterdam; photo by Derk-Jan Wooldrik

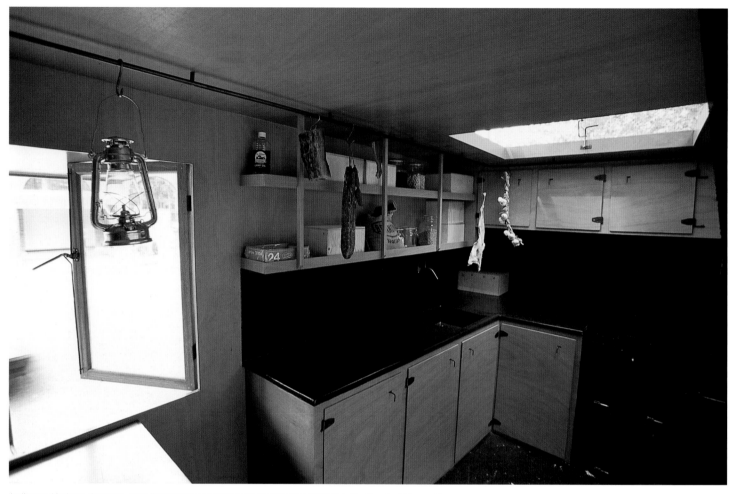

Atelier van Lieshout, *Autocraat*, 1997 (interior view); installation in *Hausfreund I*, Kölnischer Kunstverein, Cologne, Germany; courtesy Atelier van Lieshout, Rotterdam; photo by Derk-Jan Wooldrik

When we first talked about this piece you said it would be some kind of kit so that people could make their own farms or villages. Is this still part of the concept? You can imagine that someone might buy a kit that consists of a drawing to build the house and animal hutches, all of the materials, and all of the utensils you need. It would come in a big box or container, like a shipping container. You would move it to a base, take out the stuff, assemble it, and you would have your settlement. Do you think this piece is nostalgic? I think so, yeah. It's romantic, sure. Would you say the inspiration for your work is utopian? Utopian, romantic. Like longing to go back to nature or to be independent, or not to be part of this world. A mixture. It's a combination of the good things of the old world and the good things of the new world. But the result has to be very simple. How does *Pioneer Set* fit into your overall body of work? It's a very important milestone piece. It's similar to previous work but also different. The individual is more important. It's actually a new and improved *Autocraat* sculpture, which began with various containers for living. That piece is a mobile home in which you can survive with simple means on undeveloped land: it is equipped so that you can catch rainwater, cook with wood, slaughter animals, and live a basic type of subsistence. *Pioneer Set* is similar, but it also includes the possibility to colonize the world. Also, there is a connection to the Shaker communities and their furniture and their belief in making the best products possible. Do you and the members of Atelier van Lieshout (AVL) make everything in these pieces, or are some parts prefabricated? In *Pioneer Set* and *Autocraat* everything is newly made by AVL, mostly out of wood, steel, galvanized steel, and a little bit of fiberglass. Everything we make has to look very logical and explainable—it always has to be functional. We always choose no-nonsense materials appropriate for the idea of the piece. The quality of the

materials should be sober and durable, at a good price and quality. In other pieces, such as *Alfa Alfa*, we used prefabricated parts from cars and other industrial materials. But we would never copy an existing object because then we could just buy it cheaper and incorporate it.

How do you begin your projects—with the design, or the concept, or the materials, or the site? Well, it's conceptual, I think. A large part of the building technique—like the durability, the simplicity, the materials, how to set it into the space—is very much related to the conceptual basis of the work. To me there is always a very, very strong relationship between material, technique, and design. That's very important to me. That's the thing that communicates a lot of the meaning of the work because everyone sees how it is built, what kind of technique was used, what attitude you had while constructing it. Let's say at least 50% of the value of the work is displayed by the technique and the material. The other 50% is more conceptual.

Were you already thinking about making a farm before you came to St. Louis, or did this piece grow out of the site—specifically the Park surrounding the Museum? Well, I've made some chicken cages in the past, but I hadn't thought of making a whole farm. It relates to the earlier work, but I got those ideas when I was looking at the site. So, it grew out of the space. Yes. The setting looks like a real, indigenous forest. I know that before it was a park, it was a wooded area.

It's as if within the Park you're building a domestic space, a farm space, an internal space, and an external space. Exactly. In fact, you can imagine that the whole piece of land, the forest and the meadow, is the exhibition space.

What kind of experience do you think visitors will have within *Pioneer Set*? I think the reactions will be very diverse. Some people will think of pioneers or settlers. Some may object to it because they won't think it's a good way to live today. Other people might say that it's very nice to live in a small cabin and to be free and self-sufficient. So there might be contradictory reactions to it. Some people will say that the animals shouldn't live in the Park, and other people will say that this is the way animals should live. Some will think that free animals would be the best, but if you decide to have them domestically and keep them for food, this is a very nice way to do it. I think there will also be people who really see the work in the context of modern time and art and architecture.

Would you say you're constructing an alternate society or parallel universe? Sure! I think it's very, very clear. It's a wonderland. It's also so realistic—it could be a real settlement in the forest. It's a complete ideology.

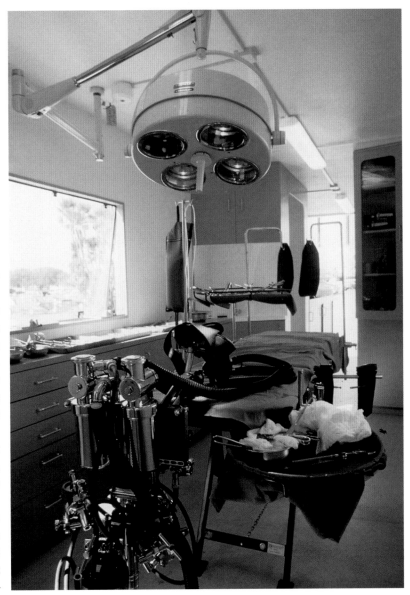

Atelier van Lieshout, *AVL Hospital*, 1998 (interior view), installation at Contemporary Art Museum, University of South Florida, Tampa; courtesy Atelier van Lieshout, Rotterdam; photo by Peter Foe

You've talked about trying to make a functioning, self-sufficient village in the Netherlands for the members of Atelier van Lieshout to live and work in. Is that being realized now? Yes, we are working on it and trying to secure a piece of land on which we can start building and experimenting. Will *Pioneer Set* become a part of your society? We don't have a farm, so certainly we could use it there. What parts of the village have you already created? Many things. In addition to the *Autocraat* there is a canteen, an alcohol factory, a hospital, an arms factory, a generator, and a heating system. We are now working on a waste disposal facility.

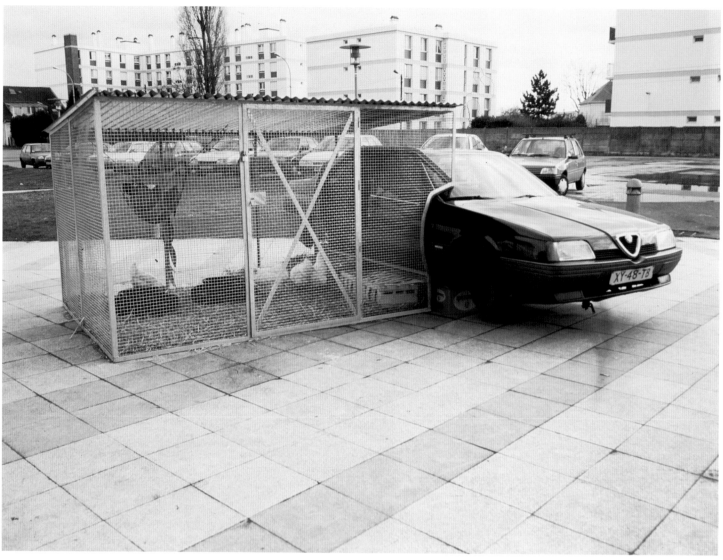

Atelier van Lieshout, *Alfa Alfa*, 1999; installation at Centre d'Art et de Culture, Brétigny-sur-Orge, France; courtesy Atelier van Lieshout, Rotterdam; photo by Bertrand Huet/Tutti

Your work is commonly viewed as a crossover between art, architecture, and design. Did you set out to situate your practice at this intersection? No. I never intended to make crossovers between art and architecture. I just wanted to make buildings. Do you think this is a misunderstanding of your work? Not a complete misunderstanding. I think it grew out of the situation that people were talking about the position of art in the art world, or art as a commodity, or design as artwork. But my work was never specifically about that. We have a very good crew of people who make nice looking stuff, which is very durable and not too expensive, so I can see why people would view it that way.

Now, I'm most interested in making robots. It would be great if they functioned as art as well as in the medical world and sex industry. It's not my goal that they become crossovers, but I'm happy when my work has a life outside of art.

Interview with Joep van Lieshout by Rochelle Steiner

ATELIER VAN LIESHOUT

Joep van Lieshout
Born Ravenstein, Netherlands, 1963
Academy of Modern Art, Rotterdam, Netherlands, 1980–85
Ateliers '63, Haarlem, Netherlands, 1985–87
Villa Arson, Nice, France, 1987
Lives in Rotterdam, Netherlands
Founded Atelier van Lieshout, 1995

WORK IN WONDERLAND

Pioneer Set, 2000
wood and galvanized steel
Courtesy Atelier van Lieshout, Rotterdam

SELECT SOLO EXHIBITIONS

2000 Galerie Fons Welters, Amsterdam, Netherlands

1999 *Atelier van Lieshout*, Contemporary Art Museum, University of South Florida, Tampa, Florida (traveled to: Contemporary Arts Center, Cincinnati, Ohio; Museum of Contemporary Art, North Miami, Florida)

The Good, The Bad & The Ugly, Museum für Gegenwartskunst Zürich, Switzerland

The Good, The Bad & The Ugly, Walker Art Center, Minneapolis, Minnesota

AVL–Equipment, Transmission Gallery, Glasgow, Scotland

1998 Galerie Rolf Ricke, Cologne, Germany

Galeria Giò Marconi, Milan, Italy

The Good, The Bad & The Ugly, Rabastens, France (traveled to: Le Parvis, Ibos, France)

Modular Multi-Woman Bed, Sprengel Museum Hannover, Germany

1997 *Saucisson*, Galerie Roger Pailhas, Paris, France

Hausfreund I, Kölnischer Kunstverein, Cologne, Germany

Museum Boijmans Van Beuningen, Rotterdam, Netherlands

1996 Galerie Fons Welters, Amsterdam, Netherlands

Jack Tilton Gallery, New York, New York

Plug In Inc., Winnipeg, Manitoba, Canada

Randolph Street Gallery, Chicago, Illinois

Richard Heller Gallery, Los Angeles, California

SELECT GROUP EXHIBITIONS

2000 *Against design*, Institute of Contemporary Art, Philadelphia, Pennsylvania

Micropolitiques, Le Magasin, Grenoble, France

1999 *A Touch of Evil*, Metrònom, Barcelona, Spain

Designprijs 1999, Museum Boijmans Van Beuningen, Rotterdam, Netherlands

Get together. Kunst als Teamwork, Kunsthalle Wien, Vienna, Austria

Le Fou Dédoublé, National Centre for Contemporary Arts, Moscow, Russia

1998 *NL*, Stedelijk Van Abbe Museum, Eindhoven, Netherlands

Artranspennine98, The Henry Moore Institute, Leeds, England

1997 *De kunst van het verzamelen*, Palais des Beaux-Arts, Brussels, Belgium

Flexible, Museum für Gegenwartskunst Zürich, Switzerland

Skulptur Projekt in Münster 1997, Westfälisches Landesmuseum für Kunst und Kulturgeschichte, Münster, Germany

Unmapping the Earth, Kwangju Biennale, Korea

1996 *Model Home*, Clocktower Gallery, New York, New York

Bars, Kunstverein Recklinghausen, Germany

Museum für Gegenwartskunst Zürich, Switzerland

1995 Le Nouveau Musée, Institut d'Art Contemporain, Villeurbanne, France

Dutch Design Cafe, The Museum of Modern Art, New York, New York

1994 *XXII Bienal de São Paulo*, Brazil

Ateliers '63, Palais des Beaux-Arts, Brussels, Belgium

SELECT BIBLIOGRAPHY

BOOKS AND CATALOGUES

1999 Margaret A. Miller, Dave Hickey, and Jade Dellinger. *A Supplement*. Tampa: Contemporary Arts Museum.

"Atelier des Armes et des Bombes." *Arte all'Arte*, 4th ed., San Gimignano: Arte Continua.

1998 Peter J. Hoefnagels, Menno Noordervliet, and Bart Lootsma. *Atelier van Lieshout—The Good, The Bad & The Ugly*. Toulouse: Les Abattoirs; Zurich: Museum für Gegenwartskunst Zürich; Rotterdam: Atelier van Lieshout and Nai Publishers.

1997 *Atelier van Lieshout—A Manual*. Cologne: Kölnischer Kunstverein; Rotterdam: Museum Boijmans Van Beuningen.

Klaus Bussman, Kasper König, and Florian Matzner, eds. *Sculpture. Projects in Münster 1997*. Münster: Westfälisches Landesmuseum (exhibition catalogue).

1996 Wayne Baerwaldt and Paul Groot. *Collection '96*. Rotterdam: Atelier van Lieshout; Winnipeg: Plug In Editions; Santa Monica: Smart Art Press.

Wilma Sütö. "Atelier van Lieshout." *De Muze als Motor II: Beeldende kunst in Brabant 1945-1996*. Tilburg: De Pont Stichting; Breda: De Beyerd; Eindhoven: Stedelijk Van Abbe Museum, pp. 118-21 (exhibition catalogue).

1995 *1993-1995*. Rotterdam: Atelier van Lieshout.

1994 Cornel Bierens. "Joep van Lieshout." *Het Grote Gedicht, Nederlandse Beeldhouwkunst 1945-1994*. Ghent: Snoeck-Ducaju & Zoon, pp. 66-7.

Bart Lootsma. "Joep van Lieshout." *Art Union Europe*. Athens: Ministerie van Buitenlandse Zaken Griekenland.

P. Tjabbes. "van Lieshout makes appliances/van Lieshout makes works of art." *Bienal Internacional São Paulo: Salas especiais*. São Paulo: Fundação Bienal de São Paulo, pp. 261-4.

ARTIST PUBLICATIONS

1996 "Le Bais-o-Drôme, 1995" (artist pages), *Blocnotes* (Paris), no. 11, January–February, pp. 38-9.

ARTICLES AND REVIEWS

1999 Rebecca Dimling Cochran. "Atelier van Lieshout." *Sculpture*, March, pp. 12-3.

Justin Hoffmann. "Atelier van Lieshout: 'The good, the bad & the ugly,' Migros Museum, Zurich." *Kunstforum International*, July–August, pp. 424-5.

Pascal Pique. "Atelier van Lieshout: Espace Jules Verne, Bretigny-sur-Orge." *Art Press*, May, pp. 81-3.

1998 Aaron Betsky. "Good, Bad or Ugly?" *The New York Times*, April 30, F2.

Klaar van der Lippe. "Joep van Lieshout in conversation with Klaar van der Lippe." *Architectural Design*, September–October, pp. 34-7.

1997 Paul Ardenne. "Joep van Lieshout." *Art Press*, June, p. XI.

Yilmaz Dziewior. "Joep van Lieshout." *Artforum*, November, pp. 124-5.

Wouter Vanstiphout. "Dirty, delicious and direct, Joep van Lieshout's manual of architecture." *Archis* (Amsterdam), November, pp. 38-41.

1996 Riet van der Linden. "Joep van Lieshout at Fons Welters." *Art in America*, July 7, p. 97.

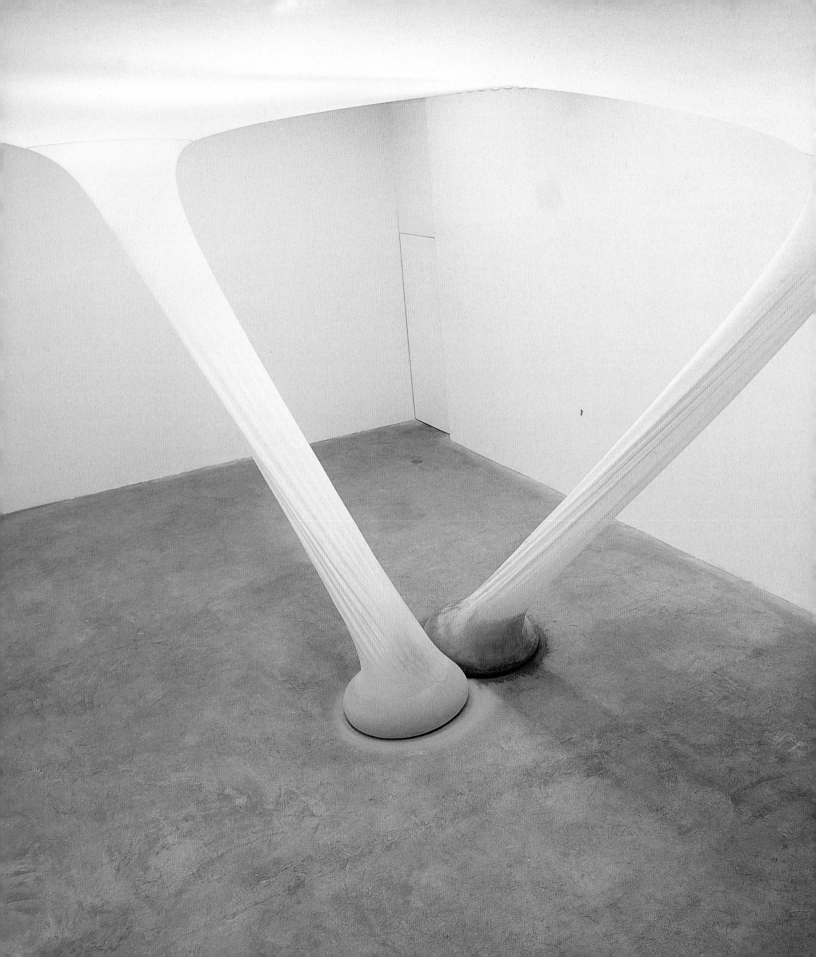

ERNESTO NETO

INTERVIEW

It seems that there has been a shift in your work in the last years. You moved from making more sculptural pieces to making environments or spaces. How did this change come about? During the last few years I have done some shows at various galleries with works like the *Poffs, Paffs, and Puffs*. The flexibility of these works and their structure gave me a great understanding of the gallery's "cube" space. For a long time I had visualized a work with a false ceiling and things hanging, like *It happens on the friction of the bodies* and *The sky is the anatomy of my body,* which make you feel like you are inside of them or as if you are under water. I also had an idea for a work that deals with the relationship between the fabric of clothing and the body. Suddenly, then came the idea of these fabric "cubes" that I call the *Naves*.

You have shown *Naves* in the 1998 São Paulo Bienial and *Carnegie International 1999/2000.* They are containers that have other containers inside of them, filled with spices and styrofoam balls. People enter into the pieces, so they are also containers for the human body. Are you interested in this idea of spaces inside of spaces? Sure. The idea was to have a gallery inside of a gallery, where the fabric skin would not contain just powder, sand, or other materials, but people as well. Also, the transparency of the fabric skin plays with the perception of what is inside and what is outside, like dermis and epidermis. Skin can also be a passageway from the outside to the inside of the body. Is this something you were thinking about? Yes. It's a passageway, a door, like the mouth of my older pieces such as *Colony* or *Puffs* and *Poffs.*

Your work is both structural in its references to architecture and organic in its references to the body. Are you trying to fuse the two? Oh yeah. I like to think of the body as both an architectural construction and a landscape. Not only the external surface, but also everything that biology tells us, from the structural organization of the cells to their shape.

How would you describe the sensuousness of your work, which seems to be conveyed through your fabrics and materials and in the way you orient us to be close to the pieces. In some cases, we are not only able to go inside them, but also to touch and smell them. Aha!!! Brancusi's *Kiss*! My work always involves relationships. The elements included in the work are always floating in a kind of interaction between their properties and personalities. I believe that our relations as human beings on earth are similar in this respect. We are always shaping and being shaped

Ernesto Neto, *It happens on the friction of the bodies*, 1998; installation in *Poéticas da Cor*, Centro Cultural Light, Rio de Janeiro; courtesy the artist, Bonakdar Jancou Gallery, New York, and Galeria Camargo Vilaça, São Paulo; photo by Beto Felicio

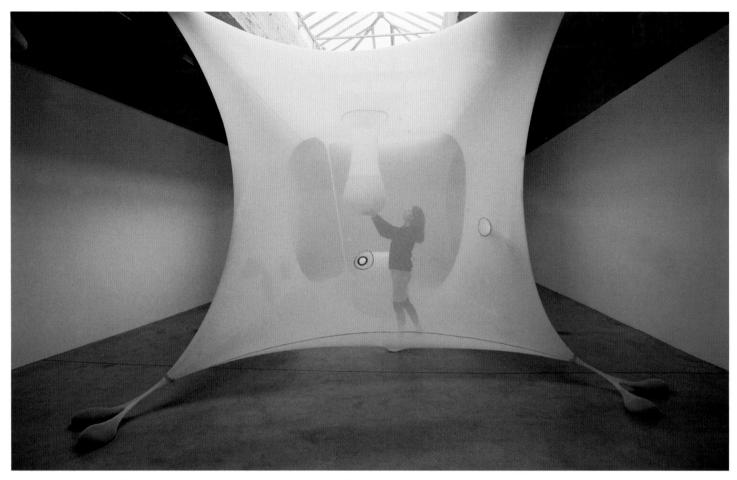

Ernesto Neto, *Navedenga*, 1998; installation at Bonakdar Jancou Gallery, New York; collection Donald L. Bryant, Jr. Family Trust; courtesy the artist and Bonakdar Jancou Gallery, New York

by the other. It's the kind of change that happens in the sub-particle structure of atoms. I prefer to think about that in a sensuous way. I know that the world is perverse, but I would prefer if it could be more sensual, with a better equilibrium and a bit more love. You mentioned your interest in Brancusi's *Kiss*. What are some other art historical interests or references embedded in your work? There are many. Calder, Brancusi, Rothko, Arp, Picasso, Duchamp, Mondrian. The Brazilian Neo-Concretists like Meireles, Tunga, Waltércio, Resende. Then there's Anselmo, Serra, Minimalism. All the Minimalist work is important to me conceptually. The first time I went to a place that sells iron and steel—the first time I saw a bar of steel—I thought it was very beautiful. I bought one even though I didn't know what I was going to do with it. It's incredible and certainly not something you see every day. Eventually, I took the bar and I took a ball and put them together, creating *BarBall*. The touch of the solid bar changes the form of the more malleable ball. Again, here is this concept of relationships between things that runs through my work: the touch of one changes the other's physical form, but it is also very significant that in the mind of the other, ideas about the first are affected. When you put different things together, there is an interaction. Each thing puts the other in a new situation, and it is within this interaction that art happens.

How did you begin working with spices? I was in a shop in Rio de Janeiro that sells spices. I had been there many times before, but this particular time I began to experience, or appreciate, the way the place smelled more intensely than ever before. It was so powerful in fact that I stayed there just enjoying the pleasure of it for a while. Again, I bought a package of spices without any idea of what I was going to do with it. I had already made the *Lipoides* with white plaster, but the stocking idea came about much later. Cloves, turmeric, and pepper were the first spices I used. Then I began to use cumin and curry because of their scent.

Is it only the way they smell that interests you? The spices appeal

to me because they come from the earth, and especially because they come from Brazil. I have spent a lot of time traveling to the interior of the country and have taken a real interest in things that come from the earth. In Rio de Janeiro, the horizon is enormous; I am constantly surrounded by this huge horizon as well as by mountains so close that they give an overall impression of eternity. The mountains are so solid and have such a strong presence, vertical and horizontal, contrasting with the manmade architecture of the city and the organic forms of nature. But the colors of the spices are also very important. The cloves are brown, and although they are not so intense visually, they are very powerful in aroma. The turmeric has a very particular smell too, and it is very intense in color. These two spices are the ones I enjoy most, because of these factors. I enjoy the more organic colors. Even when I draw, generally I use cream paper to gain a more organic feeling. The spices also resemble pigments. Oh, yes. I have made some works with pigments and some with oxides, but I wasn't so satisfied with them. They weren't exactly what I wanted. The spices are more alive.

The nylon that contains the spices seems to be so fragile and delicate, but it can hold a lot of weight and stretch very far. You seem to push the stocking to its limit. I am always surprised that it doesn't break from the weight. This is especially evident to women who are always ripping their stockings. For me the material can express the organic and sensual equilibrium of the interaction between things in this invisible gravitational camp. I can express the passage of time through the geometric deformation, a kind of topology of desire. I like to work with an idea of a lustful mathematic between the interaction of polarities.

Can you say a bit more about the importance of gravity in your work? Gravity, along with weight and mass, are fundamental issues in sculpture. How is this factored in? I guess it is in working with gravity as a structural element and experiencing how the weight of some materials can transform others. It produces in the work a sense of flotation that illustrates the idea of the moment, the instant, that everything is happening here and now. That's another idea I bring to the work—a time collapse where everything is in that high intensity point or moment, here and now.

The word "wonderland" has been used to describe your large-scale rooms and *Naves*. I think this is because of the way you transform space and alter our perceptions. Is this a reference for you? I've been thinking about Alice in Wonderland, about this universe of Alice's where the room gets alternatively big and then small. If she eats one thing, she gets bigger; if she eats something else, she gets smaller. Then, she goes inside of a space and an entire

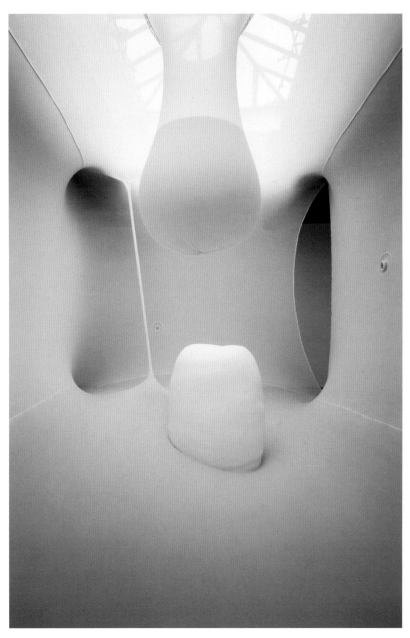

Ernesto Neto, *Navedenga*, 1998 (interior view); installation at Bonakdar Jancou Gallery, New York; collection Donald L. Bryant, Jr. Family Trust; courtesy the artist and Bonakdar Jancou Gallery, New York

alternative universe opens up for her. She passes through a door and enters into a fantastic world. This is exactly what I am trying to create in my work. I like the experience of getting inside of a space—it is an important aspect of my sculpture. But really, for me, a wonderland is a way of thinking, a mindset. You don't need to literally get inside of a work for that. The wonderland is within us. We are always getting into different spaces.

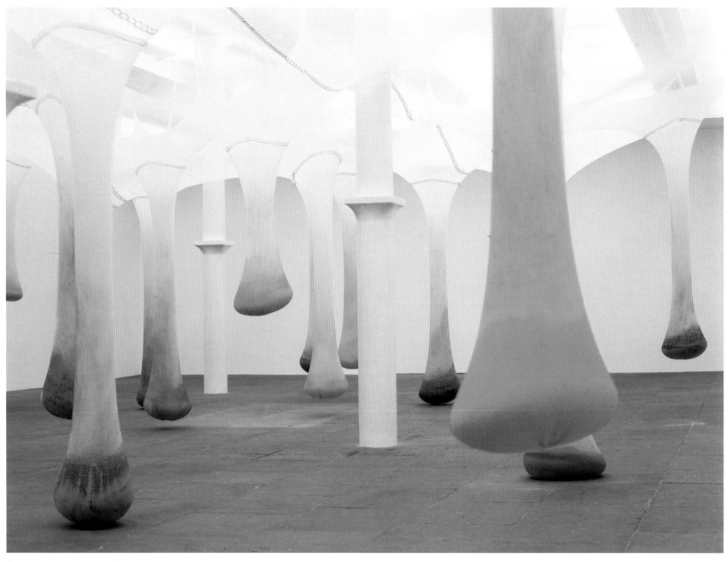

Ernesto Neto, *We Fishing the Time (worm's holes and densities)*, 1999; installation at Liverpool Biennial, England; courtesy the artist, Bonakdar Jancou Gallery, New York, and Galeria Camargo Vilaça, São Paulo

When I was young, I thought that the world was made up of cubes. So you would wake up in a cube and you go to a toilet, which is a cube, an expensive cube. Then you enter another cube to eat, after which you may enter a mobile cube, say a bus, to go to work or class, and then eat in another cube, to be followed by transport in a smaller mobile cube to another place. We constantly live in cubes because the structure of the city is all based on geometry and thus easy to construct. The *Naves,* which means "spaceships" in Portuguese, are closed spaces that you need to survive in a strange outer space. They're a kind of uterus. I guess we carry that as an idea in an abstract way all the time. Maybe it's our soul.

Interview with Ernesto Neto by Rochelle Steiner

ERNESTO NETO

Born Rio de Janeiro, Brazil, 1964
Museu de Arte Moderna, Rio de Janeiro, Brazil, 1986
Escola de Artes Visuais Pargua Lage, Rio de Janeiro, Brazil, 1987
Lives and works in Rio de Janeiro, Brazil

WORK IN WONDERLAND

It happens when the body is the anatomy of time, 2000
Lyrcra tulle, polyamide fabric, turmeric, cloves, cumin
Courtesy the artist, Bonakdar Jancou Gallery, New York, and Galeria Camargo Vilaça, São Paulo

SELECT SOLO EXHIBITIONS

2000 Wexner Center for the Arts, Columbus, Ohio
 SITE Santa Fe, New Mexico

1999 James Van Damme Gallery, Brussels, Belgium
 Ernesto Neto: Nhó Nhó Nave, Contemporary Arts Museum, Houston, Texas

1998 Museo de Arte Alvar y Carmen T. Carrillo Gil, Mexico City, Mexico
 Bonakdar Jancou Gallery, New York, New York

1997 Galeria Pedro Oliveira, Porto, Portugal
 Galeria Camargo Vilaça, São Paulo, Brazil
 Fundação Cultural do Distrito Federal, Brasília, Brazil

1996 Elba Benitez Galeria, Madrid, Spain
 Paco Imperial, Rio de Janeiro, Brazil
 Espacio 204, Caracas, Venezuela

SELECT GROUP EXHIBITIONS

1999 *Carnegie International 1999/2000,* Carnegie Museum of Art, Pittsburgh, Pennsylvania
 Trace, Liverpool Biennial, England
 A Vuelta com los Sentidos, Casa de America, Madrid, Spain
 La Metamorfosis de las Manos, Mar del Plata, Argentina
 Best of the Season, The Aldrich Museum of Contemporary Art, Ridgefield, Connecticut

1998 *XXIV Bienal de São Paulo,* Brazil
 Every Day: 11th Biennale of Sydney, Australia
 Poéticas da Cor, Centro Cultural Light, Rio de Janeiro, Brazil
 Puntos Cardinales, Museo Alejandro Otero, Caracas, Venezuela
 Loose Threads, Serpentine Gallery, London, England

1997 *Material Immaterial,* The Art Gallery of New South Wales, Sydney, Australia
 Esto es: Arte Objeto e Instalacion de Piberoamerica, Centro Cultural Arte Contemporano, Mexico City, Mexico
 As Outras Modernidades, Haus der Kulturen der Welt, Berlin, Germany
 Novas Aquisições, Museu de Arte Moderna, Rio de Janeiro, Brazil

1996 *Transformal,* Wiener Secession, Vienna, Austria
 Defining the Nineties: Consensus-making in New York, Miami and Los Angeles, Museum of Contemporary Art, Miami, Florida
 Sin Fronteras/Arte Latinoamericano Actual, Museo Alejandro Otero, Caracas, Venezuela
 transparências, Museu de Arte Moderna, Rio de Janeiro, Brazil
 Escultura Plural, Museu de Arte Moderna da Bahia, Salvador, Brazil

1995 The Drawing Center, New York, New York
 The Five Senses, White Columns, New York, New York
 Anos Oitenta: O Palco de Diversidade, Museu de Arte Moderna, Rio de Janeiro, Brazil
 Entre o Desenho e a Escultura, Museu de Arte Moderna de São Paulo, Brazil
 Beyond the Borders, Kwangju Biennale, Korea

SELECT BIBLIOGRAPHY

BOOKS AND CATALOGUES

1999 Adriano Pedrosa, ed. *Ernesto Neto: naves, céus, sonhos.* São Paulo: Galeria Camargo Vilaça.
 Carnegie International 1999/2000. Vol. 1. Pittsburgh: Carnegie Museum of Art, pp. 60-1, 103 (exhibition catalogue).

1998 Carlos Basualdo. "Ernesto Neto." *Cream: Contemporary Art in Culture.* London: Phaidon Press, Ltd., pp. 296-9.
 Benjamin Genocchio. "Ernesto Neto." *Every Day: 11th Biennale of Sydney.* Sydney: The Biennale of Sydney Ltd., pp. 168-9 (exhibition catalogue).
 Carlos Basualdo. *Ernesto Neto.* São Paulo: Galeria Camargo Vilaça (exhibition catalogue).
 Poéticas da Cor. Rio de Janeiro: Centro Cultural Light (exhibition catalogue).
 XXIV Bienal de São Paulo: Arte Contemporânea Brasileira. São Paulo: A Fundação, pp. 50, 65, 110, 211 (exhibition catalogue).

1996 Bonnie Clearwater, ed. *Defining the Nineties: Consensus-making in New York, Miami and Los Angeles.* Miami: Museum of Contemporary Art (exhibition catalogue).
 transparências. Rio de Janeiro: Museu de Arte Moderna do Rio de Janeiro (exhibition catalogue).

1995 *Beyond the Borders.* Seoul: Kwangju Biennale Foundation, pp. 310-3 (exhibition catalogue).

ARTICLES AND REVIEWS

1999 Carlos Basualdo. "Ernesto Neto: Bonakdar Jancou Gallery." *Art Nexus*, February-April, pp. 121-2.
 David Ebony. "New York: Ernesto Neto at Bonakdar Jancou." *Art in America*, June, p. 118.
 Rubén Gallo. "Ernesto Neto—Voluptuous, Sexy, and Floating Membranes." *Flash Art*, February, pp. 78-9.
 Ana Isabel Perez. "Lygia Pape and Ernesto Neto: Carrillo Gil Museum." *Art Nexus*, February-April, pp. 88-9.

1998 John Angeline. "Ernesto Neto at Tanya Bonakdar." *Art Nexus,* September, pp. 140-1.
 Benjamin Genocchio. "Concrete Poetry." *World Art*, no. 12, pp. 56-60.

1997 Nico Israel. "Ernesto Neto—Tanya Bonakdar Gallery." *Artforum*, October, p. 101.
 Adriano Pedrosa. "Ernesto Neto/Galerie Camargo Vilaça." *Frieze*, March-April, p. 91.

1996 Sue Taylor. "Ernesto Neto at Zolla/Lieberman." *Art in America,* December, p. 108.

1995 Carlos Basualdo. "Ernesto Neto—Galeria Camargo Vilaça." *Artforum,* January, p. 93.
 Carlos Basualdo. "Studio Visit Ernesto Neto." *Trans*, November, pp. 137-42.

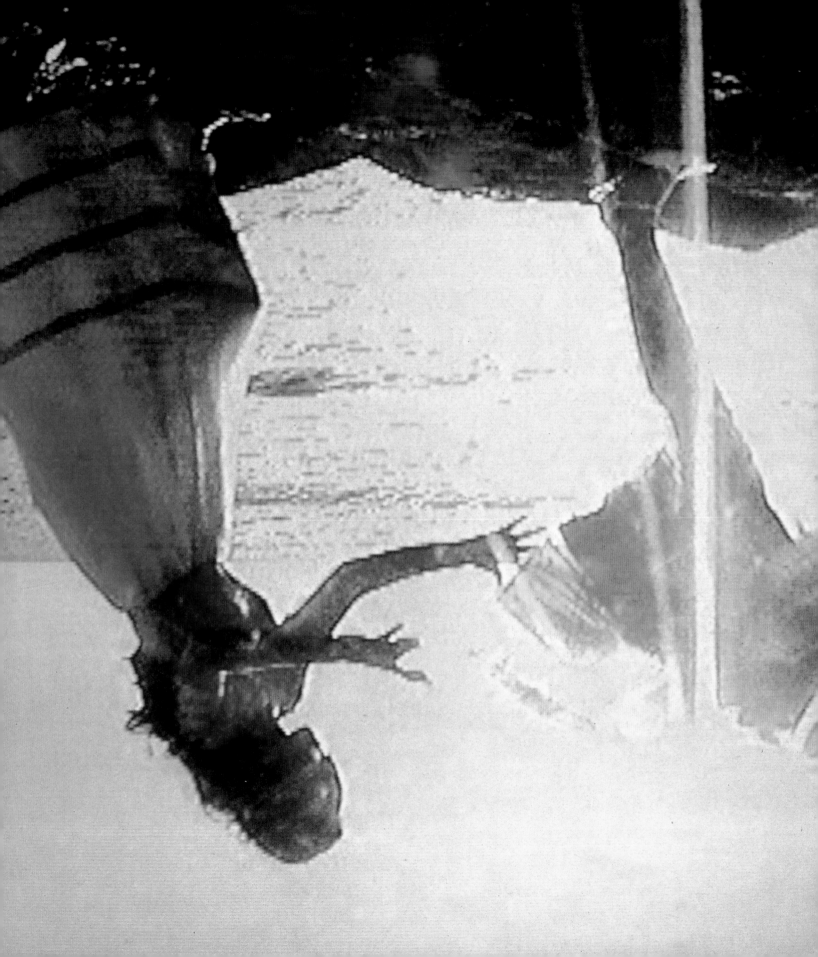

PIPILOTTI RIST

INTERVIEW

Ever Is Over All includes two video projections. One is an image of a girl walking in an urban setting, and the other is a floral scene. They contrast with one another, but they also overlap and inform each other. What was your motivation for this piece and for the combination of these distinct images? As you said, the two scenes overlap. The girl walks with a Red Hot Poker flower in her hands. To her right you see the same flowers in a garden. Then she casually destroys a series of car windows with the flower. I'm honoring nature by exaggerating the power of a tender, fibrous plant, and I juxtapose this with an extreme close-up that travels around the plants. The camera work makes the plants seem hundreds of feet tall. The blossoms remind me of a futuristic city. By watching the garden projection I imagine you could live in the blossoms. The concept of the camera movement is meant to imitate the flight of an insect, flying around and into the blossoms like a helicopter would fly around a landing pad on a rooftop. What interests me are the different perspectives or focal points. What's big and what's small, as well as what's weak and what's strong, are extremely relative. The obstacles we imagine are often bigger than they are in reality.

When I watch this piece I feel like I'm in a dream. Some people have compared it to a fairy tale. It is a fantasy. When I created it, I wasn't thinking about fairy tales. It's true that it has some similarities, but maybe that's because it depicts a delicate, feminine girl doing something very aggressive. This is a familiar aspect of fairy tales: the small child wins against the monster. There's always a balance of power to comfort the weak, the poor, and the children. Fairy tales always prove that the key to winning a struggle depends on our mental force and not on power or physical force. That interests me a lot. I'm very interested in the power of weakness and the beauty of the non-elegant. In that way, you can say that I refer to fairy tales. You know, if you glorify or empower a seemingly fragile woman, it can suggest mental strength. I'm fighting against clichés by exaggerating the person and giving her an unusual physical presence on screen. This suggests to me mental power or the strength of self-hypnosis. You mean a sense of self-confidence? Yes. You can do it, you can do it, you can do it. Things like this. Who the hell gave us all the illogical rules? In my work I want to encourage people to ignore unnecessary and hurtful limitations.

Let's talk about the comparison you've made between the camera and a bee flying through your garden image. I notice that the ideas of journey and movement are

Pipilotti Rist, *Remake of the Weekend*, 1998; video still; courtesy Galerie Hauser & Wirth, Zurich and Luhring Augustine, New York; photo by the artist

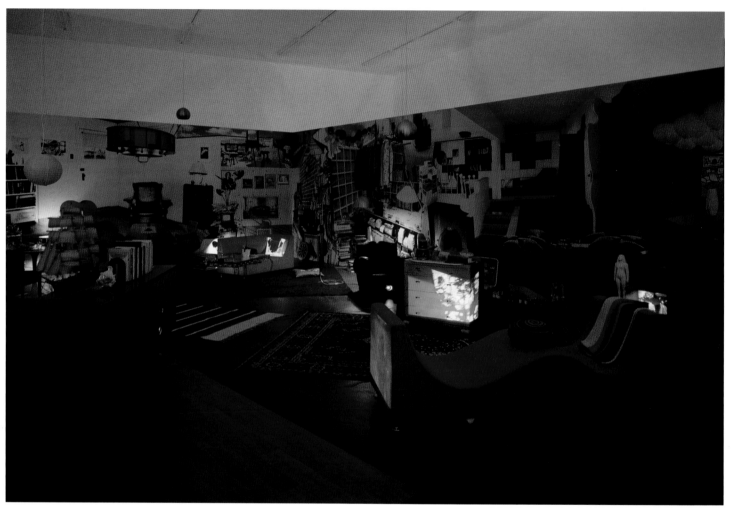

Pipilotti Rist, *Himalaya Goldstein's Living Room (Remake of the Weekend)*, 1998/99; installation at Kunsthalle Zürich;
courtesy Galerie Hauser & Wirth, Zürich and Luhring Augustine, New York; photo by Alexander Troehler

very strong in your work. There are always people in motion in your videos—and the camera is in motion, too. I'm definitely aware of the movement of the camera. I only use a handheld camera, which means that things are moving all the time. I think of it as a type of journey. I am very much interested in movements that have a really clear aim or path. The way that you move is a language itself, just like the framing of photographs is a language. How you move, with which focus, and in which direction is a language or expression without words. My sense of movement comes across very emotionally. Camera movement is something I take great pride in.

Do you use these different movements to involve the viewer in particular ways? I use the camera to guide the viewer. I guide myself and I guide you as well. But I think that's what every artist is doing. If I were to give you a camera and you were to shoot a sequence, I would be able to tell some things about you: how you moved, what you looked at, for how long.

Do you consider your video to be almost autobiographical? We see what you're looking at by where and how you move. Do you use the word "autobiographical" to mean "personal"? That's one of the classical aims of cultural expression—to try to uncover and show something to each other, to understand the other, or to see how someone is perceiving the world because we are so extremely alone. And then, if we watch something together, it might bring us closer to understanding each other. Or we might find ourselves in the way the other is watching.

I also use the camera to pay homage. I honor the thing I'm filming. In German we say *"huldigen."* I feel a bit like I'm a priest. The act of shooting is almost like a prayer. No one has ever asked me to talk about my camera movement. Most people want to talk about MTV.

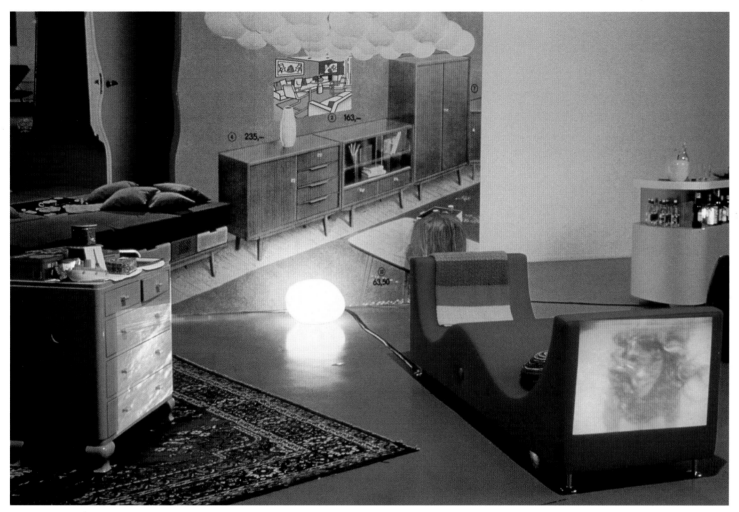

Pipilotti Rist, *Himalaya Goldstein's Living Room (Remake of the Weekend)*, 1998/99; installation at Museé d'Art Moderne de la Ville de Paris; courtesy Galerie Hauser & Wirth, Zurich and Luhring Augustine, New York; photo by Marc Domage

How do you compare your work to music videos? Some music videos utilize interesting camera work. Maybe this is part of the connection people see between MTV and my work. Music videos are different from most video art pieces where the camera work is often very rigid and strict.

Are there certain films that have been influential on your work? Like most people today, I've seen many films, especially on TV. I don't even know the titles or directors' names, but they have still influenced me. After having done drawings and Super 8 animation films early in my career, I started to work with video and music. This was about the same time that MTV was developed in England. Later on, people saw a connection. However, at that time I was more influenced by experimental films and by feature films.

There is a long history of music films that predates MTV. People saw my first video, "I'm Not The Girl Who Misses Much," as a critical response to MTV. I hadn't even seen MTV at that point, but of course it's a reflection of pop culture. I would not want to distance myself from certain clips shown by MTV because I have a lot of respect for those colleagues. The only difference is I do not have to sell someone's product with my video works. I don't have to sell a band. I use the same media, but I'm privileged to convey purely poetical, philosophical, and political content.

Are you still playing in your band, Les Reines Prochaines? No, it was too difficult to combine live tours with an art production and exhibition schedule. And, I have to admit, I never liked to go on stage during the entire six years. I suffered from the first to the last concert. But it was a good way to conquer my fears, and I learned a lot by doing it. For example, it's not necessary to worry about what people think

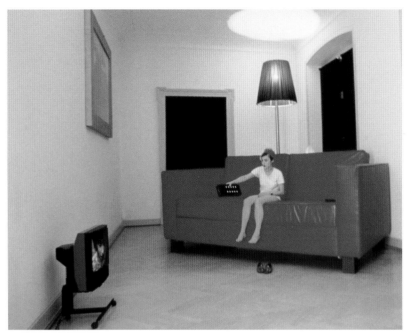

Pipilotti Rist, *Das Zimmer/The Room*, 1994; installation at Kunstmuseum St. Gallen, Switzerland; courtesy Galerie Hauser & Wirth, Zurich and Luhring Augustine, New York; photo by Stefan Rohner

of you, because you will never be able to even imagine what they think of you. This is as true in life as it was on stage.

What other things have influenced your work? What about art? I am an artist, so I pay attention to art history and contemporary art, although I came to art through the mass media. I was very interested in John Lennon when I was growing up, but I was ten years too late to be a real fan. Through the music of John Lennon I became aware of Yoko Ono, and I heard that she also made films, and I learned about The Happenings. I collected everything I could. You could say that in my small village in Switzerland I had a little window to art through mass media phenomena. And the more I learned about art, I realized that as an artist you can have interests in every-thing—architecture, psychology, sociology, politics, and more. That's what I wanted.

Were you interested in painting as well? I usually say that video is like a glass painting (*verre églomisé*) that moves. In fact, video has a rough quality and it can look like a painting. I do not want to copy reality in my work because reality is always much, much sharper and has more contrast than we can ever create with video. Video has its own quality—a lousy, nervous inner-world quality—and I'm working with that.

I'm curious about your installation pieces, such as *Das Zimmer* and *Himalaya Goldstein's Living Room*. How do these fit into your video practice? Are they an attempt to construct a setting or context for watching your videos? I see them as sculptures or room installations. They're not just places to show video but a way to think about different issues, like watching TV and the power of images in daily life. I'm also interested in the fact that museums are turning into types of living rooms. I like to open up art and explore this idea that the museum is a collective living room.

I am extremely interested in how people live and what they do to their rooms. In some ways, every living room and every person is a little museum of his or her own life.

Himalaya Goldstein's Living Room is a collection of many, many objects. Are they souvenirs that you've collected from places you've traveled to? They are a mix of things. Some borrowed, some bought, some I had. It is a collection.

And what about your piece *California Retour,* which you collabo-rated on with Anders Guggisberg? I understand it is about your fantasy trip to California. You've never been there, right? I'm going there this week for the first time in my life. In the work there are three pictures overlaid on one flat screen. The big background picture is made with a camera placed in the sand next to the ocean, with the waves crashing periodically over the lens. The other two are romantic, happy pictures made in old-world, gray Europe. The images we shot in Europe reflected our clichés and fantasies of the California feeling: a hippie festival in a German forest, happy people kissing in little Italy of Zurich, a samba festival in the rain. These are all ideas we connect with California. I'm surprised that place is not bursting with the weight of dreams from all over the world. The piece is framed with shells so it looks like a souvenir, and it relates to the idea that the western land ends in California. I'm a bit afraid to go there because it could be disillusioning or frus-trating to have nothing to dream about anymore.

Interview with Pipilotti Rist by Rochelle Steiner

PIPILOTTI RIST

Born Rheintal, Switzerland, 1962
Institute of Applied Arts, Vienna, Austria, 1982–86
School of Design, Basel, Switzerland, 1986–88
Lives and works in Zurich, Switzerland

WORK IN WONDERLAND

Ever Is Over All, 1997
2 video projections, 2 laser disc players,
audio system
sound © Anders Guggisberg
Collection Donald L. Bryant, Jr. Family Trust

SELECT SOLO EXHIBITIONS

2000 Center for Contemporary Art,
 Kitakyushu, Japan

 TRAMWAY, Glasgow, Scotland

 Luhring Augustine Gallery, New York,
 New York

1999 Pitti Immagine—Projectroom,
 Florence, Italy

 Fundação de Serralves, Porto, Portugal

1998 SITE Santa Fe, New Mexico

 Ever Is Over All, MATRIX 136, Wadsworth
 Atheneum, Hartford, Connecticut

 Remake of the Weekend, Nationalgalerie im
 Hamburger Bahnhof Berlin—Museum für
 Gegenwart Berlin, Germany (traveled to:
 Kunsthalle Wien, Vienna, Austria; Kunsthalle
 Zürich, Switzerland; Musée d'Art Moderne de
 la Ville de Paris, France; Musée des Beaux-
 Arts de Montréal, Quebec, Canada)

1996 *The Social Life of Roses. Or Why I'm Never
 Sad,* Staatliche Kunsthalle Baden-Baden,
 Germany (traveled to: Kunstmuseum
 Solothurn, Switzerland; Museum Villa Stuck,
 Munich, Germany; Stedelijk Museum Het
 Domein, Sittard, Netherlands)

 Slept in, had a bath, highly motivated,
 Chisenhale Gallery, London, England

 Shooting Divas, Centre d'Art Contemporain,
 Geneva, Switzerland

 Sip My Ocean, Museum of Contemporary Art,
 Chicago, Illinois

1995 *De kop van de kat is jarig en zijn pootjes
 vieren feest,* Galerie Akinci, Amsterdam,
 Netherlands

1994 *I'm Not The Girl Who Misses Much—
 Ausgeschlafen, frisch gebadet und hochmo-
 tiviert,* Kunstmuseum St. Gallen, Switzerland
 (traveled to: Neue Galerie am
 Landesmuseum, Graz, Austria;
 Kunstverein in Hamburg, Germany)

SELECT GROUP EXHIBITIONS

2000 *Présumé Innocents*, C.A.P.C. Musée d'Art
 Contemporain, Bordeaux, France

 Agents of Change, 12th Biennale of
 Sydney, Australia

 Over the Edges, Stedelijk Museum voor
 Actuele Kunst, Ghent, Belgium

1999 *Regarding Beauty: A View of the Late
 Twentieth Century,* Hirshhorn Museum and
 Sculpture Garden, Washington D.C. (traveled
 to: Haus der Kunst, Munich, Germany)

 Looking for a Place, SITE Santa Fe,
 New Mexico

 The Passion and the Wave, 6th International
 Istanbul Biennial, Turkey

 dAPERTutto, XLVIII Biennale di Venezia,
 Venice, Italy

 Vision of the Body in Fashion, Museum of
 Contemporary Art, Tokyo, Japan

1998 *Trance*, Philadelphia Museum of Art,
 Pennsylvania

 Shoot at the Chaos, Wacoal-Spiral Art Center,
 Tokyo, Japan

 Berlin/Berlin, Berlin Biennale, Germany

1997 *On life, beauty, translations and other
 difficulties*, 5th International Istanbul
 Biennial, Turkey

 Future Past Present, XLVII Biennale di
 Venezia, Venice, Italy

 L'Autre, 4e Biennale de Lyon, France

 Unmapping the Earth, Kwangju Biennale,
 Korea

1996 *NowHere,* Louisiana Museum of Modern Art,
 Humlebaek, Denmark

 The Scream, Nordic Fine Arts 1995–96, Arken
 Museum of Modern Art, Ishoj, Denmark

1995 *Femininmasculin—Le sexe de l'art, X/Y,* Centre
 Georges Pompidou, Paris, France

SELECT BIBLIOGRAPHY

BOOKS AND CATALOGUES

1999 Christophe Blase. "Pipilotti Rist." *Art at the
 Turn of the Millennium.* Cologne and
 New York: Taschen, pp. 426–9.

 N. Fulya Erdemci and Paolo Colombo, eds.
 *6th International Istanbul Biennial: The Passion
 and the Wave.* Istanbul: Istanbul Foundation
 for Culture and Arts, pp. 178–81
 (exhibition catalogue).

 Harald Szeemann and Cecilia Liveriero
 Lavelli, eds. *La Biennale di Venezia:
 48a esposizione internazionale d'arte:
 dAPERTutto.* Venice: Marsilio, pp. 178–81
 (exhibition catalogue).

 Looking for a Place. Santa Fe: SITE Santa Fe
 (exhibition catalogue).

1998 Hans-Ulrich Obrist. "Pipilotti Rist." *Cream:
 Contemporary Art in Culture.* London: Phaidon
 Press, Ltd., pp. 344–7.

1997 Emre Baykal, ed. *5th International Istanbul
 Biennial: On life, beauty, translations
 and other difficulties.* Istanbul: Istanbul
 Foundation for Culture and Arts, pp. 182–3
 (exhibition catalogue).

 Germano Celant, ed. *XLVII esposizione
 internazionale d'arte: la Biennale di Venezia.*
 Venice: La Biennale; Milan: Electa,
 pp. 534–41 (exhibition catalogue).

 Unmapping the Earth: 97 Kwangju Biennale.
 Kwangju: Kwangju Biennale Press
 (exhibition catalogue).

1996 Laura Cottingham, ed. *NowHere.*
 Humlebaek: Louisiana Museum of Modern
 Art (exhibition catalogue).

 Dominic Molon. *Pipilotti Rist, Sip My Ocean.*
 Chicago: Museum of Contemporary Art (exhi-
 bition catalogue).

ARTIST PUBLICATIONS

1998 Pipilotti Rist. *Himalaya: Pipilotti Rist, 50 Kg.*
 Cologne: Oktagon.

 Pipilotti Rist. *Remake of the Weekend—Pipilotti
 Rist.* Cologne: Oktagon.

1997 Pipilotti Rist. "I love you forever." *Du, die
 Zeitschrift fur Kultur,* no. 6.

1995 Pipilotti Rist. *I'm Not The Girl Who Misses
 Much.* Stuttgart: Oktagon.

ARTICLES AND REVIEWS

1999 Harm Lux. "Pipilotti Rist. A Cosmos in Her
 Own Right." *Flash Art*, Summer, pp. 106–9.

1998 Christian Haye. "The Girl Who Fell to Earth."
 Frieze, March–April, pp. 62–5.

 Terry R. Myers. "Pipilotti Rist: Grist for the
 Mill." *Art/Text*, May–July, pp. 32–5.

 Hans-Ulrich Obrist. "Rist for the mill."
 Artforum, April, p. 45.

 Ulf Erdmann Ziegler. "Rist Factor." *Art in
 America,* June, pp. 80–3.

1996 "Pipilotti Rist," with contributions by Laurie
 Anderson, Marius Babias, Paolo Colombo,
 Nancy Spector, and Philip Ursprung. *Parkett*,
 no. 48, pp. 82–120.

 Elisabeth Janus. "Pipilotti Rist." *Artforum*,
 Summer, pp. 100–1.

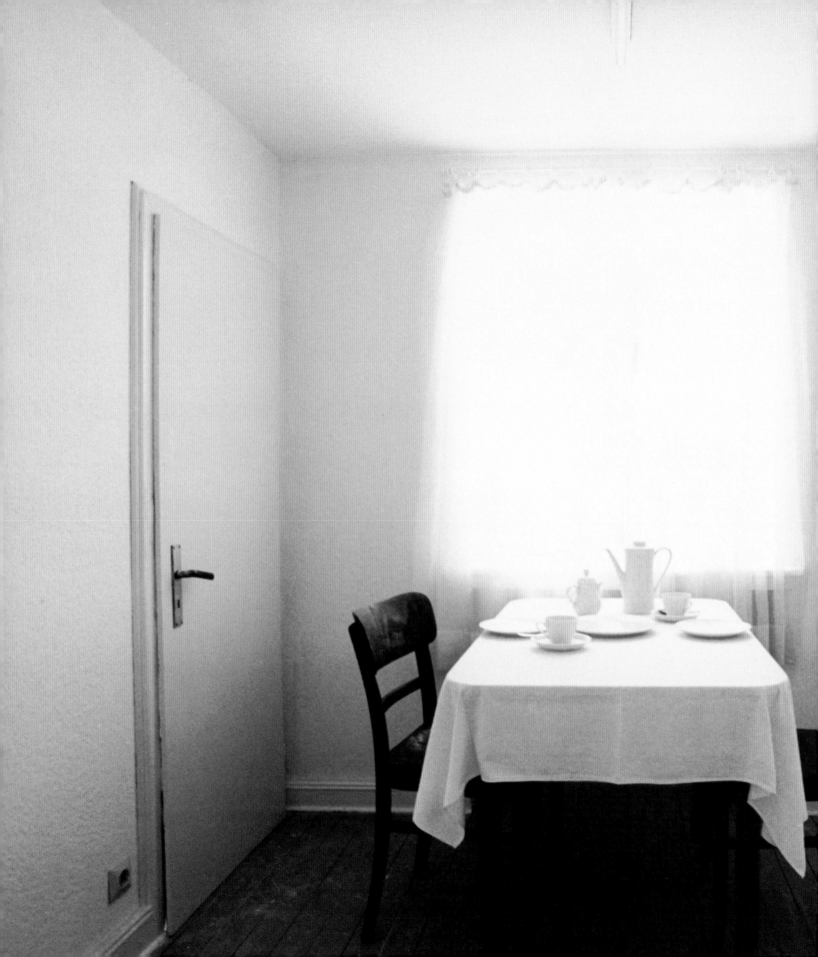

GREGOR SCHNEIDER

INTERVIEW

The following text is an edited transcript of a number of conversations between Ulrich Loock and Gregor Schneider, during the period November 1995 to January 1996, in Gregor Schneider's house on Unterheydenerstrasse in Rheydt and in the Kunsthalle Bern. These conversations preceded Gregor Schneider's 1997 exhibition at the Kunsthalle Bern.

I would be interested to know if you have more plans for this house in Rheydt, now that you have worked in it for ten years. I don't know where the work could go from here. I could go on running on the spot, just go on working until the work pushes me out of the house or swallows me up altogether. Or perhaps I'll just leave the house and get myself another one. I could systematically dismantle the work again. Or I could work in other places to make the place less important. So you are saying that your life's work, your existential praxis, is not irrevocably bound up in this house? I've always wanted to work somewhere else. It's just chance that out of necessity I've done my work here. I'd love to get out. But your works are surely very much connected with this house? By now my work has become independent. It has its own inner dynamics. The sheer amount that I have built in here means that I can't distinguish any more between what has been added and what has been subtracted. There is no way now of fully documenting what has happened in the house. The only way now would be to measure the hidden spaces. No one could get to the original structure anymore without systematically drilling apart and destroying the house. The layers of lead mean you couldn't even X-ray it.

What do you actually mean when you say your work has become independent? Considering I spend most of my time here, I have to accept the rooms as they are, and accept the most recently built as perfectly normal. And although the light in the room is from a lamp and the air is produced by a ventilator, by now the atmosphere seems quite normal to me. I need normal light and air here, I need different times of day, so I make them for myself. I have to make them and, having done so, I register them as simply being there. Sometimes the times of day even become independent. I see that it's a nice day in here and then when I go out it's nighttime. Usually the days are identical. It's grey inside and it's grey outside.

You once said that this was the work of someone who was working at insulating himself. Have I remembered that correctly? There are works where I completely insulate myself by fitting out rooms with lead, glass fiber, soundproofing materials, and other stuff. I am right in the middle of it and surrender to the work just like

Gregor Schneider, *"We sit, drink coffee and look out the window," ur 10, Rotating coffee-room*, Rheydt, 1993; courtesy Luis Campaña Galerie, Cologne and Konrad Fischer Galerie, Dusseldorf; photo by the artist

Gregor Schneider, *Vestibule (room ur 11 u 56)*, Rheydt, 1993; courtesy Luis Campaña Galerie, Cologne and Konrad Fischer Galerie, Dusseldorf

I have been looking at the catalogue from Krefeld and was impressed by the list of works. From 1985 to 1994 it reads: wall in front of wall, wall in front of wall, wall behind wall, passage in room, room in room, passage in room, wall in front of wall, room in room, room in room, room in room, red stone behind room, lead around room, lead in floor, light around room, light around room, wall in front of wall, figure in wall, wall in front of wall, wall in front of wall, room in room, wall in front of wall, wall in front of wall, wall in front of wall, ceiling under ceiling, section of wall in front of wall, wall in front of wall, section of wall in front of wall, wall in front of wall . . . I find it fascinating, it's a kind of poetry . . . up until 1994, six walls behind wall. The description of the works seems almost exclusively like the reiteration of something that is already there. There were also works that you can't recognize as such. I build complete rooms with floor, walls, and ceiling, that you can't see as a room in a room or a room around a room. There has been a constant stream of new rooms made from various materials. Some of them—imperceptibly—rise up, sink back down, or complete a full rotation. My work is really about the fact that I am always starting work again.

What kind of rooms are you building? Are they ideal rooms? Is it that you don't like the existing rooms, and you want to make a room that suits you better or which you yourself control? What drives you to construct new rooms inside existing rooms that already work fine? I'm not interested in the room itself. The first time I built a room, I had no idea that's what I had done. It was someone else that told me. How was that? I was interested in free-wheeling actions. I was interested in heading for some neutral point that I myself cannot know. Moments like that only arise through chance. The not-consciously-perceptible motion of things and the different times of day produce what I call an unknowable space of time. And so a place comes into being that can't be a place; a sense of something that we don't know. Maybe someone comes in because the door was left open or they have been invited. They drink a cup of coffee with me. We have a boring conversation, they leave again, and don't even wonder why they were there in the first place . . . They came to sell you a life-insurance policy . . . They came and didn't notice that they rotated once right round. Of course I can't know what will happen. Someone might open the wrong door at the wrong moment and plunge into an abyss.

To what extent do you actually plan the effect of your works? I am always making. I always have to be making things. That is my personal problem. The work doesn't exist in my head. I also regard doing as a higher form than thinking. The list you quoted destroys the work because I am showing what can't necessarily be shown.

anyone else who comes along. I'm not the sort to be doing tricks of some kind or other. Whether I am insulating myself from the world, or whether it's a break-through—I don't really know.

The thing that makes this work different from what other artists do is that you construct something that you yourself then live in, day and night. It takes a long time to do the work. I wouldn't like it if the only thing about it is that I live in it. Because that would mean it was just my cell. Whether it's a place of refuge, I don't know. Anyway, now I've got a guest room. Maybe some others might like to fester away there instead of me.

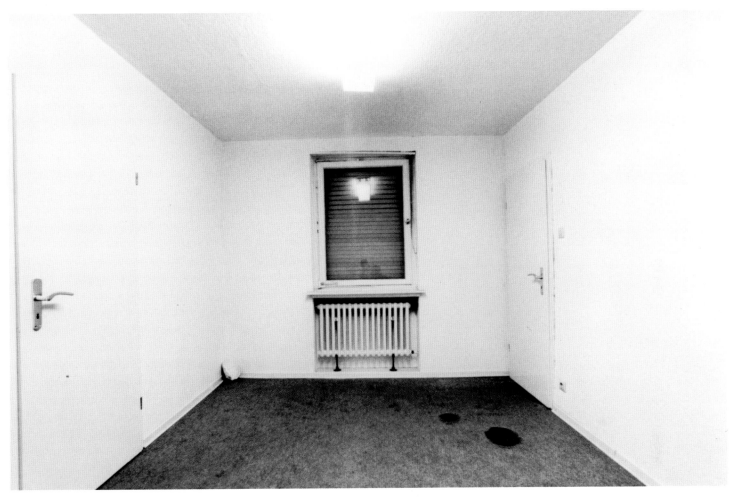

Gregor Schneider, *Passage (room ur 1),* Rheydt, 1986; courtesy Luis Campaña Galerie, Cologne and Konrad Fischer Galerie, Dusseldorf

Are you anxious about revealing something that is not visible? The terms visible and invisible are not so important as conscious and unconscious perception, recognition and non-recognition.

How long does it actually take to build a room? I don't work systematically on one room and then on the next. I work on different things at the same time, just depending on what materials I've got, it varies. The last one took a whole year . . . The guest room? The guest room. But then there was a point when you said, now the guest room is finished. That much is true. Yes, but I have to force myself to do it. The deciding factor is its usability.

Are you still interested in the room when it is finished? I keep everything, I never throw anything away.

Are you interested in using the proportions and the lighting and so on to condition the moods? I am interested in observing and . . . well, there's nothing like experience. A whole world opens up with all sorts of things that are not recognizable but which are there and which influence the way we feel, think, and act, how we live our daily lives. The fact that the room is rotating without a person knowing it can alter the direction they walk in. Cladding in various materials can alter the effect of a room without you quite being able to say why. Even the smallest protuberances and indentations on the finished surface of a wall can arouse a response in the visitor. And when that happens, the effect is registered separately from the cause. So sometimes a visitor might say, I'm having a bad day today: the feeling has been induced by the room but they can't know that. I observe these things, but I don't set out to make them happen.

You're not doing experiments on the physiology and psychology of perception . . . I'm not a scientist, I just observe what I myself experience, what I can see.

What has been your experience with works in places other than your house? I am disappointed if I have put a great deal of time, effort, and materials into making works which no one sees for what they are, have in effect thrown myself away, and then have to take it all down again. I wonder how long it will be before I have to take

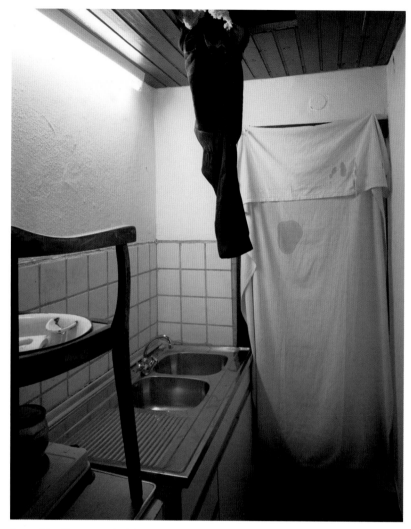

Gregor Schneider, *room ur 7-10 A (kitchen)*, 1987, from *Haus ur*, 1985; installation at
Carnegie International 1999/2000, Carnegie Museum of Art, Pittsburgh;
Rubell Family Collections, Miami; photo by Richard A. Stoner

less as it was, 10 by 5.76 by 3.25 metres. It had five individual
windows, you could look straight out. The ceiling went up and down
continuously, imperceptibly. The big room remained in place for
a whole year. Other exhibitions were held in it. I have no idea who
was aware of all of that. It was brutal work, positively killed off
economy, and when I tell people about it these days, it all scarcely
seems credible. At Konrad Fischer's I then tried to become very
concentrated. Constructed poised works, well-balanced. Whatever
I took away on one side was put back on the other. Amongst other
things I made a pillar, tried to get to the point in the work. Probably
the most concentrated work that I have done so far. At Konrad
Fischer's I could just leave the large pieces where they were. They
didn't throw me out. In Berlin at Andreas Weiss's Gallery: that was
the first room with a connection to this house. Before that I kept
the work strictly under wraps, barely even let any photos out. Built
a room somewhere else almost exactly like the existing room here.
Went specially all that way and then put it up in ten days. It was
interesting for me because the gallery was being newly opened.
The rooms there weren't yet generally known . . . Then when I was
in the finished room in Berlin, I was in Rheydt. Do you know the
way people on spaceships beam themselves from one place to
another? When I was back here again I tried to imagine the things
that were happening there. I could imagine repeatedly building a
more or less identical room from memory in various different
places, to get back here again maybe. But I don't really know. Tried
to show the extracts, the photos, and the videos at Campaña's
in Cologne. They look unremarkable and meaningless, but at
the same time they freeze everything. Of course there are also
works that I am glad to take down again, that are there one
moment like a momentary vision and gone the next. But it's the
work that decides.

Interview with Gregor Schneider by Ulrich Loock

Excerpted from *Gregor Schneider, Totes Haus ur/Dead House ur/Martwy Dom ur,
1985–1997* (Mönchengladbach: Städtisches Museum Abteiberg; Warsaw:
Galeria Foksal; Frankfurt am Main: Portikus; Paris: Musée d'Art Moderne de la
Ville de Paris, 1997).

things down that I didn't even put up in the first place. That's why I have always
made things, have had to make things, that even the exhibition organizers were not
aware of. In order to be able to work on the place. It was good working in Krefeld
at the Haus Lange. I got the key, went in and worked, quite unrestricted, stole a Mies
van der Rohe wall, copied a Haus Lange wall, and made a work that even the exhi-
bition organizer didn't know if I had made it or what it really was. And to this day he
doesn't know what it is? He doesn't know. It's still there? As far as this work is
concerned, the important question for me is whether it was ever there. I am not
going to commit myself.
Were there other important works? Spent months digging up the whole house at
Lohrl in Mönchengladbach, managed to reconstruct all by myself one room more or

GREGOR SCHNEIDER

Born Rheydt, Germany, 1969
Düsseldorf Academy, Münster Academy, and
Hamburg Academy, Germany, 1989-92
Lives and works in Mönchengladbach, Germany

WORK IN WONDERLAND

Totally Isolated Guest Room, ur 12, 1995
2 layers lead, 3 layers glass wool, 1 layer rock wool,
1 layer sound-absorbing material, 3 wooden
constructions, plaster boards, plaster, 1 door,
1 lamp, 1 grate, gray wooden floor, white walls,
ceiling, mattress with bed linen, heater, stool
Collection Dr. Th. Waldschmidt, Cologne, Germany

SELECT SOLO EXHIBITIONS

2000	The Douglas Hyde Gallery, Dublin, Ireland
1999	Massimo De Carlo, Milan, Italy
	Kunsthalle Bremerhaven, Germany
	Kabinett für aktuelle Kunst, Bremerhaven, Germany
1998	Århus Kunstmuseum, Vennelystparken, Denmark
	Wako Works of Art, Tokyo, Japan
1997	*The Dead House ur 1985-1997,* Portikus, Frankfurt am Main, Germany (traveled to: Galeria Foksal, Warsaw, Poland; Städtisches Museum Abteiberg, Mönchengladbach, Germany; Musée d'Art Moderne de la Ville de Paris, France)
	Sadie Coles HQ, London, England
	Wako Works of Art, Tokyo, Japan
	Konrad Fischer, Düsseldorf, Germany
	Luis Campaña, Cologne, Germany
1996	Künstlerhaus Stuttgart, Germany
	Kunsthalle Bern, Switzerland
1995	Luis Campaña, Cologne, Germany
1994	Galerie Andreas Weiss, Berlin, Germany
	Museum Haus Lange, Krefeld, Germany
1993	Konrad Fischer, Düsseldorf, Germany

SELECT GROUP EXHIBITIONS

2000	Hamburger Kunsthalle, Hamburg, Germany
1999	*Carnegie International 1999/2000,* Carnegie Museum of Art, Pittsburgh, Pennsylvania
	Anarchitecture, De Appel, Amsterdam, Netherlands
	The Space Here Is Everywhere, Galerie der Stadt Esslingen, Villa Merkel, Germany

German Art Today, Gasi Athens, Greece

Zeitenwenden, Kunstmuseum Bonn, Germany and Museum Moderner Kunst Stiftung Ludwig Wien, Vienna, Austria

Horizontabschreiten, Kaiser Wilhelm Museum, Krefeld, Germany

The Invisible City, Centrum Beeldende Kunst, Maastricht, Netherlands

German Open, Kunstmuseum Wolfsburg, Germany

Videodrome, The New Museum of Contemporary Art, New York, New York

Who, if not we? Elizabeth Cherry Contemporary Art, Tucson, Arizona

Focused, Gallery Tanit, Munich, Germany

1998	*perfect usual,* Kunstverein Freiburg, Germany (traveled to: Germanisches Nationalmuseum, Nuremberg, Germany; Kunstverein Braunschweig, Germany; Kunsthalle zu Kiel, Germany; Kunsthaus Gera, Germany)
	Performing Buildings, Tate Gallery, London, England
	The Confined Room, De Waag, Amsterdam, Netherlands
1997	*A Place (to be),* Galerie Paul Andriesse, Amsterdam, Netherlands
	Niemandsland, Museum Haus Lange and Museum Haus Esters, Krefeld, Germany
1996	Kunstmuseum Bonn, Germany
	Bonner Kunstverein, Bonn, Germany
1995	Museum Haus Lange, Krefeld, Germany

SELECT BIBLIOGRAPHY

BOOKS AND CATALOGUES

1999 *Anarchitecture.* Amsterdam: De Appel (exhibition catalogue).

Yilmaz Dziewior. "Gregor Schneider." *Art at the Turn of the Millennium.* Cologne and New York: Taschen, pp. 450-3.

The Space Here Is Everywhere, Art with Architecture. Esslingen: Villa Merkel/ Bahnwärterhaus.

Volkommen gewöhnlich. Cologne: Kunstfound Bonn.

1998 Anders Kold, Lars Morell, and Adam Szymczyk. *Gregor Schneider—Haus ur Rheydt.* Vennelystparken: Åarhus Kunstmuseum.

1997 Ulrich Loock. *Gregor Schneider, Dead House ur 1985-1997.* Mönchengladbach: Städtisches Museum Abteiberg; Warsaw: Galeria Foksal; Frankfurt am Main: Portikus; Paris: Musée d'Art Moderne de la Ville de Paris.

Niemandsland. Krefeld: Krefelder Kunstmuseen.

Hans-Ulrich Obrist and Guy Tortosa, eds. *Unbuilt Roads.* Ostfildern: Verlag Gerd Natje.

1996 Udo Kittelmann. "Gregor Schneider." *Dorothea von Stetten Award.* Bonn: Kunstmuseum Bonn (exhibition catalogue).

Ulrich Loock. *Gregor Schneider.* Bern: Kunsthalle Bern (exhibition catalogue).

Annelie Pohlen. *Gregor Schneider Töten.* Bonn: Bonner Kunstverein (exhibition catalogue).

1994 *Gregor Schneider, Arbeiten 1985-1994.* Krefeld: Museum Haus Lange (exhibition catalogue).

ARTICLES AND REVIEWS

1999 Matthew Ritchie. "Franz Ackerman, Manfred Pernice, Gregor Schneider: the new city." *Art/Text,* May-July, pp. 74-9.

1998 David Barrett. "Gregor Schneider." *Art/Text,* May-July, pp. 89-90.

Yilmaz Dziewior. "Gregor Schneider." *Artforum,* Summer, pp. 142-3.

Matthew Higgs. "Gregor Scheider." *Art Monthly,* February, pp. 21-2.

Ulrich Loock. "Gregor Schneider." *Artist Kunstmagazine,* vol. 35, February, p. 26.

Ulrich Loock. "Gregor Schneider: junggesellenmaschine Haus ur (interview with Gregor Schneider)." *Kunstforum International,* October-December, pp. 202-11.

Stach Szablowski. "Haus Ur." *Architektura* (Warsaw), June, p. 74.

1997 Michael Hierholzer. "Lebenswelt im Kunstraum." *Frankfurter Allgemeine Zeitung,* August 31.

1996 Renate Puvogel. "Das Atelier als Thema—Das Atelier als Bild und Raum." *Artis* (Bern), October-November.

Hans Rudolf Reust. "Der Windhauch im Vorhang von Hannelore Reuen—Gregor Schneiders Haus in Rheydt." *Kunstbulletin,* March, p. 32.

Hans Rudolf Reust. "Gregor Schneider." *Kunstforum,* April, p. 440.

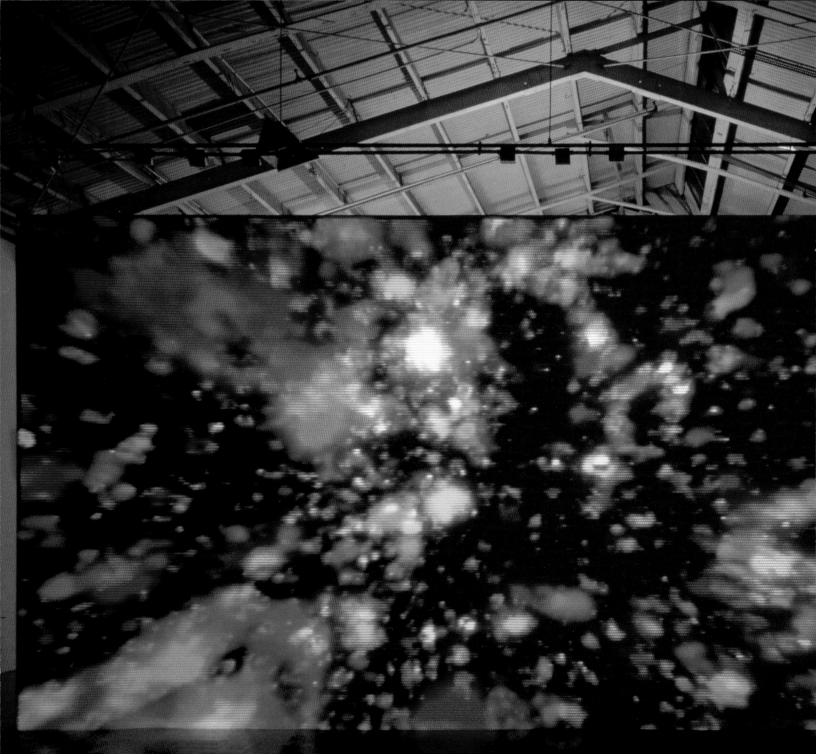

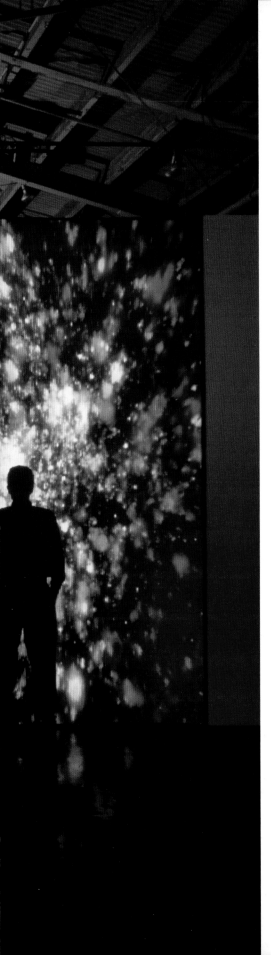

JENNIFER STEINKAMP

INTERVIEW

Your work is not just about the projected, abstract image, but also about its placement within space. Today, at the Museum, you did a lot of measuring of our galleries. Is that where your process begins? It depends on the space. Sometimes the work will have something to do with the history of the site, or some kind of architectural detail. I usually pick up on something existing in the space. However, because *Wonderland* will be very constructed, I think this piece will be different. I may actually create the space in which the video appears. Lately I seem to be adding to the architecture of the exhibition space. This seems like an important shift, from playing off of existing architecture and maneuvering within it, to building whole environments. How did that come about? I've become more aware of what I'm doing with space and what it means to work with space. Gradually, I have come to understand the differences between real and virtual space. But the possibility to build gives me more options for my work.

By building a space in which to situate your work are you also trying to situate the viewer in a certain way? Definitely. I'm very interested in the viewer's experience. What I'm trying to do is similar to the goals of structuralist cinema, except I think I'm taking certain aspects further. Traditionally cinema takes you in and the viewer is passive. But structuralist filmmakers were trying to make viewers aware of themselves as they were watching films. They were interested in a more active participation. I think I do that as well, but I put more emphasis on the space.

Are you trying to predict or achieve a specific response from your viewers? I definitely want you to become part of the work. You play an important role. As you realize your participation, you also understand that you have experienced a shift in perception. The work can alter your mental state. That is the ideal response I would like from a viewer. Recently it has been intriguing to work with interactivity. This brings up another level of consideration about the role of viewers and their responses to my work. For example, I can set trigger points so that the image changes—or even slows down and stops—when viewers pass a certain point in the room.

Can you describe how you actually make your pieces? That varies, too. I'll measure the space and input the dimensions into my computer so I have an exact three-dimensional model in Virtual Reality. Then I use the computer to calculate and compensate for projection distortions. At that point do you have an image in mind,

Jennifer Steinkamp, *SWELL* (collaboration with Bryan Brown), 1995; installation at ACME., Santa Monica; collection of The Museum of Contemporary Art, Los Angeles; purchased with funds provided by the Ruth and Jake Bloom Young Artist Fund; photo by Joshua White

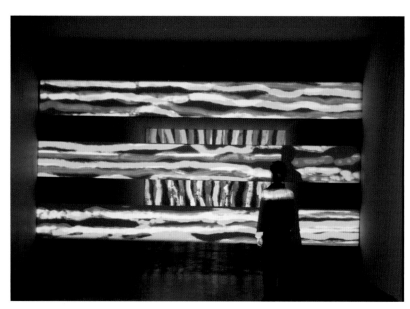

Jennifer Steinkamp, *The TV Room* (collaboration with Andrew Bucksbarg), 1998;
installation at Santa Monica Museum of Art; courtesy the artist; photo by Alex Slade

or are you working on the space alone? No, at that point there isn't an image. I usually have a direction in mind—for example, I might know that the piece will be horizontal or vertical, or I might have a speed in mind. Sometimes there's a new software effect that I would like to try. For example, there's software that simulates physical phenomena or nature. These tools can create lifelike motion. The motion in the work is very important; when it succeeds, the whole space becomes anthropomorphized in some way.

Light is also an important element in your work, isn't it? Projected video is light. It has a quality of its own, and it's continually shifting. I tend to notice light more than the average person.

Are you trying to make the space feel like it's in motion? Often the room starts to feel like it's shifting or breathing. Yes. I like the optical illusions that occur because of persistence of vision, or the way we resolve images in the brain. I am fascinated by those kinds of effects and the way they make you feel. I recently discovered a great one by accident while working on my piece for the Henry Art Gallery: the image is supposed to drip down, but my equipment accidentally froze and the still image appeared to drip upwards. It was bizarre. I thought it was great. I'm definitely going to use this. Many ideas occur through serendipity, and then I edit the result into the piece.

I think your work reminds us that we are constantly in motion. We tend to forget that the world is not static. The motion in your work reminds me that everything else around me is moving. That's a nice thought. It's true, even down to the molecular level the world is moving and so are we. But we are only aware of it in an unconscious way. We are constantly seeing it, but we have to filter it out or we'd be seasick all the time.

I've heard that a few of your pieces have made some viewers feel seasick. I think that's so great. Did you know that would happen? Yes. With *Untitled* at FOOD HOUSE, I discovered that you can make people physically seasick with light, which is nonmaterial. It was just wonderful to find that out. Were you working with a program that simulated breathing? I timed the work to feel that way. That is one of many devices I use to involve the viewer. It's sort of like the scene in *2001* when the computer named Hal is about to kill Dave and you hear Dave breathing for the longest time. That's such a great scene—really scary—and you become Dave.

You have included sound in a number of your pieces. How did these collaborations come about? I'll make a simulation of the space and figure out the motion and imagery, and then I'll talk to the composer. I've talked to Andrew Bucksbarg about collaborating for *Wonderland*. The composer usually responds to the image and I leave the concepts behind the sound to him.

What are you trying to achieve with the sound element? I think it adds another spatial representation. Sound can change the dimension of a space; for example, a square room can become circular as the sound travels across speakers. Sound cues the visuals, anticipates when things will happen. It creates a mood by adding to the emotional level and guides you towards a way of thinking about the piece. For example, if you have really soft music, you're going to have a different impression of the piece than if you hear something that's hard core.

You have mentioned before that you create a place in between real, virtual, and illusionistic space. Can you elaborate on those relationships? My work is inspired by the tools and ideology of Virtual Reality. I investigate our experiential relationship to architectural space, real and imagined, as it is experienced through time. Virtual or representational space is combined with real space, and the two transform each other: real space is dematerialized through animation, while the virtual space of 3-D animation is corporealized through architecture, creating a sort of dreamlike experiential space, or altered state.

There has been a lot of discussion about your work in terms of abstract painting, and you have been included in shows with painters. Is this an influence on you and a relationship you'd like to promote? My influences come from all over. Abstract painting is an obvious reading. I am inspired by the conceptual and formal aspects of abstract painting, but there are also links to structuralist film, Light and Space artists, architecture, music, and performance. Are you interested in the perceptual aspects of Light and Space environments? Those artists have had a huge influence on me in terms of the way they consider the space, and how they take

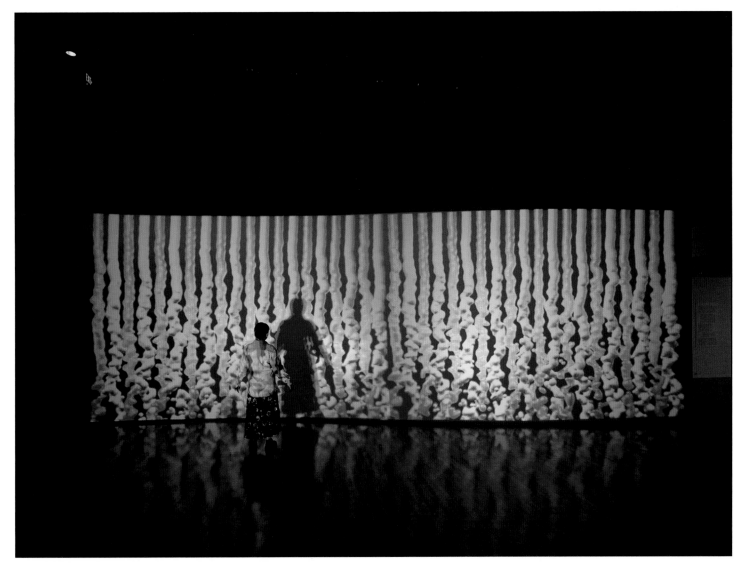

Jennifer Steinkamp, *Phase = Time* (collaboration with Jimmy Johnson), 1999; installation at Henry Art Gallery, Seattle; courtesy the artist; photo by Richard Nicol

control of the light in their fabricated, almost architectural environments. There is certainly a link, but artists like James Turrell are more spiritually inclined than I am. Once there were people chanting in one of my pieces—that was very strange! I guess they were inspired by the beautiful light. But that's certainly not the point for me.

It seems that your work is moving beyond the art or video art context into popular culture and commercial projects. How do you feel about operating in these two worlds? I was on the Sci-Fi Channel, which generated some attention to my work, and there was the U2 tour, and now the Staples Center, which is a new sports complex in Los Angeles. I've been approached about sets for theater and dance. I'm continually considering my boundaries. I see my practice as an experiment.

I find it very interesting that the software—the tools—are influencing your imagery as well as helping you make it. It's not that different from the way technology has changed more traditional media, like sculpture. Without certain tools, Richard Serra couldn't make those huge ellipses. Artists have always been limited by what color paints are available. But I don't feel limited at all: we've barely tapped into what can be done with the types of technology and software I'm using.

Where do you think technology might be taking us in terms of art? Well, one fairly obvious point is that as computers become faster we will be able to make more imagery in real time, and so art will become more responsive or behavioral. And

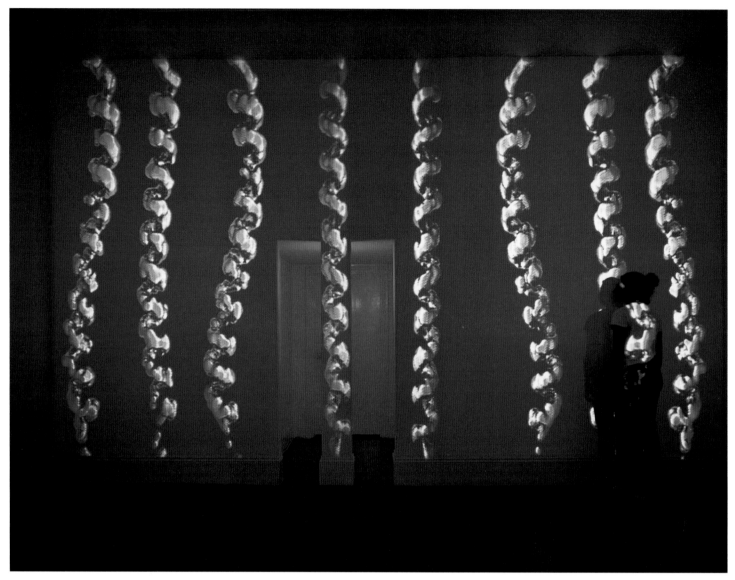

Jennifer Steinkamp, *Space Ghost* (collaboration with Jimmy Johnson) 1999; installation at greengrassi, London; courtesy the artist; photo by Marcus Leith

then there are the developments in Virtual Reality. We don't know exactly what that will develop into yet, which is how people felt about video 35 years ago. Anybody who is a pioneer doesn't necessarily know what they've got. Actually, I think in the 21st century art will become more genetic or biological. I will be out of the loop. Have you seen the goggles that project images onto their own lenses so you're looking directly into what appears to be a screen, but the screen is only the size of lenses? I saw a lot of artists working with these new gadgets in Japan. I refuse to have people wear goggles, although it's tempting because the space and image really change dramatically. But I don't want people to wear an apparatus when they look at my work. I'm very strict about that. I don't like having to wear the 3-D glasses

to experience Mariko Mori's work. But if we get to a point where we can project 3-D without the glasses, that would interest me.

It's a lot of work to keep up with all the changes and advancements in technology. I do a lot of research, but at the same time, that's not the point of my work. I am really intrigued by advances in technology, but only in light of creating and transforming spaces and experiences.

Interview with Jennifer Steinkamp by Rochelle Steiner

JENNIFER STEINKAMP

Born Denver, Colorado, 1958
California Institute of the Arts, Valencia,
California, 1984
BFA, Art Center College of Design, Pasadena,
California, 1989
MFA, Art Center College of Design, Pasadena,
California, 1991
Lives and works in Los Angeles, California

WORK IN WONDERLAND

X-Room, 2000
collaboration with Andrew Bucksbarg
video installation
Courtesy the artist

SELECT SOLO EXHIBITIONS

2000 Williamson Gallery, Art Center College of
Design, Pasadena, California

1999 *Phase = Time,* Henry Art Gallery, University of
Washington, Seattle

Space Ghost, greengrassi, London, England

1998 *A Sailor's Life is a Life for Me* (soundtrack by
Grain), ACME., Los Angeles, California

1997 *Cornering,* The Exchange, New York,
New York

Stripey, INOVA, Institute of Visual Arts,
University of Wisconsin–Milwaukee

Happy Happy (soundtrack by Grain),
Bravin Post Lee, New York, New York

1996 *Naysplatter* (soundtrack by Grain), University
of La Verne, California

1995 *Smoke Screen* (soundtrack by Grain),
Museum of Contemporary Art,
North Miami, Florida

SWELL (soundtrack by Bryan Brown),
ACME., Los Angeles, California

Bender (soundtrack by Grain), Bravin Post
Lee, New York, New York

Inney, Huntington Beach Art Center,
California

SELECT GROUP EXHIBITIONS

1999 *Videodrome,* The New Museum of
Contemporary Art, New York, New York

POSTMARK: An Abstract Effect,
SITE Santa Fe, New Mexico

1998 *Ultralounge: The Return of Social Space
(with Cocktails),* Diverseworks Artspace,
Houston, Texas

The Light Show, Nevada Institute of
Contemporary Art, Las Vegas, Nevada

1997 *Spot Making Sense,* Grand Arts,
Kansas City, Missouri

Club Media, XLVII Biennale di Venezia,
Venice, Italy

Sunshine & Noir, Single Channel Videos from
*Sampler Two—More Videos from Southern
California,* Louisiana Museum of Modern Art,
Humlebaek, Denmark (traveled to:
Kunstmuseum Wolfsburg, Germany; Castello
di Rivoli, Turin, Italy; UCLA at the Armand
Hammer Museum of Art, Los Angeles,
California)

*TRUCE: Echoes of Art in an Age of Endless
Conclusions* (performance with Micro
International), SITE Santa Fe, New Mexico

1996 *TRUE.BLISS.,* Los Angeles Contemporary
Exhibitions, California

Glow, New Langton Arts, San Francisco,
California

1995 *Heaven Is in the Back Seat of My Cadillac,*
N.A.M.E., Chicago, Illinois

1994 *Thanx Again,* FOOD HOUSE, Los Angeles,
California

New Voices 1994, Allen Memorial Art
Museum, Oberlin, Ohio

Photography and the Photographic, California
Museum of Photography, Riverside, California

Bad Girls West, UCLA Wight Gallery,
Los Angeles, California

SELECT BIBLIOGRAPHY

BOOKS AND CATALOGUES

1999 Peter Lunenfeld. *Snap to Grid.* Cambridge:
Leonardo/MIT Press.

Anne Morgan Spalter. *The Computer in the
Visual Arts.* Reading, Massachusetts: Addison
Wesley Longman, Inc., pp. 113–5.

Bruce W. Ferguson and Louis Grachos.
POSTMARK: An Abstract Effect. Santa Fe:
SITE Santa Fe (exhibition catalogue).

1998 David Hickey. *Ultralounge: The Return of
Social Space (with Cocktails).* Houston:
Diverseworks Artspace (exhibition catalogue).

1997 Francesco Bonami. *TRUCE: Echoes of Art in
an Age of Endless Conclusions.* Santa Fe:
SITE Santa Fe (exhibition catalogue).

Roxana Marcoci, Diana Murphy, and Eve
Sinaiko, eds. *New Art.* New York: Harry N.
Abrams, Inc., p. 130.

David Pagel. *Spot Making Sense.* Kansas City:
Grand Arts (exhibition brochure).

1996 *TRUE.BLISS.* Los Angeles: Los Angeles
Contemporary Exhibitions
(exhibition catalogue).

1995 Yvette Brackman. *Heaven Is in the Back Seat
of My Cadillac.* Chicago: N.A.M.E.
(exhibition brochure).

Marilu Knode. *Inney.* Huntington Beach:
Huntington Beach Art Center
(exhibition catalogue).

1994 Marcia Tucker, ed. *Bad Girls.* New York:
The New Museum of Contemporary Art;
Cambridge: MIT Press, p. 124
(exhibition catalogue).

ARTIST PUBLICATIONS

1993 Peter Lunenfeld, ed. "Frame-Work" (artist
pages). Los Angeles: Los Angeles Center for
Photographic Studies, vol. 3, issue 4, pp. 5–6.

Miyoshi Barosh, ed. "Now Time" (artist
pages). Los Angeles: A.R.T. Press, no. 3,
pp. 87–8.

ARTICLES AND REVIEWS

1999 David Pagel. "At Home on the Rainbow:
Jennifer Steinkamp's Sound-and-Light
Shows." *Art Issues,* Summer, p. 20.

1998 Bill Jones. "You Say You Want a Revolution."
ArtByte, April–May, pp. 10–1.

Holly Willis. "A Conversation with Jennifer
Steinkamp, Artist." *Artweek,* October, p. 16.

1997 Peter Lunenfeld. "Jennifer Steinkamp/Light in
Space." *Art/Text,* August–October, pp.
58–63.

1996 David A. Greene. "Jennifer Steinkamp."
Frieze, March, pp. 72–3.

Peter Lunenfeld. "Technofornia." *Flash Art,*
March, pp. 69–71.

Virginia Rutledge. "Jennifer Steinkamp at
ACME." *Art in America,* March, p. 106.

1995 Hunter Drohojowska-Philp. "Awash in a
Dance of Colors." *Los Angeles Times,*
November 19, pp. 67–9.

David Pagel. "High-Tech Abstractions."
Los Angeles Times, December 7, pp. F3, F6.

Roberta Smith. "Art in Review." *The New York
Times,* May 19, p. C28.

WEBSITE
http://www.jsteinkamp.com

Every room is the centre of the world. OCTAVIO PAZ

TERENCE RILEY

HETEROTOPIA: DISPLACING ARCHITECTURE

There are two aspects to an exhibition like *Wonderland* that I, as an architect and a curator, find very compelling. The first is, how do the practices involved in what we call installation art compare to those we refer to as architecture? Secondly, if we think of *Wonderland* as a series of individual spaces within a larger one, how does this differ from the traditional notion of a larger structure divided into smaller rooms? Or more specifically, how does such an exhibition differ from the more typical spatial experience of a museum wherein the larger structure is divided into individual galleries?

In his 1853 book, *The Stones of Venice,* the Englishman John Ruskin posed a rhetorical question, "What are the possible Virtues of Architecture?"[1] Answering his own question, Ruskin responded:

That it act well, and do the things it was intended to do in the best way.

That it speak well, and say the things it was intended to say in the best words.

That it look well, and please us by its presence, whatever it has to do or say.

One hundred and fifty years later, we can consider the extent to which Ruskin's qualifications for virtuous architecture have relevance for the subject at hand—installation art or, more specifically, installation environments. Despite their obvious differences, there does seem to be enough common ground between architecture and the works presented in *Wonderland* to speak of them in terms of Ruskin's definitions.

The first is the most objective of Ruskin's three tests and could certainly be applicable to either practice: Does the work do what it was planned to do? In other words, does it function well? In fact, this first qualification might be applied to many types of activities, artistic and otherwise.

Ruskin's second test, the notion that non-literary practices have an ability to "speak," is a little more thought provoking. Clearly, he is insisting that virtuous architecture would have been able to communicate the author's intended meaning. It is this presumption—that the work has meaning—that traditionally has been used, in Ruskin's time and our own, to differentiate between architecture and the more prosaic act of building. While this is an important way of theorizing architecture, it must be added that the works in *Wonderland* may equally, if not more so, be able to "speak well."

Like the first test, the third would seem to apply equally to both, if not all, artistic practices. While the pursuit of visual appeal in itself rarely produces significant work, it is equally difficult to think of meaningful works of art or architecture that do not have a remarkable and memorable aesthetic component.

As a way of thinking through Ruskin's tripartite criteria and contemporary artistic practices, we might also consider in which ways the former could be seen as intersecting. The Latin word for building is *aedes,* one of the root words of the term edifice and, by extension, edification. This last term—edification—not only subsumes the word for building but also has easily recognizable links to the function, the message, *and* the appearance of architecture as defined by Ruskin. Furthermore, this link creates an even stronger bond between architecture and the artistic practices evident in *Wonderland*.

To further examine the appropriateness of these comparisons, it might be useful to adopt a more skeptical attitude, at least momentarily. One has to ask whether it is really possible to compare installation art with architecture? Or is it rather that one can simply apply the same criteria of "virtuousness" even though they are fundamentally different activities?

The answer is a mixed one. To further understand their relative positions, it might be useful to consider installation art and the key *components* of architecture: structure, scale, form, spatiality, and function. The first of these—structure—certainly defines a gap between installation art and architecture, between the works in *Wonderland* and the architecture that houses them. While an installation might address issues of structure or rely on structural devices as a means of expression, installation art as we see it in *Wonderland* (with, perhaps, the exception of the work of Atelier van Lieshout) simply does not engage the range of structural issues which underlie any conception of architecture.

It might also be thought that architecture and installation art, at least those installation environments in *Wonderland*, might be separately defined by their disparities in scale. Yet, as John Summerson points out in his essay "Heavenly Mansions," the diminutive *aedicula* (Latin for "little building") has a long history in Western architecture. From shrines and wall paintings in ancient times to the pedimented or arched niches for statuary in Gothic or Classical architecture to the dollhouses and playhouses of childhood, the concept of small-scale architecture, Summerson says, "exercises a most powerful fascination. The 'little house' is a phrase which goes straight to the heart, whereas 'the big house' is reserved for the prison and the public assistance institution."[2] In other words, architecture has never been conceptually defined by its size and, in fact, structures much smaller than those presented in *Wonderland* have been considered to have the essential elements of architecture.

It is useful to reconsider the relationship between exterior form and interior space—the two interrelated but substantially different aspects of an architectural whole—in order to draw any meaningful parallels between architecture and installation art. While many contemporary artists—Ed Ruscha, Mary Miss, Oliver Boburg, among others—have demonstrated an interest in the exterior forms of architecture, the artists represented in *Wonderland*, for the most part, demonstrate a greater interest in the artistic potential of space rather than form. The difference might be described as the difference between the

objective interpretations that are historically associated with exterior architectural form and the subjective readings that are frequently associated with the interior space—a distinction which certainly correlates with the work in *Wonderland*. But, it might be asked, could these two aspects of architecture—exterior form and interior space—be reconstituted separately? Can Joel Shapiro's cast metal houses, for example, which have no interior spaces, be considered architecture on the basis of their form alone? Conversely, can interior spaces that have no external form, such as retail shops in a mall, be considered architecture simply because they provide enclosure?

It becomes clear that architecture cannot exist as form alone. Shapiro's houses represent architecture, but they don't purport to *be* architecture. In a similar way, architecture is represented in Giovanni Battista Moroni's *Full-Length Portrait of a Bearded Man in Black* by a background which includes a number of architectural details. In this work the artist provides the subject with an architectural backdrop to evoke the sense of the *gravitas* associated with architecture in Classical culture. Yet, even the most diminutive forms of the *aedicula*, whether it be a household shrine or a Pompeiian wall painting or tabernacle from the Della Robbia workshop, retain a recognizable space that can be tangible or illusion. While such a space may have been unable to accommodate an actual human being, the space is apparent nonetheless.

It becomes equally apparent that architecture *can* exist without an exterior expression. While this might seem counter-intuitive at first, one only needs to consider Michaelangelo's Medici Chapel in the Church of San Lorenzo, Florence (1519–34). Certainly, there is no relationship between the interior of this renowned space and its exterior forms. In fact, most people are not even aware of the chapel's exterior forms.

In short, it might be said that installation art as represented in *Wonderland* does indeed share some important affinities with architecture, affinities that provide new ways of understanding the art and the artists themselves. Still, other questions might be raised: why are so many artists working today drawn to a particular artistic activity that has, as a key feature, certain relationships to architecture?

One reason harks back to Ruskin's second criterion: that architecture is virtuous if it "speaks well." The notion that architecture might speak at all, it should be noted, was not an observation unique to Ruskin. The great medieval cathedrals were seen in their times as a kind of text, embodying in stone the totality of Catholic belief. Furthermore, the costliness, permanence, and monumentality of the cathedral created a virtual monopoly on the part of the Church with regards to the dissemination of information about the world. Interestingly, in Victor Hugo's great novel of 1831, *Notre Dame de Paris*, his character Froddo predicts, "The book will kill the edifice." Through Froddo, Hugo was expressing an evident fact of his age: the proliferation of the printed word offered the first challenge to architecture as the pre-eminent source of information. The ability to challenge architecture's monopoly on knowledge was due to its opposite characteristics: relatively low cost, portability, and serial production. Even so, in its structure and language, the book pays homage to architecture—the original "media event." Text is printed in "columns" and organized into "chapters"—a term with the same etymological roots as the word "capital"—

Design for the Frame of an Altarpiece (left),
anonymous, late 16th century. Collection Centre
Canadien d'Architecture/Canadian Centre for
Architecture, Montreal

Giovanni Battista Moroni, *Full-Length Portrait
of a Bearded Man in Black* (above), 1581.
Isabella Stewart Gardner Museum, Boston

the sculptural device at the top of an architectural column. More tellingly, a frontispiece is referred to as a *portada* in Spanish—a portal—and is frequently decorated with architectural motifs.

The term *speculus mundi* not only has been used to describe the medieval cathedral, but in translation—"mirror of the world"—the term captures much of the contemporary sense of the word "media." (In fact, the phrase incorporates two of the most popular words adopted as newspapers' titles.) Of course, to speak of the media as we do today would have made no sense to Hugo, although in *Wonderland* we can certainly see the efforts of artists to once again interweave information and space—to mediate space.

In contrast to the cathedral, which sought to convey a philosophically universal message, the messages conveyed through *Wonderland*'s installations reflect a contemporary emphasis on the importance of individual experience. Inevitably, this attitude makes an artist's installation more open to the idea of the subjective: the sensory, the emotive,

and the expressive. In this regard, the fact that most of *Wonderland*'s artists make installations that are essentially interiors rather than architectural forms is notable. The interior has a long history of associations with the subjective. In his essay, "Louis-Philippe, or the Interior," Walter Benjamin notes the changing relationships between the harshness of the increasingly industrialized exterior world and the inversely fantastic nature of contemporary interiors: "The private person who squares his accounts with reality in his office demands that the interior [of his living space] be maintained in his illusions."[3] The implicit rejection of the outer world noted by Benjamin was fraught with the contradictions within 19th-century bourgeois culture. In contemporary artistic practices, the same emphasis on the subjective nature of interior space might be said to underscore contradictions within our own culture.

An installation that is conceived as more of an object than a space might still be able to convey the same subjectivities. The impulse to draw a boundary around the work, to conceive it as a defined, inward-oriented space, has other interpretations that should be considered. Certainly, a number of the projects in *Wonderland* aspire to become totalizing experiences: a kind of rapture that is created by a completely idealized environment. This experience must be exclusionary as much as totalizing; the partitions that define the space not only capture the viewer in a unique environment, they also edit out random effects of the world outside it.

An undeniable part of this exclusion is a further assertion of the artist's voice in light of the contextualizing power of the museum. This attitude can be seen not only in the proliferation of the kind of installation art that we see in *Wonderland* but also in the establishment of museums by artists devoted to their own work. Gustave Courbet's creation of an alternative exhibition pavilion when one of his works was refused by the jury for the 1855 *Exposition Universelle* in Paris might be considered a precursor of this phenomenon, at least in spirit. Courbet was acting upon an anxiety that has affected artists throughout the centuries: How was their work to be seen? Who would decide the fate of a work of art?

Donald Judd's Minimalist installations of his sculptures in Marfa, Texas, is a more recent example of an artist retaining control over his work by providing the environment in which it is to be seen. In this instance, however, Judd not only determined what was to be seen, but how it was to be seen. The stark landscape of West Texas and the rough utilitarian structures of a former military installation were selected to provide a sympathetic environment for his Minimalist sculptures, which in certain instances seem to blur the distinctions between architecture and works of art. In another example, Co-op Himmel(blau)'s unbuilt design for a living, working, and exhibition compound for Anselm Kiefer, named Werkstadt, similarly promises an idealized environment for the creation and display of the artist's work.

Again, there appear to be crossover influences that can be seen between artists' installations and the artists' museums. To the extent that neither lends itself to the juxtapositions, narrational continuums, and chronological sequencing that typify many curatorial practices, both can be interpreted as attempts to resist museological contextualization. Equally, both can be interpreted as further examples of contemporary culture's

particular emphasis on personal experience and expression rather than universal themes or authoritative interpretations.

Like artists' museums, the museums that are dedicated to private collections, such as the Isabella Stewart Gardner Museum in Boston, achieve a similar level of subjective expression. Named for its founder, the Museum was actually Mrs. Gardner's home, which she named Fenway Court, and the works of art within it were all collected during her far-flung travels. As such, the Museum first and foremost represents a personal story, and it privileges personal experience over canonical thought, gnosis over orthodoxy: a grandly scaled architectural scrapbook or charm bracelet. As autobiography, it is inventive and self-confident. (Gardner's decision to use the liturgical vestments she collected as backgrounds on which to hang paintings and otherwise as decorative wall hangings was then and remains now a singular notion.) The motto she inscribed over the entryway was "C'est mon plaisir." This attitude is quite different from many of the "City Beautiful" museums, such as The Saint Louis Art Museum, which were built in the late 19th and early 20th centuries throughout America and conceived as authoritative repositories of artistic treasures. Virtually all designed in the neo-Classical style and patterned after palaces, villas, and other historical precedents, these institutions aspired to be canonical bastions of cultural expression. Their purpose can be seen in the roll call of the Western "greats" that populated the collections and, frequently, was chiseled into their facades.

In terms of their personal subjectivity, Mrs. Gardner's installations often rival contemporary artists' installations. John Singer Sargent's *Jaleo*, a large portrayal of a flamenco dancer in swirling mid-step, rendered in a sensual, smoky manner, is set under a fantastic scalloped Moorish archway at the end of a gallery filled with architectural elements from the Spanish Pyrenees. Her approach to installation, here and elsewhere, was meant to evoke a kind of artistic reverie more than detached academic study. It was based on the notion of the direct sensuous comprehension of the work of art.

The fact that most of the art collected by Mrs. Gardner pre-dates the 20th century does not mean that her non-analytical method has no relevance for the modern mind. Indeed, it is interesting to compare her installation methods with Sergei Eisenstein's description of his directing technique. Citing the Grand Guignol, Kabuki, and Chaplin films, Eisenstein outlined the concept of a "montage of attractions" that had to do with "aggressive" movements, such as a cannon fired over the head of the audience. In his own words, the "montage of attractions," (*montazh attraksionov*) consisted of actions "that bring to light in the spectator those senses or that psychology that influence his experience—every element that can be verified and mathematically calculated to produce certain emotional shocks in a proper order within the totality—the only means by which it is possible to make the final ideological conclusion perceptible."[4]

If Mrs. Gardner's museum represents a more subjective, even theatrical, statement, as opposed to the universalizing aspirations of its larger metropolitan counterparts, it is not the first or the last museum of this type. Until the Enlightenment, art collections were the prerogative of the aristocracy, and their purpose was unabashedly one of personal pleasure. While more recent private collections, such as those housed in Fenway Court,

View of the Spanish Cloister in the Isabella Stewart Gardner Museum, Boston. Photo by David Bohl

The Morgan Library, the Barnes Collection, and the Menil Collection, aspire to a more public purpose—that is education—all of them retain the personal stamp of their collectors/ founders. Furthermore, the role of the collector in establishing museums and the number of "private galleries" founded to house and display personal collections seem to be increasing.

At various times and for various reasons, the subjective and even sensuous approach described above has been characterized as the inverse of the rational and the analytical. It may be that the dialectic nature of Western thought is such that it constantly reformulates itself along such seemingly irreconcilable axes. Again, reference to Summerson's

writings provides a thoughtful analogy. As he points out in his elegant essay, "Antitheses of the Quattrocento," the "Hypnerotomachia Poliphili," a 15th-century poem by Francesco Colonna, is a poetically evocative reverie that conjures up the world of Classical culture as a dream. He compares this work with *Re de aedificatoria*, Leon Battista Alberti's 1450 treatise on Classical architecture, which attempts to revive Classical architecture by sheer intellect, by conscientiously studying and emulating the extant Classical monuments as well as texts of Vitruvius.

Summerson does not see the two attitudes as mutually exclusive. Of Alberti and Colonna he writes: "But there they stand, at the gateway to the Renaissance, the two opposite principles contained in that, as, I suppose, in all great historic movements. Alberti, the man of rules, insistent on the concrete, the absolute, the present. Colonna, the dreamer, never formulating, but only discovering and recording the Golden Past, refracted in his own imagination."[5]

Even though all the works in *Wonderland* are by definition subjective spaces, it is possible to read through them various expressions of these axes. Certainly Ernesto Neto's installations make a direct appeal to the senses. Highly tactile and visually seductive, Neto's projects even include spices to incite the olfactory nerves. Neto's work, like the "Hypnerotomachia Poliphili," provokes the senses in order to reveal its meanings. Drawing Summerson's duality to its obvious conclusion, Teresita Fernández's *Landscape (Projected)* of 1997 might be seen as the more cerebral side of the same coin. Rather than immediately appealing to the senses, Fernández invites us to consider her work from a more rational perspective. The molding that snakes along the floor invites various interpretations: A metric device that allows the visitor to size up the space? A way of knitting two sides of the space together? A way of *separating* the same two sides? Light comes into the space from an oculus. Its placement suggests a kind of revelation, recalling the root meanings of such words as illumination or clarity.

No less than the objective/subjective axis, the dialectic between the artificial (or the manmade) and the natural has been a powerful tool in organizing major aspects of Western thought. The central courtyard, such as that of the Gardner Museum, represents a type of spatial arrangement commonplace not only in Western architecture but worldwide. It is, in fact, so commonplace that we often forget that it is essentially an attempt to "install" a part of—or even an idealization of—the natural environment within the house.

Among the artists included in *Wonderland*, Bill Klaila's and Olafur Eliasson's efforts to import aspects of nature into the closed environment of the museum can be seen as analogous to what was once a very common element of traditional architecture. The ubiquity of the courtyard has much to do with its ability to ventilate, heat, and cool a traditional structure; however, function alone does not explain the high degree of artistic development it enjoyed throughout history. For example, the cloisters of monastic and other religious structures have been interpreted to be visions of paradise. In similar ways, the courtyard rock garden at Ryoanji is intended to represent a microcosm of a vast landscape, and the atrium court at the Casa dei Veti in Pompeii was planted with not only herbs for cooking but fragrant flowers and plants to enhance the atmosphere of the adjacent rooms.

The artificial/natural and the objective/subjective axes can be readily identified with certain points in history for which they had tremendous relevance. Relatively new, the real/virtual dialectic has recently entered contemporary consciousness. The work of various artists in *Wonderland* achieves an equally new level of complexity when the "virtual" installation becomes embedded within the "real" architecture. In his essay, "The Thing," the German philosopher Martin Heidegger worried about the collapse of traditional notions of time and space in the presence of broadcast media: "Everything gets lumped together into uniform distancelessness. How? Is not the merging of everything into the distanceless more unearthly than everything bursting apart?"[6] What Heidegger could not have imagined at the time that he committed these words to paper is that "distanceless-ness" would become a commonplace and, even, a strategy for artistic practices.

We must raise yet another issue posed by an exhibition like *Wonderland,* as has been noted at the outset of this essay. We are all familiar with architecture that has different functional spaces within a single spatial envelope. In a typical museum, it is not unusual to encounter galleries for looking at art, restaurants for eating, and offices for working, etc. The model presented in *Wonderland,* however, does not propose to arrange different objective functions in a spatial organization but different subjective experiences. In other words, *Wonderland* presents a much more complex spatial model wherein multiple, individually conceived environments co-exist in various states of tension—with each other *and* within a larger architectural superstructure. In effect, *Wonderland* within The Saint Louis Art Museum constitutes a heterotopia—that is, a place of many places—rather than a *gesamtkunstwerk*—literally, a total work of art wherein all elements are governed by a single esthetic and philosophical point of view.

Despite the neologism, heterotopias already exist and, in a popular way, are very familiar. After all, a shopping mall is a large architectural volume with any number of individual themed environments within it. More to the point, however, is the intellectual rigor that is being brought to the concept by such contemporary architects as Bernard Tschumi and Rem Koolhaas. In Tschumi's Le Fresnoy Media Center, the architectural scheme interweaves old and new construction and then covers the entire complex with a new single roof struc-ture. Walking through the school, a visitor constantly shifts between pre-existing and new environments, much like a jump cut or a flashback in a film. In Koolhaas's entry for the Bibliothèque Nationale de France, the overall structure serves as a neutral container—a big box—for the heterogeneous spaces within. Neither of these projects aspires to the archi-tectural continuity, spatial or ideological, associated with traditional architecture. They do, however, address the restless intellectual wandering of modern life, and in their own ways reflect Eisenstein's notion of a "montage of attractions."

The Gardner Museum might be considered in the same way. In its proportions, its plan, and its principal architectural elements, the Museum resembles an Italian palazzo. Even so, it's an Italian palazzo except when it's not. Inside, a northern European medieval hall opens onto a stair hall borrowed from a French chateau; a contemporary Neoclassical drawing room is connected to a Spanish chapel by a Romanesque cloister; and so on.

Bernard Tschumi, Le Fresnoy National Center for Contemporary Arts, computer image. Courtesy Bernard Tschumi Architects

Like Mrs. Gardner's museum or the work of many contemporary architects, *Wonderland* is neither spatially nor ideologically seamless nor necessarily consistent: it is a place of unreconciled tensions, of "distancelessness," to use Heidegger's term. Yet, it is not a game of smoke and mirrors but a conceptual model that attempts to balance out the rational with the emotional. Like Ruskin's second test, the works in *Wonderland* "speak well," but as a montage of attractions the works speak to the senses as much as, if not more than, the mind. The lessons to be drawn from *Wonderland* suggest that seamlessness is not necessarily the appropriate expression for contemporary culture. Rather, it argues for heterotopicity, with all its discontinuities. Like Summerson's "Antitheses," *Wonderland* embodies the forces that drive our culture and does so in more complex patterns than standard histories and traditional museums can typically accommodate.

Rem Koolhaas–O.M.A. Bibliothèque Nationale de France, Paris. Competition proposal, 1989. Courtesy Office for Metropolitan Architecture, Rotterdam

NOTES

1 John Ruskin, *The Stones of Venice* (London: Smith, Elder, and Co., 1851-53).

2 John Summerson, "Heavenly Mansions," *Heavenly Mansions and Other Essays on Architecture* (New York: W. W. Norton & Co., 1998), p. 2.

3 Walter Benjamin, *Reflections: Essays, Aphorisms, Autobiographical Writings*, ed. Peter Demetz, trans. Edmund Jephcott (New York: Schocken Books, 1978), p. 154.

4 Sergei M. Eisenstein, "Montage of Attractions," *The Film Sense*, ed. and trans. Jay Leyda (New York: Harcourt, Brace and Company, 1942), pp. 229–30. This essay is an appendix in Leyda's translation and edition of Eisenstein's *The Film Sense*. It was first published in the magazine *Lef* in 1923.

5 John Summerson, "Antitheses of the Quattrocento," *Heavenly Mansions and Other Essays on Architecture*, p. 50.

6 Martin Heidegger, "The Thing," *Poetry, Language, Thought,* trans. and intro. Albert Hofstader (New York: Harper and Row, 1971), p. 166.

True wars are not waged over people or fatherlands, but rather between various media, communications technologies, and data streams. FRIEDRICH A. KITTLER

BEATRIZ COLOMINA

ENCLOSED BY IMAGES: THE EAMESES' MULTISCREEN ARCHITECTURE

INFORMATION OVERLOAD

We are surrounded today, everywhere, all the time, by arrays of multiple, simultaneous images. In the streets, airports, shopping centers, and gyms, but also on our computers and television sets. The idea of a single image commanding our attention has faded away. It seems as if we need to be distracted in order to concentrate. As if we—all of us living in this new kind of space, the space of information—could be diagnosed en masse with Attention Deficit Disorder. The state of distraction in the metropolis described so eloquently by Walter Benjamin at the beginning of the 20th century seems to have been replaced by a new form of distraction, which is to say a new form of attention. Rather than wandering cinematically through the city, we now look in one direction and see many juxtaposed moving images, more than we can possibly synthesize or reduce to a single impression. We sit in front of our computers on our ergonomically perfected chairs, staring with a fixed gaze at five simultaneously "open" windows through which different kinds of information stream towards us. We hardly even notice it. It seems natural, as if we were simply breathing in the information.

How would one go about writing a history of this form of perception? Should one go back to the organization of television studios, with their walls of monitors from which the director chooses the camera angle that will be presented to the viewer; or should one go to Cape Canaveral and look at its Mission Control room; or should one even go back to World War II, when so-called Situation Rooms were envisioned with multiple projections bringing information from all over the world and presenting it side by side for instant analysis of the situation by leaders and military commanders?

It is not simply the military or war technology that has defined this new form of perception. Designers, architects, and artists were involved from the beginning, playing a crucial role in the evolution of the multiscreen and multimedia techniques for presenting information. While artists' use of these techniques tends to be associated with the Happenings of the 1960s, artists were involved much earlier and in very different contexts, such as military operations and governmental propaganda campaigns.

Life magazine cover, August 10, 1959.
Life Magazine ©Time Inc.; ©Corbis

Kitchen Debate between Nikita Khrushchev and Richard Nixon in front of American kitchen, July 24, 1959.
Photo courtesy AP Wide World Photos

A key example is the 1959 American exhibition in Moscow, where the government enlisted some of the country's most sophisticated designers. Site of the famous Kitchen Debate between Richard Nixon and Nikita Khrushchev, the American exhibition was a Cold War operation in which the Eameses' multiscreen technique turned out to be a powerful weapon.

To reconstruct a little bit of the atmosphere: The USA and USSR had agreed in 1958 to exchange national exhibits on "science, technology and culture." The Soviet exhibition opened in the New York Coliseum at Columbus Circle in New York City in June of 1959, and the American exhibition opened in Sokolniki Park in Moscow in July of the same year. Vice President Nixon, in Moscow to open the exhibition, engaged in a heated debate with Khrushchev over the virtues of the American way of life. The exchange became known as the Kitchen Debate because it took place—in an event that appeared impromptu but was actually staged by the Americans—in the kitchen of a suburban house split in half to allow easy viewing. The Russians called the house "the Splitnik," a pun on the Sputnik, the satellite the Soviets had put into orbit two years before.

What was remarkable about this debate was the focus. As historian Elaine Tyler-May has noted, instead of discussing "missiles, bombs, or even modes of government . . . [the two leaders] argued over the relative merits of American and Soviet washing machines, televisions, and electric ranges."[1] For Nixon, the American superiority rested on the ideal of the suburban home, complete with modern appliances and distinct gender roles. He proclaimed that this "model" suburban home represented nothing less than American freedom:

To us, diversity, the right to choose, is the most important thing. . . . We don't have one decision made at the top by one government official. . . . We have many different manufacturers and many different kinds of washing machines so that the housewife has a choice.[2]

The American exhibition in Moscow captivated the national and international media. Newspapers, illustrated magazines, and television networks reported on the event. Symptomatically, *Life* magazine put the wives instead of the politicians on the cover. Pat Nixon appears as the prototype of the American woman depicted in advertisements of the 1950s: slim, well-groomed, fashionable, happy. In contrast, the Soviet ladies appear stocky, dowdy, and unfashionable, and while two of them, Mrs. Khrushchev and Mrs. Mikoyan, look proudly towards the camera, the third one, Mrs. Kozlov, in what Roland Barthes may have seen as the "punctum" of this photograph, can't keep her eyes off Pat Nixon's dress.[3]

Envy, that is what the American exhibition seems to have been designed to produce (despite vigorous denials by Nixon in his debate with Khrushchev: "We do not claim to astonish the Soviet people"[4]). Not envy of scientific, military, or industrial achievements. Envy of washing machines, dishwashers, color televisions, suburban houses, lawn mowers, supermarkets stocked full of groceries, Cadillac convertibles, make-up colors, lipstick, spike-heeled shoes, hi-fi sets, cake mixes, TV dinners, Pepsi-Cola, and so on. "What is this," the newspaper *Izvestia* asked itself in its news report, "a national exhibit of a great country or a branch department store? Where is American science, American industry, and particularly their factory techniques?"[5] And a Russian teacher is quoted by the *Wall Street Journal*: "You have lots of dolls, furniture, dishes, but where are your technical exhibits?"[6] Even American newspapers described the main pavilion of the exhibition as a "lush bargain basement," but one that, due to the dust of a crumbling concrete floor, forty-eight hours after the opening, already looked as if it "had barely survived a fire sale."[7]

Already in 1936, George Nelson, in charge of the design of the overall exhibition in Moscow, had written about the changing role of fairs and expositions, displaced by department stores:

> Today our market is permanent, and the commodity fair [has] given way to the department store. . . . The days of representing Montana with a stuffed cow, or Florida with a bungalow constructed of oranges, have passed. . . . At the Crystal Palace the public was so fascinated by the exhibits that no thought was given to the amusements. Today no fair dares open without the support of a Midway. . . . Man's capacity for wonder is undiminished, but, finding little to wonder at, he makes for the roller coaster.[8]

Why then turn the American exhibition in Moscow into a "branch department store"? Precisely because the Soviets had not achieved the same level of consumer goods. Despite criticism by the press, the exhibition was tremendously successful with the public, who said their interest in the exhibition was that they were seeing the future—where they might themselves be in ten years. In that sense, the role of the exhibition was similar to that of a traditional fair.

It was for this context that Ray and Charles Eames produced their film, *Glimpses of the USA*, projecting it onto seven 20 by 30-foot screens suspended within a vast (250-foot

diameter) golden geodesic dome designed by Buckminster Fuller. More than 2,200 still and moving images (some from Billy Wilder's *Some Like It Hot*) presented "a typical work day" in the life of the United States in nine minutes and "a typical weekend day" in three minutes.[9] Thousands and thousands of images were pulled from many different sources, including photo archives (such as Magnum Photos, Photo Researchers, and the magazines *Fortune, Holiday, Life, Look, The Saturday Evening Post, Sports Illustrated, Sunset,* and *Time*), individual photographers (such as Ferenc Berko, Julius Shulman, Ezra Stoller, Ernst Braun and George Zimbel, and Charles Eames), and friends and associates of the Eameses (including Eliot Noyes, George Nelson, Alexander Girard, Eero Saarinen, Billy Wilder, Don Albinson, and Robert Staples).[10] The images were combined into seven separate film reels and projected simultaneously through seven interlocked projectors. Fuller later said that nobody had done anything like this before and that advertisers and filmmakers would soon follow.[11]

The Eameses did not simply install their film in Fuller's space. They were involved in the organization of the whole exhibition from the beginning. George Nelson, who had been commissioned by the United States Information Agency (USIA) to design the exhibition, and Jack Massey from the USIA brought them into the team. According to Nelson, it was precisely in an evening meeting in the Eameses' house in Los Angeles, culminating three days of discussions, where "all the basic decisions for the fair were made. Present were Nelson, Ray and Charles (the latter occasionally swooping past on a swing hung from the ceiling), the movie director Billy Wilder, and Massey."[12] By the end of the evening a basic scheme had emerged:

A dome (by Buckminster Fuller)

A glass pavilion (by Welton Beckett) "as a kind of bazaar stuffed full of things, idea being that consumer products represented one of the areas in which we were most effective, as well as one in which the Russians . . . were more interested."

An introductory film by the Eameses, since the team felt that the "80,000 square feet of exhibition space was not enough to communicate more than a small fraction of what we wanted to say."[13]

In addition, the USIA had already contracted for the inclusion of Disney's "Circarama," a 360-degree motion picture that offered a 20-minute tour of American cities and tourist attractions and played to about 1,000 Russians an hour;[14] an architecture exhibit curated by Peter Blake; a fashion show curated by Eleanor Lambert; a packaging exhibition by The Museum of Modern Art's Associate Curator of Design, Mildred Constantine; and Edward Steichen's famous photographic exhibit "The Family of Man."[15] The American exhibition also included a full-scale ranch-style suburban house, put up by a Long Island builder and furnished by Macy's. It was in the kitchen of this $14,000, six-room house filled with appliances that the Kitchen Debate began with an argument over automatic washers.

The multiscreen performance turned out to be one of the most popular exhibits at the fair (second only to cars and color televisions).[16] *Time* magazine called it the "smash hit of the Fair,"[17] *The Wall Street Journal* described it as the "real bomb shell" exploding, and U.S. officials believed this was "the real pile-driver of the fair."[18] Groups of 5,000 people

were brought in the dome every 45 minutes, 16 times day, for the duration of the fair.[19] Close to three million people saw the show; traffic was so heavy that the floor had to be resurfaced three or four times during the six-week exhibition.[20]

The Eameses were not just popular entertainers in an official exhibition. *Glimpses of the USA* was not just a film in a movie theater. It was not just images inside a dome. The huge array of suspended screens defined a space, a space within a space. The Eameses were self-consciously architects of a new kind of space. This was not a classical space. The screens were not like murals suspended in a church. The film breaks with the fixed perspectival view of the world. In fact, we find ourselves in a space that can only be apprehended with the telescopes, zoom lenses, aeroplanes, and night-vision cameras of high technology, and where there is no privileged point of view. It is not simply that many of the individual images that make up *Glimpses* have been taken with these instruments. More importantly, the relationship between the images re-enacts the operation of the technologies.

The film starts with images from outer space on all the screens: stars across the sky, seven constellations, seven star clusters, nebulae, etc., then moves through aerial views of the city at night, from higher up to closer in, until city lights from the air fill the screens. The early morning comes with aerial views of landscapes from different parts of the country: deserts, mountains, hills, seas, farms, suburban developments, urban neighborhoods. When the camera eyes finally descend to the ground, we see close-ups of newspapers and milk bottles at doors. But still no people, only traces of their existence on earth.

Not by chance, the first signs of human life are centered around the house and domestic space. From the stars at night and the aerial views, the cameras zoom to the most intimate scenes: people having breakfast at home, men leaving for work, kissing their wives, kissing the baby, being given lunchboxes, getting into cars, waving goodbye, children leaving for school, being given lunchboxes, saying goodbye to dog, piling into station wagons and cars, getting into school buses, baby crying.

As with the Eameses' later and much better known film, *Powers of Ten* (1968)[21], which incidentally re-used images of night sky from *Glimpses of the USA*,[22] the film moves from outer space to the close-up details of everyday life. As the working script of the film indicates, the close-ups are: "last sips of coffee" of men before leaving for work, "children washing hands before dinner," "housewives on the phone with clerks (supermarket food shelves in b.g.),"[23] and so on. In *Powers of Ten,* the movement is set in reverse, from the domestic space of a picnic spread with a man sleeping beside a woman in a park in Chicago out into the atmosphere, and then back down inside the body through the skin of the man's wrist to microscopic cells and ultimately to the atomic level. Even if *Powers of Ten*, initially produced for the Commission on College Physics, is a more scientific, more advanced film in which space is measured in seconds, the logic of *Glimpses* and *Powers of Ten* is the same. Intimate domesticity is suspended within an entirely new spatial system—a system that was the product of esoteric scientific-military research but had entered the everyday public imagination with the launching of the Sputnik in 1957. Fantasies that had long circulated in science fiction had become reality. This shift from research and fantasy to tangible fact made new forms of communicating to a mass audience possible.[24] The Eameses'

innovative technique did not simply present the audience with a new way of seeing things. Rather it gave form to the new mode of perception that was already in everybody's mind.

Glimpses breaks with the linear narrative of film to bring snippets of information, an ever-changing mosaic image of American life. And yet the message of the film is linear and eerily consistent with the official message represented by the Kitchen Debates. From the stars in the sky at the beginning of the film—which the narrative insists are the same in the Soviet Union as in the USA—to people kissing goodnight, and forget-me-not flowers in the last image, the film emphasized universal emotions,[25] while at the same time it unambiguously reinforced the material abundance of one country. From the parking lots of factories, which the narrative describes as filled with the cars of the workers, to the aerial views of suburban houses with a blue swimming pool in each one of them, to the close-ups of shopping carts and shelves full of goodies in supermarkets, and housewives cooking dinner in kitchens equipped with every imaginable appliance, the message of the film is clear: we are the same, but on the material level we have more.

Glimpses, like the "Splitnik" where the Kitchen Debate took place, displaced the USA-USSR debate from the arms and the space race to the battle of the appliance. And yet the overall effect of the film is that of an extraordinarily powerful viewing technology, a hyper-viewing mechanism, which is hard to imagine outside the very space program the exhibition was trying to downplay. In fact, this extreme mode of viewing goes beyond the old fantasy of the eye in the sky. If *Glimpses* simulates the operation of satellite surveillance, it exposes more than the details of life in the streets. It penetrates the most intimate spaces and reveals every secret. Domestic life itself becomes the target, the source of pride or insecurity. The Americans, made insecure by the thought of a Russian eye looking down on them, countered by exposing more than that eye could ever see (or at least pretending to, since "a day in the life of the USA" became an image of the "good life" without ghettos, poverty, domestic violence, depression, etc.)

Glimpses simply intensified an existing mode of perception. In fact, it synthesized several already existing modes, manifest in television, space programs, and military operations. As is typical of all the Eameses' work, it was the simplicity and clarity of this synthesis that made it immediately accessible to all.[26]

ART X

What kind of genealogy can one make of the Eameses' development of this astonishingly successful technique? It was not the first time they had deployed multiscreens. In fact, the Eameses were involved in one of the first multimedia presentations on record, if not the first. Again, it was George Nelson who set up the commission. In 1952 he had been asked to make a study for the Department of Fine Arts at the University of Georgia in Athens, and he brought along Ray and Charles Eames and Alexander Girard. Instead of writing a report, they decided to collaborate on a "show for a typical class" of 55 minutes. Nelson referred to it as "Art X" while the Eameses called it "A Rough Sketch for a Sample Lesson for a Hypothetical Course." The subject of the lesson was "Communications,"[27] and the stated goals included "the breaking down of barriers between fields of learning . . . making people

A sequence of three-image passes selected from the Eameses' slide show *Circus*. Courtesy Eames Office © 2000 Lucia Eames dba Eames Office (www.eamesoffice.com)

a little more intuitive . . . [and] increasing communication between people and things."[28] The performance included a live narrator, multiple images (still and moving pictures), and even smells and sounds (music and narration). Charles later said: "We used a lot of sound, sometimes carried to a very high volume so you would actually feel the vibrations."[29] The idea was to produce an intense sensory environment so as to "heighten awareness." The effect was so convincing that apparently some people smelled things even when no smells were introduced, only a suggestion in an image or a sound (for example the smell of oil in the machinery).[30]

It was a major production. Nelson described the team arriving in Athens "burdened with only slightly less equipment than Ringling Brothers. This included a movie projector, three slide projectors, three screens, three or four tape recorders, cans of films, boxes of slides, and reels of magnetic tape. Girard brought a collection of bottled synthetic odors that were to be fed into the auditorium during the show through the air-conditioning ducts."[31]

The reference to the circus was not accidental. Talking to a reporter for *Vogue* magazine, Charles later argued that "'Sample Lesson' was a blast on all senses, a super-saturated three-ring circus. Simultaneously the students were assaulted by three sets of slides, two tape recorders, a motion picture with sound, and peripheral panels for further distraction."[32]

The circus was one of the Eameses' lifelong fascinations[33]—so much so that in the forties, when they were out of work and money, they were about to audition for parts at the circus. They would have been clowns, but ultimately a contract to make plywood furniture allowed them to continue as designers. And from the mid-1940s on, they took hundreds and hundreds of photographs of the circus which they used in many contexts, including *Circus,* a 180-slide, three-screen slide show accompanied by a soundtrack featuring circus music that was presented as part of the Eliot Norton lectures at Harvard University which Charles delivered in 1970, and the film *Clown Face* (1971), a training film about "the precise and classical art of applying makeup" made for Bill Ballentine, director of the Clown College of Ringling Brothers and Barnum & Bailey Circus. The Eameses had been friends with the Ballentines since the late forties when they had photographed the behind-the-scenes activities of the circus during an engagement in Los Angeles.[34] Charles was on the board of the Ringling Brothers College and often referred to the circus as an example of what design and art should be, not self-expression but precise discipline:

> Everything in the circus is pushing the possible beyond the limit—bears do not really ride on bicycles, people do not really execute three and a half turn somersaults in the air from a board to a ball, and until recently, no one dressed the way fliers do. . . . Yet within this apparent freewheeling license, we find a discipline which is almost unbelievable. . . . The circus may look like the epitome of pleasure, but the person flying on a high wire, or executing a balancing act, or being shot from a cannon must take his pleasure very, very seriously. In the same vein, the scientist, in his laboratory, is pushing the possible beyond the limit and he too must take his pleasure very seriously.[35]

As an event that offers a multiplicity of simultaneous experiences that cannot be taken in entirely by the viewer, the circus was the Eameses' model for their design of multimedia

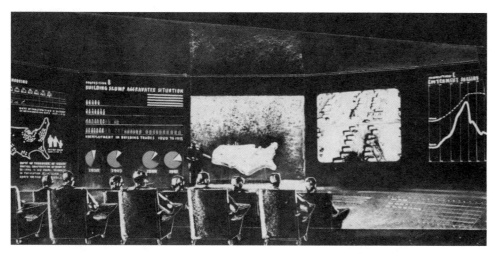

Presidential War Situation Room as envisioned by the Visual Presentation Branch. Office of Strategic Services R[ecord] G[roup] 226, U.S. National Archives and Record Administration

exhibitions and the fast-cutting technique of their films and slide shows.[36] The objective was always to communicate the maximum amount of information in a way that was both pleasurable and effective.

But the technological model for multiscreen, multimedia presentations may have been provided by the War Situation Room, which was designed in those same years to bring information in simultaneously from numerous sources around the world so that the president and military commanders could make decisions. It is not without irony, in that sense, that the Eameses read the organization of the circus as a form of crisis control. In a circus, Charles said, "there is a strict hierarchy of events, and an elimination of choice under stress, so that one event can automatically follow another. . . . There is a recognized mission for everyone involved. In a crisis there can be no question as to what needs to be done."[37] A number of the Eameses' friends were involved in the secret military project of the War Rooms—including Buckminster Fuller, Eero Saarinen, and Henry Dreyfuss, whose unrealized design involved a wall of parallel projected images of different kinds of information.[38] It is not clear that the Eameses knew anything about the project during the war years, but it is very likely, given their friendship with Fuller, Saarinen, and Dreyfuss, that they would have found out after the war. In the 1970s, in the context of his second Eliot Norton Lecture at Harvard University, Charles referred to the War Rooms as a model for city management:

> In the management of a city, linear discourse certainly can't cope. We imagine a City Room or a World Health Room (rather like a War Room) where all the information from satellite monitors and other sources could be monitored (Fuller's World Game is an example). . . . The city problem involves conflicting interest and points of view. So the place where information is correlated also has to be a place where each group can try out plans for its own changing needs.[39]

The overall theme of the Norton Lectures was announced as "Problems Relating to Visual Communication and the Visual Environment," and a consistent theme was the "neces-

sity to devise visual models for matters of practical concern where linear description isn't enough." Kepes's *Language of Vision* was a constant reference point for the Eameses. The "language of vision" was seen as a "real threat to the discontinuity" (between the arts, between university departments, between art and everyday life, etc.) that the Eameses were always fighting.[40] Architecture, "a most non-discontinuous art," was seen as both the ultimate model for discontinuity and the place where the new technologies should be implemented. They thought of architecture and city planning as forms of war. If the great heroes of the Renaissance were, for the Eameses, "people concerned with ways of modelling/imaging, . . . not with self-expression or bravura. . . Brunelleschi, but not Michelangelo,"[41] the great architects of our time would be the ones concerned with the new forms of communication, particularly computers:

> It appeared to us that the real current problems for architects now—the problems that a Brunelleschi, say, would gravitate to—are problems of *organization of information*. For city planning, for regional planning, the first need is clear, accessible models of current states-of-affairs, drawn from a data base that only a computer can handle for you.[42]

A number of wartime research projects, including work on communication, ballistics, and experimental computers, had quickly developed after the war into a full-fledged theory of information flow, most famously with the publication in 1949 of Claude Shannon's *The Mathematical Theory of Communication*, which formalized the idea of an information channel from sender to recipient whose efficiency could be measured in terms of speed and noise. This sense of information flow organized the Eameses' "Sample Lesson" performance. They said: "we were trying to cram into a short time, a class hour, the most background material possible."[43] As part of the project, the Eameses produced *A Communication Primer,* a film that presents the theory of information, explaining Shannon's famous diagram of the passage of information. The film was subsequently refined and completed in an effort to present current ideas in communication theory to architects and planners, and to encourage them to use these ideas in their work. The basic idea was to integrate architecture and information flow.[44]

The Eameses further developed the logic of information flow in their 1955 film *House: After Five Years of Living*. The film was made entirely with thousands of color slides the Eameses had been taking of their house over its first five years of life.[45] The images are shown in quick succession and accompanied with music by Elmer Bernstein. As Michael Braune wrote in 1966:

> The interesting point about this method of film making is not only that it is relatively simple to produce and that rather more information can be conveyed than when there is movement on the screen, but that it corresponds surprisingly closely with the way in which the brain normally records the images it receives. I would assume that it also corresponds rather closely with the way the Eames's own thought processes tend to work. . . . Computers, an interest of the Eames, also separate information in components before assembling it.[46]

The technique developed even further in *Glimpses,* which is organized around a strict logic of information transmission. The role of the designer is to design a particular flow of infor-

Charles Eames, details of the Eames House and studio from 1949 to 1978. Courtesy Eames Office
© 2000 Lucia Eames dba Eames Office (www.eamesoffice.com)

mation. The central principle is one of compression. At the end of the first design meetings in preparation for the American exhibition in Moscow, the idea of the film emerged precisely "as a way of compressing into a small volume the tremendous quantity of information" they wanted to present and that would have been impossible to do in the 80,000 square feet of the exhibition.[47] The space of the multiscreen film, like the space of the computer, compresses physical space. Each screen shows a different scene, but all seven at each moment are on the same general subject—housing, transportation, jazz, and so forth. As *The New York Times* described it:

> Perhaps fifty clover-leaf highway intersections are shown in just a few seconds. So are dozens of housing projects, bridges, skyscrapers scenes, supermarkets, universities, museums, theatres, churches, farms, laboratories and much more.[48]

According to the Eameses, repetition was done for credibility. They said: "if, for example, we were to show a freeway interchange, somebody would look at it and say, 'We have one at Smolensk and one at Minsk; we have two, they have one'—that kind of thing. So we conceived the idea of having the imagery come on in multiple forms, as in the 'Rough Sketch for a Sample Lesson.'"[49] But the issue was much more than one of efficiency of commu-

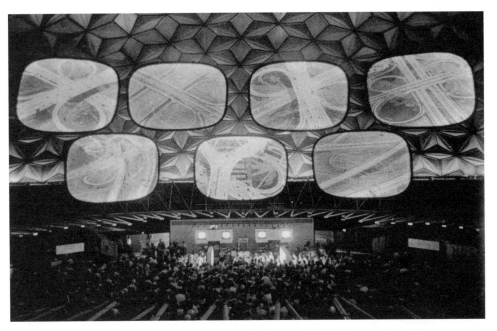

View of the Moscow Fair auditorium showing the seven screens for *Glimpses of the U.S.A.* Courtesy Eames Office
© 2000 Lucia Eames dba Eames Office (www.eamesoffice.com)

nication or the polemical need to have multiple examples. The idea was, as with the Lesson, to produce sensory overload. As the Eameses suggested to *Vogue,* "Sample Lesson" tried to provide many forms of "distraction," instead of asking students to concentrate on a singular message.[50] The audience drifts through a multimedia space that exceeds their capacity to absorb it. The Eames/Nelson team thought that the most important thing to communicate to undergraduates was a sense of the relationships between things, what the Eameses would later call "Connections." Nelson and the Eameses argued that this awareness of relationships between seemingly unrelated phenomena is achieved by "high-speed techniques." They produced an excessive input from different directions that had to be synthesized by the audience. Likewise, Charles said of *Glimpses*:

> We wanted to have a credible number of images, but not so many that they couldn't be scanned in the time allotted. At the same time, the number of images had to be large enough so that people wouldn't be exactly sure how many they have seen. We arrived at the number seven. With four images, you always knew there were four, but by the time you got up to eight images you weren't quite sure. They were very big images—the width across four of them was half the length of a football field.[51]

One journalist described it as "information overload—an avalanche of related data that comes at a viewer too fast for him to cull and reject it . . . a twelve-minute blitz." The viewer would be overwhelmed. More than anything, the Eameses wanted an emotional response, produced as much by the excess of images as by their content. They said:

> At the Moscow World's Fair in 1959—when we used seven screens over an area that was over half the length of a football field—that was just a desperate attempt to make

a credible statement to a group of people in Moscow when words had almost ceased to have meaning. We were telling the story straight, and we wanted to do it in 12 minutes, with images; but we found that we couldn't really give credibility to it in a linear way. However when we could put 50 images on the screen for a certain subject in a matter of 10 seconds, we got a kind of breadth which we felt we couldn't get any other way.[52]

Exterior of Oviod Theater and IBM Kor-ten supports with program host on elevated platform. Courtesy Eames Office © 2000 Lucia Eames dba Eames Office (www.eamesoffice.com)

The multiscreen technique went through one more significant development in the 1964 World's Fair in New York. In the IBM Ovoid building designed by the Saarinen office, visitors would board the "people wall" and be greeted by a "host," dressed in coattails, who would slowly drop down from the IBM Ovoid; the seated 500-person audience then would be lifted up hydraulically from the ground level into the dark interior of the egg where they would be surrounded by 14 screens on which the Eameses projected the film *Think*.[53] To enter the theater was no longer to cross the threshold, to pass through the ceremonial space of the entrance, as in a traditional public building. To *enter* here was to be lifted in front of a multiplicity of screens. The screens wrapped the audience in a way reminiscent of Herbert Bayer's 1930 diagram of "Field of Vision," produced as a sketch for the installation of an architecture and furniture exhibition.[54] The eye could not escape the screens, and each screen was bordered by other screens. Unlike the screens in Moscow, those in the IBM building were of different sizes and shapes. The Eameses no longer were presenting simultaneous variations of the same subject on each screen, nor were all of them on at the same time. But once again the eye had to jump from image to image and could never fully catch up with all of them and their diverse contents. Fragments were presented to be momentarily linked together. The film was organized by the same logic of compression. Each momentary connection was replaced with another. The speed of the film was meant to be the speed of the mind. The "host" welcomed the audience to "the IBM Information machine":

> a machine designed to help me give you—a lot of information—in a very short time. . . . The machine brings you information in much the same way as your mind gets it. In fragments and glimpses—sometimes relating to the same idea or incident. Like making toast in the morning.[55]

Already in 1959, the design team (Nelson, the Eameses, etc.) had used exactly the same term—"information machine"—to describe the role of Fuller's dome in Moscow, taking it from the title of a film the Eameses had prepared in 1957 for the 1958 Brussels Fair. In addition to the multi-screens, the dome housed a huge RAMAC 305 computer, an "electronic brain" which offered written replies to 3,500 questions about life in the United States.[56] The architecture was conceived from the very start as a combination of structure, multi-screen film, and computer. Each technology creates an architecture in which inside/outside, entering/leaving, etc., meant entirely different things and yet they co-existed. All were housed by the same physical structure, Fuller's dome, but each defined a different kind of space to be explored in different ways. From the "Sample Lesson" in 1953 to IBM in 1964, the Eameses treated architecture as a multichannel information machine and, equally, multimedia installations as a kind of architecture.

Detail from the IBM 14-screen presentation, *Think*. Courtesy Eames Office
© 2000 Lucia Eames dba Eames Office (www.eamesoffice.com)

Herbert Bayer, *Diagram of the field of vision,* 1930. ©2000 Artists Rights
Society (ARS), New York/VG Bild-Kunst, Bonn

CONNECTIONS

All of the Eameses' designs can be understood as multiscreen performances: they provide a framework in which objects can be placed and replaced. Even the parts of their furniture can be rearranged. Spaces are defined as arrays of information collected and constantly changed by the users.

This is the space of the media. The space of a newspaper or an illustrated magazine, for example, is a grid in which information is arranged and rearranged as it comes in. A space the reader navigates in his or her own way, at a glance, or by fully entering a particular story. The reader, viewer, consumer, constructs the space, participating actively in the design. It is a space where continuities are made through "cutting." The same is true of the space of newsreels and television. The logic of the Eameses' multi-screens is simply the logic of the mass media.

The logic of architecture as a set for staging the "good life" was central to the design of the Moscow exhibition. Even the famous kitchen, for example, was cut in half not only to allow viewing by visitors, but most importantly to turn it into a photo-op for the Kitchen Debate. Photographers and journalists knew already the night before that they had to be there, choosing their angle. Architecture was reorganized to produce a certain image. Charles had spoken, already in 1950, of our time as the era of communication. He was acutely aware that the new media were displacing the old role of architecture. And yet everything for the Eameses, in this world of communication that they were embracing so happily, is architecture: "The chairs are architecture, the films—they have a structure, just as the front page of a newspaper has a structure. The chairs are literally like architecture in miniature . . . architecture you can get your hands on."[57] In the notes for a letter to Italian architect Vittorio Gregotti accompanying a copy of *Powers of Ten*, they write:

In the past fifty years the world has gradually been finding out something that archi-
tects have always known, that is, that *everything* is architecture. The problems of envi-
ronment have become more and more interrelated. This is a sketch for a film that shows
something of how large—and small our environment is."[58]

In every sense, Eames architecture is all about the space of information. Perhaps we can
no longer talk about "space," but rather about "structure," or more precisely, about time.
Structure for the Eameses is organization in time. The details that are central to Mies van
der Rohe's architecture are replaced by "connections." As Charles said in a film about a
storage system they had designed: "The details are not details. They make the product.
The connections, the connections, the connections."[59] But, as Ralph Caplan pointed out,
the connections in their work are not only between such "disparate materials as wood and
steel," or between "seemingly alien disciplines" as circus and physics, but also between
ideas. Their technique of "information overload," used in films and multimedia presenta-
tions as well as in their trademark "information wall" in exhibitions, was not used to "overtax
the viewer's brain," but precisely to offer a "broad menu of options" and to create an
"impulse to make connections."[60]

For the Eameses, structure is not linear. They reflected often on the impossibility of
linear discourse. The structure of their exhibitions has been compared to a scholarly paper,
loaded with footnotes, where "the highest level of participation consists in getting fasci-
nated by the pieces and connecting them for oneself."[61]

The multi-screen presentations, the exhibition technique, and the Eameses' films are
likewise important not because of the individual factoids they offer, or even the story they
tell, but because of the way the factoids are used as elements in creating a space that says:
"this is what [the space of information] is all about."[62]

Like all architects, the Eameses controlled the space they produced. The most impor-
tant factor in controlling space for them was to regulate the flow of information. They
prepared extremely detailed technical instructions for the running of even their simplest
three-screen slide show.[63] Performances were carefully planned to appear as effortless as
a circus act. Timing and the elimination of "noise" were the major considerations. The office
produced masses of documents, even drawings showing the rise and fall of intensity
through the course of a film, literally defining the space they wanted to produce, or more
precisely, the existing space of the media that they wanted to intensify.

Coming out of the war mentality, the Eameses' innovations in the world of communi-
cation, their exhibitions, films, and multiscreen performances transformed the status of
architecture. Their highly controlled flows of simultaneous images provided a space, an
enclosure—the kind of space we now occupy continuously without thinking. The experience
for the audience in Moscow was overwhelming. Journalists speak of too many images, too
much information, too fast. For the MTV and Internet generations watching the film today,
it would not be fast enough. Yet we do not seem to have come that far either.

NOTES

1 Elaine Tyler May, *Homeward Bound: American Families in the Cold War Era* (New York: Basic Books, 1988), p. 16. See also Karal Ann Marling, *As Seen on TV, The Visual Culture of Everyday Life in the 1950s* (Cambridge and London: Harvard University Press, 1994).

2 Quoted by May in *Homeward Bound*, p. 17. For transcripts of the debate, see "The Two Worlds: A Day-Long Debate," *The New York Times* (July 25, 1959), pp. 1-3; "When Nixon Took on Khrushchev," a report of the meeting and the text of Nixon's address at the opening of the American exhibition in Moscow on July 24, 1959, printed in "Setting Russia Straight On Facts about U.S.," *U.S. News and World Report* (August 3, 1959), pp. 36-9, 70-2; "Encounter," *Newsweek* (August 3, 1959), pp. 15-9; and "Better to See Once," *Time* (August 3, 1959), pp. 12-4.

3 *Life* (August 10, 1959).

4 Khrushchev: "You Americans expect that the Soviet people will be amazed. It is not so. We have all these things in our new apartments." Nixon: "We do not claim to astonish the Soviet people." *U.S. News & World Report* (August 3, 1958), pp. 36-7.

5 Quoted in Alan L. Otten, "Russians Eagerly Tour U.S. Exhibit Despite Cool Official Attitude," *The Wall Street Journal* (July 28, 1959), p. 16, col. 4.

6 Ibid.

7 Max Frankel, "Dust From Floor Plagues U.S. Fair," *The New York Times* (July 28, 1959), p. 12, col. 3.

8 George Nelson, "Fairs," *Architectural Forum*, (September 1936). Quoted in Stanley Abercrombie, *George Nelson: The Design of Modern Design* (Cambridge: MIT Press, 1995), pp. 151-2.

9 John Neuhart, Marilyn Neuhart, and Ray Eames, *Eames Design: The Work of the Office of Charles and Ray Eames* (New York: Harry N. Abrams, 1989), pp. 238-41. See also Hélène Lipstadt, "Natural Overlap: Charles and Ray Eames and the Federal Government," *The Work of Charles and Ray Eames: A Legacy of Invention,* ed. D. Albrecht (New York: Abrams, 1997), pp. 160-6.

10 Eames Archives, Library of Congress, box 202.

11 Letter from Buckminster Fuller to Ms. Camp, November 7, 1973. Eames Archives, Library of Congress.

12 Abercrombie, op.cit., p. 163.

13 Ibid., p. 164.

14 Max Frankel, "Image of America at Issue in Soviet," *The New York Times* (August 23, 1959). "Circarama" had already been shown in the 1958 World's Fair in Brussels.

15 Abercrombie, op.cit., p. 167.

16 "The seven screen quickie is intended as a general introduction to the fair. According to the votes of the Russians, however, it is the most popular exhibit after the automobiles and the color television." *The New York Times* (August 23, 1959).

17 "Watching the thousands of colorful glimpses of the U.S. and its people, the Russians were entranced, and the slides are the smash hit of the fair." "The U.S. in Moscow: Russia Comes to the Fair," *Time* (August 3, 1959), p. 14.

18 "And Mr. Khrushchev watched unsmilingly as the real bomb shell exploded—a huge exhibit of typical American scenes flashed on seven huge ceiling screens. Each screen shows a different scene but all seven at each moment are on the same general subject—housing, transportation, jazz and so forth. U.S. officials believe this is the real pile-driver of the fair, and the premier's phlegmatic attitude— not even smiling when seven huge Marilyn Monroes dashed on the screen or when Mr. Nixon pointed out golfing scenes—showed his unhappiness with the display." *The Wall Street Journal* (July 28, 1959).

19 Pat Kirkham, *Charles and Ray Eames: Designers of the Twentieth Century* (Cambridge and London: MIT Press, 1995), p. 324. From interview Wilder/Kirkham, 1993.

20 Frankel, "Dust From Floor Plagues U.S. Fair."

21 *Powers of Ten* was based on the 1957 book by Kees Boeke, *Cosmic View: The Universe in Forty Jumps*. The film was produced for the Commission on College Physics. An updated and more developed version was produced in 1977. In the second version the starting point is still a picnic scene, but it takes place in a park bordering Lake Michigan in Chicago. See Neuhart et al, *Eames Design*, pp. 336-7 and pp. 440-1.

22 See handwritten notes on the manuscript of the first version of *Powers of Ten*. Eames Archives in the Library of Congress, box 207. The film is still referred to as Boeke's *Cosmic View*.

23 Working script of *Glimpses*, Eames Archives, Library of Congress, box 202.

24 In 1970, in the context of Charles Eames' third Norton Lecture at Harvard University, where he once again insisted on the need to incorporate media into the classroom, he still spoke of changing forms of communications with reference to the Sputnik: "In post-Sputnik panic, a great demand for taping science lectures; when they were shown on television, distribution cost ended up as 100:1 of production cost; no way to run a railroad." Eames Archives, Library of Congress, box 217-10.

25 Apparently even the forget-me-not flowers were understood exactly in the intended way, as symbols of friendship and loyalty. According to the Eameses, the audience could be heard saying "*nezabutki,*" "forget-me-not," as the flowers appear on the screen as the last image of the film. Neuhart et al, op. cit., p. 241.

26 For example, *Powers of Ten* was a "sketch film" to be presented at an "assembly of one thousand of America's top physycists" but the Eameses decided that it should "appeal to a ten-year-old as well as a physicist."

27 "Grist for Atlanta paper version," manuscript in the Eames Archives, Library of Congress, box 217-15.

28 Neuhard et al, op. cit., p. 177.

29 Owen Gingerich, "A Conversation with Charles Eames," *The American Scholar*, vol. 46, no. 3 (summer 1977), p. 331.

30 Ibid.

31 Abercrombie, op. cit., p. 145, quoting George Nelson, "The Georgia Experiment: An Industrial Approach to Problems of Education," manuscript, October 1954.

32 Allene Talmey, "Eames," *Vogue* (August 15, 1959), p. 144.

33 Beatriz Colomina, "Reflections on the Eames House," *The Work of Charles and Ray Eames*, p. 128.

34 Neuhart et al, op. cit., p. 373. Bill Ballentine, *Clown Alley* (Boston/Toronto: Little, Brown and Co., 1982).

35 Charles Eames, "Language of Vision: The Nuts and Bolts," *Bulletin of the American Academy of Arts and Sciences,* vol. XXVIII, no. 1 (October 1974), pp. 17-8.

36 Neuhart et al, op. cit., p. 91.

37 Charles Eames, "Language of Vision," pp. 17-8. See also typescript of the actual lecture in Eames Archives, Library of Congress, box 217-12.

38 Barry Katz, "The Arts of War: 'Visual Presentation' and National Intelligence," *Design Issues*, vol. 12, no. 2 (summer 1996), pp. 3-21. I am grateful to Dennis Doordan for pointing out this article to me.

39 Partial transcript from Norton Lectures in Eames Archives, Library of Congress, box 217-10.

40 See, for example, Charles Eames, "On Reducing Discontinuity," manuscript of a talk to the American Academy of Arts and Sciences in 1976: "My wife and I had made a commitment to disregard the sacred enclosure around a special set of phenomena called art; in our view preoccupation with respecting that boundary leads to an unfortunate and unwarranted limitation on the aesthetic experience." Eames Archives, Library of Congress, box 217-17.

41 Notes for second Norton Lecture. Eames is referring here to "Professor Lawrence Hill's Renaissance," Eames Archives, Library of Congress, box 217-10.

42 "Grist for Atlanta paper version," manuscript in the Eames Archives, Library of Congress, box 217-15.

43 Gingerich, op. cit., p. 332.

44 "'Communications Primer' was a recommendation to architects to recognize the need for more complex information. . . . for new kinds of *models* of information." "Grist for Atlanta paper version," manuscript in the Eames Archives, Library of Congress, box 217-15.

45 Beatriz Colomina, op. cit.

46 Michael Braune, "The Wit of Technology," *Architectural Design* (September 1966), p. 452.

47 See notes 12 and 13.

48 Frankel, "Image of America at Issue in Soviet."

49 Gingerich, op. cit., pp. 332-3.

50 Talmey, "Eames," p. 144.

51 Gingerich, op. cit., p. 333.

52 Digby Diehl, "West Q & A: Charles Eames," manuscript in the Eames Archives, Library of Congress, box 24, pp. 4-5.

53 Mina Hamilton, "Films at the Fair II," *Industrial Design* (May 1964).

54 Arthur A. Cohen, *Herbert Bayer: The Complete Work* (Cambridge: MIT Press, 1994), p. 292. Mary Anne Staniszewski, *The Power of Display: A History of Exhibition Installations at the Museum of Modern Art* (Cambridge: MIT Press, 1998), pp. 25-8.

55 Script of IBM film "View from the People Wall" for the Ovoid Theater, New York World's Fair 1964. Eames Archives, Library of Congress.

56 "U.S. Gives Soviet Glittering Show," *The New York Times* (July 25, 1959).

57 Gingerich, op. cit., p. 327.

58 "Powers of Ten—Gregotti," handwritten notes. Eames Archives, Library of Congress, box 217-11.

59 Charles Eames in a film about a storage system the Eameses had designed. Quoted in Ralph Caplan, "Making Connections: The Work of Charles and Ray Eames," *Connections: The Work of Charles and Ray Eames* (Los Angeles: University of California Press, 1976), p. 15.

60 Caplan, op. cit., p. 43.

61 Ibid., p. 45.

62 Charles Eames, "Mies van der Rohe," photographs by Charles Eames taken at the exhibition, *Arts & Architecture* (December 1947), p. 27.

63 "To show a 3-Screen slide show," manuscript in the Eames Archives detailing the necessary preparations for an "Eames 3 screen 6 projectors slide show" with "sound" and "picture operation procedure," illustrated with multiple drawings, 14 pages. Eames Archives, Library of Congress, box 211-10.

Why couldn't we have the windows of our living room open onto a diorama, representing a beautiful landscape . . . It would be wonderful to change the view from one's window once a month—to go from Rome to Naples, from Naples to Messina, or wherever we like, without having to move. THÉOPHILE GAUTIER

What does travel ultimately produce if it is not, by a sort of reversal, "an exploration of the deserted places of my memory". . . , something like an "uprooting in one's origins" (Heidegger)? MICHEL DE CERTEAU

GIULIANA BRUNO

HAPTIC JOURNEYS

"Geography"—as Gertrude Stein put it—"includes inhabitants and vessels."[1] Moving from sight to site, the landscape of modernity has been designed by new "fashions" of inhabited spatiality. Aesthetic movements have been "taking place" in a cultural journey that has traveled from topographical view painting and cartography to landscape design and panoramic vision. Vision has been transformed along the route of mapping, as it was being located and dislocated. The new pleasure was not the effect of an incorporeal eye, because it was a "matter" of space. The eye/I that was designing—"fashioning"—new visions was a traveling eye/I, and it carved spatial expansion. As space was absorbed and consumed by a moving spectator, a new "architectonics" was set in motion. A "picturesque revolution" began by setting sites in moving perspectives, expanding outward to incorporate larger portions of space. The new sensibility engaged the physicality of the observer, challenging her ability to take in space, more space, a mobilized space.

During the 18th century, there was an increasing production of observational visibility, which included travel discourse. Journey poems, view paintings, and garden views were among the new forms of shared visual and spatial pleasure. They combined a sensualist theory of the imagination with an emphasis on physicality. A growing spatial production integrated new modes of visual pleasure with a rising physical awareness. The broadening of visuality inaugurated in the 18th century was essentially about changing the way desire was positioned, that is, effectively "locating" desire in space, and articulating it as a spatial practice. A haptic consciousness was being produced. Such physical remaking of space was the effect of bodies-in-space, traveling through sites. The new mechanism of visual pleasure was an opening of spatial horizons. Scanning sites and cityscapes, moving through and with landscapes, fashioned spectacular spectatorial pleasures.

Hunger for space led the subject from vista to vista, in an extended search for urban and spatial pleasures. Spatial curiosity and the pleasures of siteseeing were consolidated through the 18th century's travel culture, which designed a route ranging from topographical views to maps to the architectonics of gardens, and led to the opening of travel to more people, the circulation of travel narratives, and the rise of a leisure industry.

This included traveling to resorts and spas, as well as amusing oneself by peering at cabinets of curiosities, evolving into visiting museums, and browsing through the composition of natural settings or taking in their depictions. Moving along towards the path of modernity, from view painting to garden views, from travel sketches to itinerant viewing boxes, from panoramas and other geographical "-oramas" to forms of interior/exterior mapping, from the viewing motion of train travel to urban street-walking, the subject was "incorporated" in the moving image. This process even led to the invention of motion pictures. It is this moving haptic space that created the motion picture and its spectator—a body who is indeed a "passenger."

Geography and the human body have a tangible shared territory: the restless terrain of lived space. Historically, the corporeal domain was designed at the intersection of inner and outer. Beginning in the 18th century, the intersection became more fluid. For example, as Richard Sennett shows in his urban history of "flesh and stone," links were established "between the city and the new science of the body . . . The Enlightment planner emphasized the journey . . . Thus were the words 'artery' and 'veins' applied to city streets by designers who sought to model traffic systems on the blood system of the body."[2] The motion of the city, an end in itself, was becoming compared to the circulation of bodily fluids. The analogy between spatial movement and bodily function was defining a new, mobile haptic mapping.

A late 18th-century movement known as the picturesque established its own sensuous visions of space in landscape design and pictorial views. The picturesque model established a "sense" of space, while another movement sought a more factual approach to spatiality.[3] This way of picturing landscape culminated in the realistic tradition of the 19th century. Both, in different ways, however intertwining in a plurality of hybrid forms, enhanced the vision of space by calling attention to location.

Spatial expansion continued through the 19th century's mechanized version of the traveling eye. The passion for traveling, in the words of architectural historian Christine Boyer, meant "simultaneously perceiving travel narratives, history books, historical painting, and architectural ruins to be modes of vicarious travel through time and space . . . Traveling, visiting museums, studying maps, gazing upon architecture, and even observing a city's plan were all optical means by which the beholder organized his mind and his visual memory."[4]

CARTOGRAPHIC VIEWING

The mobilized inhabited space produced by the mid-18th century and its aftermath encompassed a flourishing of topographical and view painting, whose effect was to carry away—transport—the spectator into the depicted landscape or cityscape, creating a powerful effect of simulated travel. The art of viewing sites assumed widely varying forms. It ranged from the display of architectural sites in an emotional matter—growing on the footsteps of the Neapolitan artist Salvator Rosa (1616–1673), among others—to a more descriptive representational fashion. Descriptive imaging circulated widely as paintings, prints, illustrations in travel accounts, and also as atlases and topographical mappings.

A panoramic interior in the Ladies' Salon seen in Wilhelm Rehlen, *Le Salon des princesses Sophie et Marie de Baviere à Nymphenburg*, c.1820.
Courtesy Wittelsbacher Ausgleichsfonds, Munich

Foregrounded by a growing interest in architectural forms, the paintings of city views were recognized as an autonomous aesthetic category in the late 17th century.[5] They were a part of "the art of describing."[6] In particular, the Italian *veduta* evolved from widespread *furor geographicus* that, from the 15th century onward, took the form of book illustrations, drawings, and prints as well as paintings. Topographical books were instrumental in establishing a taste for viewing sites in many types of illustrated books including histories, travel reports, geographic surveys, and atlases. The *veduta* itself is inseparable from the history of the Grand Tour.

In the *veduta*, the portrait of the city was environmentally shaped in a type of staged representation that transferred the codes of landscape painting to the urban terrain. Masters of these kinds of representations included Canaletto (1697–1768) and Giovanni Paolo Panini (c.1691–1765). This genre of view painting, which worked closely with topographical representation, emphasized the drama of location. The portrait of the city that generally characterized the Italian *vedutismo* tended towards a narrative dramatization of sites. A heightened and tactile texture of places characterized the way the *veduta* pictured the city.

As they merged the codes of urban topography and landscape painting, city views also incorporated the cartographic drive, creating imaginative representational mapping. The city was approached from different viewpoints. These ranged from profile and prospective views to plan, map-view, and bird's-eye view, and were often even combined in topographical views. Factual accuracy was not the representational aim of urban views. Views exhibited an interest in rendering, representationally, a mental "image of the city,"[7]

Jacopo de' Barbari, *View of Venice,* 1500. Photo courtesy Giuliana Bruno

establishing not one "cognitive mapping"[8] but diverse observational routes. As far back as 1473, the Genovese humanist Antonio Ivani wrote about a partial view of his city that he sent to a Florentine friend; the representation shows "not the whole city, but only parts which meet the need of writers, with the sites [shown] in such a manner as to occur [to one] in connection with a narration."[9] Urban portraits showed a haptically lived city, presenting it for further *transito* and spectatorial inhabitations because there is always more than one embedded story in "the naked city."

City views were in many ways an object of the everyday narrative of urban life. As suggested in an 18th-century catalogue description for a printed view of London, city views were considered a "cheap and proper ornament for Halls, Rooms and Staircases."[10] City views interestingly participate in the history of the interior, as well as in the mapping of the exterior, following the "domestic" use that had been made of world maps. From the 16th century on, maps were produced in great number as objects of display suitable for wall decoration.[11] The wall map became a feature of domestic interiors, together with other cartographic objects. Atlases brought the world into the domestic space while the globe reduced it to a miniature size, easy to "handle" in one's own home. From wall maps to atlases to globes, ornament and mapping progressed hand in hand.

It follows that city views also became a feature of domestic urban life, participating in the history of exhibition and private life. Furthermore, urban view traveled from forms of architectural decor and decoration all the way to the decorative arts. From the mid-18th century on, views appeared as illustrations of domestic objects. They entered table manners, garnishing plates, bowls, glasses, cups, and trays, and illustrating the tops of dining room tables or inscribing their surfaces. They "illuminated" pieces of furniture such

as writing desks and decorated ladies' jewelry boxes and fans. City views traveled from the outside to the inside, mapping out the space of domestic interiors and in such a way partaking in the liminal passage that marks "domestic" cartography.

Although the realm of city views cannot be completely collapsed into cartography, which became an independent genre by the 17th century, the history of urban views certainly parallels that of (artistic) maps and interacts with it in many interesting ways. Artists who painted views often made use of such optical instruments as the *camera obscura* or the perspective glass. A cartographic impulse pervaded this form in all its manifestations. Although city views were not necessarily the same as plans, they shared the representational terrain of mapping. Views were often made as prints and published by map-makers, thus showing a direct link to cartography. Even when the artist was not a cartographer, or the cartographer was not an artist, their representations showed that they acted as if they were interchangeable.[12] Rather than being two different domains, the aesthetic and the scientific realms were being merged in the form of a cartographic art. In general, cartography and the art of viewing, including landscape painting, figured in the development of notions of space as well as attitudes towards space. Throughout the history of views, in their many manifestations, city views established a form of siteseeing: they endeavored to extend the limits, the borders, and the perspective of picturing into an act of mapping.

The art of viewing followed the older touristic drive to survey and embrace a particular terrain—a compulsion to map the territory and to position oneself in it that had led to the climbing of church towers, mountains, and buildings to take in the panorama. From its early days, the city view developed this practice and went beyond its limits, for instance, in Jacopo de' Barbari's 15th-century bird's-eye view of Venice, one of the most significant and early examples of panoramic views. The all-embracing view was not a totalizing vision in this multi-sheet mapping of the city designed for wall decoration, and it is speculated that it possibly even served touristic aims. As the art historian Juergen Schulz claims, this was an impressively imaginative enterprise of topographic rendering, for the overall view was assembled from a number of disparate drawings made from different high points throughout the city.[13] There is no clear focal point in this imaginary view, which is constructed rather as a montage of different vanishing points. The observer is not fixed to a position or to a set distance, but appears free to wander in and around the space.

Generally speaking, the bird's-eye view was an imaginary perspective, taken from an impossible viewpoint, which was neither the actual high point of the real surroundings nor the ground, but above the supposed vantage point and tilted. From Leonardo da Vinci's early attempts to turn earthbound observation into aerial vision—in his oblique map of Milan, anticipated by his panoramic landscape drawings—this cartographic measure was a product of the creative imagination of the artist-cartographer.[14] With a number of possibilities open, the artist-cartographer could take the road suggested by Louis Marin, who claims that "a bird's-eye view gives us a 'snapshot' of the city."[15] However conceived, the bird's-eye view was a permeable place of encounters between the map and the landscape, where a number of (im)possible itineraries are inscribed. Often dismissed as a teleological perspective, mistaken for a "cognitive mapping" from a superior eye, the bird's-eye view

Explanation of the View of Rome taken from the Tower of Capitol, by R. R. Reinagle, 1804. Courtesy Museo Nazionale del Cinema, Turin

needs to be reconsidered insofar as it was not a totalizing perspective but a view from no/where now/here. This imagined dislocated view, made possible much later by cinematic spatio-visual techniques, attempted to free vision from a singular fixed viewpoint, imaginatively mobilizing visual space. The scene of bird's-eye views staged a fabricated spatial observation, opening a door to narrative space.

The city could become part of a sequence of imaginary surveys, including the traveler's journey. The view described the city as an integral part of cultural travel and inscribed it into the trajectory of this voyage. A geographical rendering of imagination, the bird's-eye views were imaginary maps for those who knew as well as those who had never seen a city: both kinds of spectators could find the site described in a mobilized form. Alongside this type of view, the wide vistas of prospect and profile views also functioned in a way that pushed perspectival boundaries. These vistas strove to overcome the limitations of perspective by creating a wider horizontal expanse, often made of aggregate views, that eroded the notion of a single prioritized perspective.

The image of the Western city expanded, "unlimiting the bounds of painting."[16] Such expansion—an uncontainability of borders and frames—made it impossible for the ideal city of Renaissance perspective to be captured in a single image. In the 18th century, urban *vedute* were produced in several parts, even as different viewpoints. The image of the city underwent an intense process of fragmentation and multiplication, before being refigured in the all-embracing views of the panorama, which extended the very borders of the frame.

MOBILE MAPPINGS: VIEWS IN FLUX

A relation between space, movement, and narrative was articulated by the techniques of observing architectural views, thus establishing a tradition of spatial storytelling.[17] This geography was not devoid of history. History, for example, occupied the format of view painting, for the views often offered an outlook on what was "taking place" in the site. Eighteenth-century views were even accompanied by remarks on the history of the city portrayed. Representing space as being inhabited by events, moving with the dynamics of the city, the views exhibited a potential for narrativization. In the 18th century, the rectangular space of the view was extended to incorporate more narrative space. Pre-dating the film strip, pictures began to tell stories in long formats. The enlarged perspective extended into the full view of 19th-century panoramas, where the subjects of history and narrative realism featured large. Prior to the art of film, "cinemascope" picturing was "designed" as a mapping of narrative space.

This mapping is to be retraced topographically. It was primarily the topographically oriented view painting which established a form of depiction that began to move narratively. Until the mid-18th century, spatio-temporal unity appeared to organize the view. But the flow of history entered representation by way of a movement that included different framings. The topographical views showed interest in a work of diachronic documentation that exceeded perspectival frames. View painting sought to chart a space in time. Representing the life of the site, it captured its motion. Spatial depiction became historical documentation. Showing real space and time, the views exhibited the here and now of

Apparatus for rolling panoramic wallpaper, 19th century.
Courtesy Galerie Perrin, Paris

O. B. Bunce, *Washington, Madison, and Union Squares, New York,* from *Picturesque America, or The Land We Live in,*
William Cullen Bryant, ed., 1874

the representation. In such a way, they anticipated the work of the pictures brought about by the age of mechanical reproduction.[18] With photography, it became possible to map space at the moment when it was captured. Later with motion pictures, it became possible to map a spatio-temporal flow, and thus fully re-embody a "sense" of space.

Retracing the steps of the mobile mapping before filmmaking, we are taken through a fluid, haptic geography. As view painting shows, urban representations often incorporate these moving elements in their depiction, from literal portrayals of the god Aeolus blowing the winds to a wider mobilization of representational codes. In the 18th century, the rectangular proportions of the pictures expanded widely to accommodate the particular "course" of river towns, whose representations could not be contained by the conventional geometry of picturing.[19] Prospect or profile views literally extended their borders, elongating their space. A long format emerged, which also suited the telling of geo-historical stories and narrative movements, including those to come beyond perspectivism.

The flow of moving images passed by way of numerous fluid mechanical representations before motion pictures were invented. Particularly significant were the hydraulic exhibitions, which were popular through the 18th century. The Water Works, a play of elaborate hydraulic performances, were exhibited in theaters from the early part of the century.[20] Even before cinema, spectators came to watch a mechanically produced flow of images.[21]

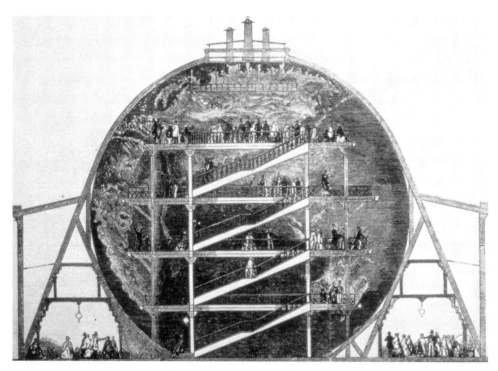

Cross section of the interior of James Wyld's Great Globe, *Illustrated London News,* June 7, 1851. Photo courtesy Giuliana Bruno

At the Paris Exposition in 1900, the *Maréorama* simultaneously unrolled two moving panoramas for the delight of spectators, who were positioned in their midst to give them the illusion of being on the deck of a ship, which would be mechanically agitated to render the sense of navigation.[22] This maritime "-orama" spectacle took up to 1500 spectators on a simulated cruise through the Mediterranean, beginning in Marseille and the Riviera, continuing across to Sousse in Tunisia, then onto Naples, Venice, and ending in Constantinople. It was a sensory voyage in time as well as space. Changes of day and night were represented in a synesthetic form of journey that included smell, sea breeze, and the sound of live music which accompanied and punctuated the trip. Spectators became "passengers," simulating the (e)motion of traveling by sea—the sea of moving images.

JOURNEYS OF THE HOME BODY

This traveling space tangibly affected the world of mapping. Maps involve imagined spaces and imaginative spatial explorations. Their viewing pleasure entails a form of journey: viewing maps stimulates, recalls, and substitutes for travel. Engaging with a map is akin to experiencing film: it is to be passionately transported through a geography, to experience passage. One is carried away by this imaginary travel, as one is moved when one actually travels or moves (domestically) through architectural ensembles. Maps—like films and architecture—offer the emotion of motion.

Architecture and mapping participate in many ways in the construction of a protofilmic traveling space. A particular case of moving spectacles concerns city plans and architec-

tural models. From the 18th through the 19th century, architecture and topography were literally a form of exhibition. Topographical and architectural models, ranging from singular buildings to whole towns or regions, were objects of display in Cosmorama Rooms, among other sites of exhibition. The aim of these exhibits was to take the spectators on a journey. As *The Literary Gazette* explained in 1825, in reference to the exhibit "Switzerland in Piccadilly," this was a form of composite architectural tourism:

> The accomplished Tourist may likewise here renew his acquaintance with scenes too splendid and romantic to be evanescent, and explain to inquisitive friends, who have not had the opportunities of seeing the realities, the objects which most attracted his attention on his travels.[23]

As this text makes clear, the function of the topographic and architectural display was to induce recollection and desire for the actual tourist, but also to provide an imaginary voyage for the "home body." City dwellers could be taken places via the display of architectural sites. A body of spectatorship left home by way of topographic journeys. The very equation of body with home, and home with body, was shattered with the creation of a different voyage—a traveling "domestic." Not just a vicarious type of journey, this was the enactment of a different form of voyage—an interior voyage, a phantasmic journey, an experience of heterotopia.

Such an architectural journey, to be later embodied in the cinematic moving passion, began by transporting spectators through various forms of topography and cartography. As exemplified by the case of "Switzerland in Piccadilly" at London's Egyptian Hall, this popular urban affair was a geographic montage. The confines of the homeland are demolished, opening up to border-crossing imaging. Not only could one go to Switzerland without leaving London, but one experienced a new form of voyage—an architectural montage of places. As in topographical view painting, here one was transported to the city viewed, and also transported by it, as the city itself moved towards the spectator. A new geography was constructed, adopting the principle of editing and creating an architectural heterotopia— an elsewhere nowhere.

The observational impulse of modernity—a complex phenomenon working on the edge of spatial realism—reframed its codes, culminating in film's own mobile remaking of "location." A multifaceted experience of geo-psychic voyaging marked the path leading to the rise of modernity in ways that intertwined not only actual but also simulated forms of journey. The geographical obsession was acted out in forms of alternative (im)mobile journeys, a traveling "domestic" that included a whole range of different topographical spectacles and travel writing. Collections of travel, often illustrated with topographical and architectural scenes, were extremely popular, beginning as early as the mid-17th century and beyond the 18th century. Volumes devoted solely to the "illustration" of sites proliferated, eventually leading to virtual picturesque voyages. Maps and prints decorated the walls of those who could not afford higher forms of travel and its depiction. Travel circulated—becoming another form of journey—and it did so in many ways, even beyond the diverse forms of cartographically oriented illustration and publication. Travel diaries and letters circulated widely in unpublished form, enriching the field of topographical writing

with the incorporation of autobiography. To be knowledgeable meant to be well-traveled. Travel was being constituted as a form of knowledge—a spatial education.

The distilled Grand Tour, as it appeared in Laurence Sterne's *Sentimental Journey*,[24] led to traveling practices in which more women and less privileged classes participated. The voyaging craze traversed the picturesque and gave way to a Romantic version, which was sensualist, melancholic, and dreamy. With an eye to natural landscapes, it searched the landscapes of love and ruins, indulging in lovable ruins and the ruins of love.

HAPTIC DESIGN

[I have] anatomized so considerable a tract of land, and given the most exact representation. SIR WILLIAM HAMILTON

The history of travel designs an anatomy of passage, which involves geo-psychic movement. Such mapping of space bears changes over time. For one, travel evolved into a visual "matter." It was not even always considered a visual experience. As Judith Adler has shown, tourism was not originally a form of sightseeing.[25] The travel experience was historically visualized from an earlier literary and linguistic bend. Between 1600 and 1800, treatises on travel shifted from considering touring an opportunity for discourse, even when engaging direct experience and personal observation to "viewing" travel as, fundamentally, an eye-witness observation. The tongue gave way to the eye.

G. M. Towle, *View from Steeple, Boston,* from *Picturesque America, or The Land We Live in,* William Cullen Bryant, ed., 1874

Fan of anonymous design showing the Grove at Vauxhall Gardens. Photo courtesy Giuliana Bruno

Wandering or traveling became a "way" to know, transforming knowledge itself into a geographical matter. Preparation for travel went this way from reading books to enhancing visual materials as a form of preparatory voyage or simulated travel. The travel route incorporated maps, illustrations, and views, expanding out into the 19th century, guiding the spectator-traveler to attend travel lectures incorporating visual aids. Lantern slide illustration gave way to motion pictures. The road led to filmic mappings, as film visually and aurally reinvented the topographic-anatomic route.

Looking from a geographical perspective to the cultural process of visualization, it appears that such sightseeing was actually turning into siteseeing. An eyewitness activity implies that the beholder is physically there, as a material presence observing cultural space. Seeing with one's own eyes involves a (dis)placement. Becoming a direct observer, the tourist acknowledges her body in space. A form of visual absorption of space, tourism establishes a being-in-place that is moving through space. The travel practice is an embodiment of space and a mobilization of sites. The body is its "vehicle." Looked at in this way, modern tourism shows its tangible tie—a haptic bond—to film and its way of making space. Creating travelogues and a simulated experience of travel, motion pictures participated in a haptic movement: the cultural transformation of sightseeing into siteseeing.

PICTURESQUE SPACES

On the road to siteseeing, the modern traveling eye passed through garden views to embrace larger environments. The design of the picturesque, in theory and practice, was an important step in the modern construction of space. The history of the picturesque intertwines with the history of tourism and participated in shaping its views. An essential moment in the formation of traveling space, the picturesque revolution took part in the modern making of haptic space. In such a way, it prepared the ground for and incorporated elements of filmic traveling space.

The impact of the picturesque is important to highlight and articulate.[26] A complex and ultimately elusive notation of taste in landscape aesthetics and tourism that emerged between classic and romantic art, the picturesque has a pictorial genealogy.[27] It first appeared, in the definition of the 18th-century poet Alexander Pope, as a term referring to a scene that would be proper for painting.[28] Not a homogeneous notion, inseparable from philosophical and visual arts stances, it was redefined in various theories as well as practices. Although the English picturesque, notably elaborated by William Gilpin, Uvedale Price, and Richard Payne Knight,[29] among others, has tended to draw the most critical attention, the picturesque actually was articulated in the cultural contexts of different countries and diverse forms of expression, which historically "fleshed out" a multifaceted notion of space.

It is often remarked that, as an art of landscaping, the picturesque as initially inspired by the paintings of Claude Lorrain, Poussin, and Salvator Rosa was imaged pictorially—as a series of pictures created for aesthetic enjoyment. Painted landscape was seen as a model for the design of landscape architecture. Nature, a product of a cultivated aesthetic pleasure, was to be experienced in the form and shape of a view. It was to be viewed as picture—as an unfolding visual narration. The garden was a form of museum. Composed of a series of pictures, often joined by way of association, the picturesque was constructed sceneographically. Perspectival tricks were used to enhance the composition of the landscape and its way of reception.

In picturesque journeys, the activity of viewing was sometimes accompanied by touristic gadgets such as the Claude glass, named after the painter.[30] These concave mirrors, made of variously tinted glasses, were used by the viewer to look at, color, "frame," and even modify the view. The Claude glass was an itinerant object, more portable than its ancestor, the *camera obscura*. This touristic device mediated between an already spectacularized landscape—a set—and the spectator in ways that call to mind the genealogy of viewing apparatuses from which the cinema descends.

In the picturesque design of the garden, nature is not a "natural" landscape but a cultural artifact. An object of mediated views, where views are a desirable objective, the garden is an image—a culturally constructed visual space. A product of imaging, the picturesque garden is sequentially assembled and deployed for viewing as an actual spatio-visual apparatus. Looking at picturesque space in this way, we can begin to see how a relation to the filmic apparatus can be built on the "grounds" of an activity of viewing space.

Jeux de l'amour à Tivoli, anomymous portrayal from *Paris métamorphosé* by Pierre-Jean-Baptiste Nougaret, 1799. Photo courtesy Giuliana Bruno

Indeed, thinking by way of the moving image about the picturesque unleashes series of theoretical questions about genealogies. When it comes to the film image, it is the aesthetics of the sublime and its derivatives that tend to be privileged as the cinematic "moment."[31] However, the often misunderstood, condemned, and even derided concept of the picturesque is undergoing re-evaluation in different fields: assessed as a modern form of visuality and aesthetics, it can also be seen as significantly embodied in a modern picturesque.[32] In particular, art historian Yve-Alain Bois pre-dates the "rupture of modernity" in the late 18th century in a provocative text on the picturesque in which he also makes reference to film.[33] So does Anthony Vidler, who reconsiders the picturesque in relation to the modern architecture of Le Corbusier.[34] Vincent Scully credits the cerebral and visual picturesque with impacting the views of modern architecture, especially directing its interest in the visual arts and the notion of place, and also refers to Le Corbusier, who viewed the city as a garden.[35]

The picturesque as defined by architectural historian Renzo Dubbini is "an art of composing scenes and a system for the analysis of the character of place, emerging from the materality and the cultural matrix of objects."[36] In this respect, the impact of the picturesque can be seen as extending widely, for this advanced reflection on the observation of landscape impacted the urban scene as well, and created an expansive reconfiguration of geographic affects. The very act of establishing this particular genealogy is a way of recognizing both the picturesque and cinema as complex practices of spatial mapping involving an affective design, to be investigated historically and theoretically with cartographic tools. The montage of the picturesque promenade is a matter of spectatorial *emotion*. The moving picturesque scene, composed to provoke emotional reaction, has traveled to film's own scenic design, inextricably linked to a landscape of emotions. Before the landscape was mobilized by panoramic vision and the culture of metropolitan movements, the picturesque established the geo-psychic possibility of a modern traveling spectator. Along with cartographic representation, this practice lies at the origin of the construction of a modern, gendered spatio-corporeality, which film mechanically reproduces.

Let us look closer at this geography. First of all, what moves from vista to vista was not a traveling eye, but a traveling body. Views were set in motion by movement. In the picturesque, the pictorial composition of the views was actually "mobilized"—not just revealed to the eye or multiplied—as one physically moved through space. The promenade was the enactment of siteseeing.

Before cinema, the picturesque set forth a spectatorial experience of space. The architectural and urbane Italian garden, which laid out narrative sequence for the English and French picturesque landscape design, had turned the visitor into an active spectator, one involved in the narrative display of the space. Often conterminous with the geography of the cabinet of curiosity, these gardens enacted memory theaters.[37] In particular, the picturesque inherited the psychological depth of the Italian garden, with its topographic representation of disquieting psychic views.[38] In a more pictorial way, the picturesque garden renewed this emotional fashion of representation and was pictorially imaged for its

client and visitor. The user was embedded in garden design as a spectator-in-the-text and was engaged in the poetics of the architectural deployment of the site. A body was both actor and spectator of the drama of the space. In such a way, the viewer entered the picture—as a psychosomatic entity. As in the paintings of anatomy lessons, in garden design a spectator was "incorporated" in the very picturing of visual space.

In the garden, especially in the picturesque version, design was anything but static. The placing of objects in space was a function of the moving absorption of visual space. In some cases of pleasure gardens, displays of objects, derived from 16th- and 17th-century garden design—automata, sculptures, playful hydraulic mechanisms (*giochi d'acqua*) such as fountains and watery landscapes—were made into moving views. In the picturesque, vistas themselves incited the viewer to move into the space. Before filmic close-ups made it possible to approach the image and literally move into it, the picturesque enabled one to physically move into the picture, and into the picturing.

Ultimately, the picturesque garden was designed for peripatetic bodies: the visitor who moved into the picture was asked to travel through it. As in film, the spectator was induced to explore a place and traverse its different spaces. Made of floating images, the scenery constantly changed, as the spectator's movement remade the garden's own shifting perspectives. A sequence of events unraveled as the visitor passed through. Discoveries were made at every turn. The garden was a nomadic affair for spatial wanderers.

A physicality was involved at various levels in this siteseeing, where a *genius loci* unfolds progressively as location is physically revisited and itself becomes embodied. First of all, as Robert Smithson wrote, the picturesque "is based on real land; it precedes the mind in its material external existence. . . . A part [is] a process of ongoing relationships existing in a physical region . . . a 'thing-for-us.'"[39] As a trace left by the future, the construction of the garden can be filmically read in phenomenological terms. This is a logic of perception that becomes "embodied" in the language of cinema.[40] Read with Merleau-Ponty's understanding of phenomenology, space is not positioned at a distance in front of us but surrounds the body: it is an effect of the lived body's own motility.[41] Seen from this angle, the construction of the modern picturesque is revealed in its physicality, for it implicates a situated existence and a material world.

At stake in such comparison is the delineation of a modern haptic spatiality. In film as in the picturesque garden, space exists not as a thing-per-se but as a thing-for-us. The movement of a body creates space as a series of unfolding relationships. Like film, picturesque space materializes as practice. It is a user's space. It comes into being as a site for traversal. Inhabited by the passerby, lived as a *transito*, this is the space of a passenger. An intersubjective corporeal mapping, it is nomadically situated.

In this light, the picturesque can be seen as a "mode of processing the physical world for our consumption."[42] Its spatial construction was used to engage the passenger's imagination and incite her (e)motion. The already non-natural nature of sites is further "cultivated" in a traveling practice which was attracted to the (e)motion of physical locales that itinerantly revealed themselves to be "consumed." This nomadic practice of geo-psychic spatial consumption was the very "material" that was incorporated into filmic *emotion*.

Women strolling in the garden, anonymous engraving. Photo courtesy Giuliana Bruno

THE PERIPATETICS OF THE PLEASURE GARDEN

Thus understood, the peripatetics of the garden unfolds as the geographic enactment of a "heterotopia."[43] Like the cinema, the nomadic garden enacts geo-psychic dis-placements, for it is a site capable of juxtaposing a single real place with several (mental) spaces and slices of time. A traveling space, this is a site whose system of opening and closing makes it both isolated and penetrable in relation to other sites. As in film, the garden's ability to be a fluid geography derives from its being able to house a private, even secretive experience while being a fully social space.

Space, as developed in gardens and garden theory, was a social practice. Historically speaking, the garden embodied a philosophy of space and was in many ways a theater of public display, particularly, but not exclusively, in the design and use of the French formal garden.[44] Even solitarily strolling against the *mise en scène* of the landscape in the presence of others, one engaged in a form of social theater. Many gardens were a site of collective life and, when becoming parks, decisively became a place of public participation. Gatherings and many forms of leisure activities took place within the set of the garden.

Organized forms of public leisure—a public spectacle of moving images—could be set in motion by garden life. Following the theatrical and pre-Romantic architecture of Italian

gardens, the English picturesque produced "pleasure gardens" such as London's Vauxhall and Ranelagh.[45] As Richard Altick shows in his study of exhibition, the various tricks of illusion played on topography—in places where spatial deceits were among the pleasures of discovery—were accompanied by other spectacular illusions set in motion for public enjoyment.[46]

Enhancing the spectacle of garden views, further forms of entertainment were devised for the visitors. Masques and *fêtes champêtres* turned the gardens into sites of public spectacle.[47] A social game was displayed in these forms of entertainment, which involved social role playing. The very material of the masques—a game of social transformations—paralleled the movement of spatial transformation enacted by the garden's own architectonics.

Shifting vistas also included a mixing of social classes and sexes, for the Vauxhall Gardens was a recreational place for all social classes and a place of sexual intrigue. The pleasure garden was a composite moving space of promenading and flirting, interspersed with other pleasures to be consumed. Besides absorbing vistas, pictures, and spectacles, one could engage in other ingestive activities such as eating and drinking.

Pleasure gardens included a number of prototypical filmic pleasures. For example, they displayed large-scale topographical and architectural picture models of sites which were constructed like filmic set designs.[48] Vauxhall Gardens offered a famous display of a lighted landscape scene. This "set" was constructed as a remake of a water mill, a miller's house, and a waterfall, and it included a number of other animated scenes of mechanized motion. Such scenes foregrounded the workings of the filmic apparatus and its fabrication of a simulated reality. In the pleasure gardens, this effect was also achieved with cinematically conceived *tableaux* which created the illusion of the real. *Tromp l'oeil* paintings also functioned this way, and they were positioned in the landscape in such a way as to interact with the very "special effects" of the unfolding garden views.

Vauxhall Gardens was architecturally shaped as a picture gallery. It also exhibited transparent pictures. Protofilmic in texture, transparencies were made with translucent paints and were part of the Garden's many "illuminations." Transparencies often aided "machinery" in garden performances, as in the case of the celebrated eruption of the volcano Vesuvius, a favorite spectacle alongside the display of sea storms.

The erotics of garden machinery was matched by a machination of landscape aesthetics and the architectonics of lighting. Traditionally, the garden was an erotic affair as it was a theatrical site of sensual pleasures. Garden erotics became sensuously noir. It is not by chance that Vauxhall Gardens did not open until after five o'clock in the evening.[49] Pleasure gardens were a dark affair that lit up. The night-time entertainment of the light spectacles offered by the apparatus of the pleasure garden foregrounded the darkness of the movie theater's own light show.

What was unfolding in the garden is the spectacular origin of filmic siteseeing. On the moving set of the pleasure gardens, the mobilized and spectacularized grounds of the picturesque garden gave way to more illusionary moving scenery. Instituting a dreamy mechanics of pleasure, the public spectacles offered by these gardens prepared the grounds for film's own sensuous apparatus and its deployment in the public sphere.

The associative journey of the picturesque garden became transformed into the mechanized travel that made motion pictures and designed some of its housing. An attraction that was established in 1813 at the Parisian park of Tivoli speaks of this shift. The "Mountains of Tivoli" was a ride from the hilltop of the park, where one could enjoy a panorama of the city, down through a grotto and onto a site of pedestrian promenade. The design of the park incorporated this voyage into its picturesque setting. Many points of intersection linked the ride to the pedestrian picturesque promenade. Gazing at the landscape included looking at the speedier prefilmic spectatorial journey. "Ladies" were encouraged to mobilize: "The voyage is not dangerous: the perfection of the mechanism (not visible to the naked eye) and the solid construction must reassure the ladies who are timid."[50]

GENDER MOVEMENTS

In speaking of the reception of the gardens and their spatial construction, questions of gender arise. Although the picturesque is intricately and interestingly involved with female subjectivity, it has often been only stereotypically associated with womanliness. As architectural historian Sylvia Lavin effectively shows, the way that the feminine and the picturesque have been co-defined has resulted in a marginalization of both.[51] Calling attention to Claude-Henri Watelet's *Essai sur les jardins*,[52] a 1770 text on the French picturesque, Lavin argues that the female body is the actual terrain of garden construction, which is imaged as a spatial plenum: a "penetrable space of pleasures" made of "tissues of desire," Watelet's garden is "a reclining female body who offers herself to the observer and entices him to enter her."[53] Defined as female body, this picturesque garden uses the very definition to contain the impact of the feminine which was shaping French culture at the time.

Derided because it was perceived as a feminized space, repressed for its analogy with the female body, the picturesque needs to be reconsidered precisely as a space of the articulation of feminine subjectivity. In this respect, we should re-view the sensuous aesthetic and psychic "taste" of the French picturesque, which notably includes, along with Watelet's work, Nicolas Duchesne's *Traité de la formation des jardins* (1775) and Jean-Marie Morel's *Théorie des jardins* (1776),[54] assuming its seduction for ourselves. The tools of feminist film theory can be helpful in this regard, enabling us to turn the body of the picturesque into a subject of revision involving a body of female pleasures.[55] As the picturesque itself shows, the shifting viewpoint changes the object of the picture as well as the picturing. Female spectatorship, and its theorizations of desire, can change the perspective, turning the garden from an object of view—a body to be penetrated by a (phallic) eye—into a different geo-psychic viewing space, one which does not exclude or marginalize the feminine but rather affirms it. Acknowledging the force of women in spectatorship and their agency in this position reveals another angle of picturesque viewing and its geographic fabrications of shifting (gender) positions.

The activity of pleasure that picturesque space articulated, its texture of affects, was opened to a body of female spectatorship as well as being fabricated by women. Women strolled the grounds of gardens and participated in the public spectacles of the (pleasure) gardens. They were also involved in both actual and virtual picturesque voyages. Illustrations

and paintings, as well as texts, document a female presence and show the extent of its participation in garden life and discourse.[56] Looking at these pictures, we can see that a female public was being formed on the gardens' grounds—a public that turned into a traveling authorship.

As the female characters of Jane Austen's novels testify, the picturesque entered the female universe in many delightful ways.[57] On a picturesque journey through Pemberly Woods in *Pride and Prejudice*, Elizabeth "saw and admired every remarkable spot and point of view. . . . [She] was delighted."[58] In the novel named after her, Emma "was glad . . . to look around her; eager to refresh and correct her memories with more particular observations, more exact understanding of a house and grounds which must ever be so interesting to her . . . Walking some time over the gardens in a scattered, dispersed way, . . . led to . . . a sweet view—sweet to the eye and to the mind."[59]

By way of garden strolling, the picturesque opened traveling cultures to women. Participating in the making of a tactile knowledge of space—of "haptic" epistemologies—the picturesque sense and sensibility paved the road to a new form of spatiality, where the female body was not just a penetrable object, but the very subject of an intersubjective spatial mobilization. "Street-walkers" were positively pre-situated in nomadic gardens before breaking through the new spaces of modernity. Their paths redefined modern space itself, as well as the space assigned to gender. Looking from this gendered angle, the picturesque appears to have made a real impact on modernity, not only as modern vision but as modern spatiality—as a form of mobilization that enabled the very affirmation of the female pleasures of *transito*.

GEOGRAPHIC SENSES

It was the 18th century that enhanced the notion that motion and travel would expand one's sensate universe. Movement was craved as a form of physical stimulation. Sensations were at the basis of this geographical impulse. Geography became an experience of a "sense" of place and of a sentient space. Although garden theory was not the only site of this articulation, the garden was a privileged locus of the pursuit of sensualism, in which women took active part.

Diversely shaped by associative philosophies, 18th-century landscape design embodied the very idea that motion rules mental activity and generates a fancying. The images gathered by the senses produce "trains" of ideas.[60] As Thomas Whately put it in 1770 in his garden theory, a set of *Observations on Modern Gardening*:

> Certain disposition, of the objects of nature, are adapted to excite particular ideas and sensations . . . instantaneously distinguished by our feelings. Beauty alone is not so engaging as this species of character . . . [which] affects our sensibility. . . . The power of such characters is . . . [that they] are connected with others and related . . . by a similitude in the sensation they excite. . . . We follow the tract they have begun. . . . The scenes of nature have a power to affect our imagination and our sensibility. . . . The emotion often spreads far beyond the occasion: when the passions are roused, their course is unrestrained.[61]

Garden Plan of Chiswick House, Middlesex by John Rocque, 1736. Photo courtesy Giuliana Bruno

This philosophy of space embodied a form of fluid emotive geography. Sensuously associative in connecting the local and the topographic to the personal, it enhanced the passionate voyage of the imagination. Fancying was the configuration of a series of relationships created on imaginative tracks. It was the emergence of such sensuous, serial vision that made it possible for the serial filmic image to make sense, and for trains of ideas to inhabit the tracking shots of (e)motion pictures.

The movement that created filmic (e)motion was an actual "sensing" of space. Emerging at the close of the 18th century, the picturesque contributed a tactile vision to this scenario and to cartographic imagery. As Christopher Hussey put it back in 1927, the force of the picturesque was "to enable the imagination to form the habit of feeling through the eye."[62] Thus what was fleshed out was not an aesthetics of distance. In picturesque terms, one is taught to feel through sight. The eye is epidermic. It is a skin. Sight becomes a sense of touch. Picturesque vision is haptic vision. Seen in this way, picturesque aesthetics can be said to have had the important function of steering the shift towards haptic imaging and imagination. And it was this e*motion*al habit—a haptic "fashioning" of space—that was to become embodied in the film sense.

In the garden, strolling activated an intersubjective terrain of physical connections and responses. Kinetic journeys across fragmentary terrains generated kinesthetic feelings. Mobilization, further activated by climbing towers and observatories or dwelling in rooms built in the garden as observational sites, was a form of sensory animation. Sensational

Anonymous engraving. View of the *Hortus Botanicus* at Leiden, 17th century. Photo courtesy Giuliana Bruno

movements through the space of the garden were used to "animate" pictures, fore-grounding the type of sensing enacted by film's own animated motion pictures.

Not unlike filmic space, picturesque space was an aesthetics of fragments and discontinuities. Sometimes, as is particularly the case for the French picturesque, architectural fragments contributed to create a microcosmic heterotopia. By way of *fabriques* (garden buildings), one could navigate surprising collections of worlds of knowledge on the set of a garden stroll.[63] Topography as well is not a totality, but a matter of unfolding variety and disparateness. As architectural scholar Alessandra Ponte claims, there is a varied "character" of the land, which corresponds to the way combined features would mark the character of a face.[64] Combinatory permutations of feelings are impressed on a landscape of the surface. Picturesque architectonics, creating a drama of changing sets, acted as a medium of emotional responses. In the garden, as in the cinema, one could traverse series of imaginative states of mind in the form of living pictures. A mobilized montage of multiple asymmetrical views emphasized the diversity and heterogeneity of this representational terrain. The obsession for irregularity led to roughness and dishevelment. Fragments turned into a passion for ruins and debris. Relics punctuated the picturesque map.

A memory theater of sensual pleasures, the garden was an exterior which put one in "touch" with inner space. Traveling through the space of the garden, a constant double movement connected external to internal topographies. The garden was an outside that

turned into an inside. It was also the projection of an inner world onto the outer geography. In a sensuous mobilization, the exterior of the landscape was transformed into an interior map—the landscape within us—as this inner map was itself culturally mobilized. On the garden route, the picturesque topographic aesthetic incorporated an actual reading of the skin surface—the very border between inside and outside. Seen this way, psychophysiologically, picturesque space is inscribed in a gender passage—that which crossed the boundaries between interior and exterior, and the border assigned to sexual spaces.

The geography of the interior, which begins to take shape during the early part of modernity in the form of garden design and theory and moves along with history, is linked to the image of the body's own interior. A philosophy of the senses and treatises on sensations traveled into the body's sensibility. Anatomical discourse contributed to the sensing of space, the analyzing of passion, and the shape of the body's own interior. This "finer touch" was "part of a greater movement within the history of perception that sent vision inward bound."[65]

The expansion of vision towards the interior opened possibilities for new forms of travel: journeys into haptic space. This touching geography took shape as an *emotion*al cartography. In many ways linked to garden design, charting interior and exterior as passage, such cartography activated woman as the very subject of geography. This was a "tender mapping." It was "a geography of inhabitants and vessels,"[66] such as it was envisaged in *La Carte du pays de Tendre* (The Map of Tenderness) published in 1654 by Madeleine de Scudéry with her novel *Clélie*.[67] A spatial journey of the interior, this map traced an emotional experience on the topography of the land it described. Emotional moments were literally inscribed on the map as sites. A map of a landscape, this was an anatomy of tender love. On its seas, rivers, lakes, mountains, cities, and villages, a siteseeing of affects took place. *Carte de Tendre* made a world of *emotion*s visible to us. In the design of the map, the exterior world conveyed an interior landscape. Emotion was materialized as a moving topography. To traverse the land designed in the map was to visit the ebb and flow of a psychogeography—the very movement of inhabitants and vessels.

Adapted from *Atlas of Emotion: Journeys in Art, Architecture and Film.* London and New York: Verso, forthcoming 2000.

NOTES

1. Gertrude Stein, "Geography" (1923), *A Stein Reader*, ed. Ulla E. Dydo (Evanston: Northwestern University Press, 1993), p. 470. First published in Gertrude Stein, *Painted Lace and Other Pieces (1914-1937),* vol. 5 of *The Yale Edition of the Unpublished Writings of Gertrude Stein* (New Haven: Yale University Press, 1955).

2. Richard Sennett, *Flesh and Stone: The Body and the City in Western Civilization* (New York: W. W. Norton, 1994), pp. 263-4.

3. See Barbara Maria Stafford, *Voyage into Substance: Art, Science, Nature, and the Illustrated Travel Account, 1760-1840* (Cambridge: MIT Press, 1984). See also Kenneth Clark, *Landscape into Art* (London: Murray, 1976).

4. M. Christine Boyer, *The City of Collective Memory: Its Historical Imagery and Architectural Entertainments* (Cambridge: MIT Press, 1994), pp. 228-30.

5. On this subject see, among others, Cesare De Seta, ed., *Città d' Europa: Iconografia e vedutismo dal XV al XIX secolo* (Naples: Electa, 1996); De Seta, "Topografia urbana e vedutismo nel Seicento: a proposito di alcuni disegni di Alessandro Baratta," *Prospettiva*, no. 2 (July 1980), pp. 46-60; "Bernardo Bellotto vedutista e storiografo della civiltà urbana Europea," *Quaderni dell' Istituto di Storia dell' Architettura*, nos. 15-20 (1990-92), pp. 813-8; De Seta, *L'Italia del Grand Tour da Montaigne a Goethe* (Naples: Electa, 1992); Giuliano Briganti, *The View Painters of Europe*, trans. Pamela Waley (London: Phaidon, 1970); and *The Origins of the Italian Veduta* (Providence: Brown University, 1978). For a bibliography on view painting, see the proceedings of the conference "Archeologie du paysage" published in *Caesarodunum*, vol. 1, no. 13 (1978), bibliography compiled by Elisabeth Chevallier, p. 579-613.

6. See Svetlana Alpers, *The Art of Describing: Dutch Art in the Seventeenth Century* (Chicago: University of Chicago Press, 1983).

7. On this notion, see Kevin Lynch, *The Image of the City* (Cambridge: MIT Press, 1960).

8. On this notion, as developed from Lynch, see Fredric Jameson, "Cognitive Mapping," *Marxism and the Interpretation of Culture*, ed. and with an intro. by Cary Nelson and Lawrence Grossberg (Chicago: University of Illinois Press, 1988); and Fredric Jameson, *Postmodernism, or the Cultural Logic of Late Capitalism* (Durham: Duke University Press, 1991), especially pp. 51-2.

9. The letter is cited in Juergen Schulz, "Jacopo de' Barbari's *View of Venice: Map making, City Views, and Moralized Geography Before the Year 1500,*" *The Art Bulletin*, vol. 60, no. 3 (September 1978), p. 458.

10. *The East Prospect of London Southwark and Bridge* and *The West Prospect of London Southwark and Bridge* (c.1734) is so described in John Bowles's 1731 and 1736 catalogues of *London Printed and Sold.* Cited in Ralph Hyde, *Guilded Scenes and Shining Prospects* (New Haven: Yale Center for British Art, 1985), p. 88.

11. See, among others, Alpers, *The Art of Describing*; Christian Jacob, *L'empire des cartes: approches théorique de la cartographie à travers l'histoire* (Paris: Editions Albin Michel, 1992), especially chap. 1; and Joy Kenseth, ed., *The Age of the Marvelous* (Hanover: Hood Museum of Art, Dartmouth College, 1991).

12. On the art of mapping, in addition to the above, see David Woodward, ed., *Art and Cartography* (Chicago: The University of Chicago Press, 1987); and P.D.A. Harvey, *The History of Topographical Maps* (London: Thames and Hudson, 1980).

13. See Schulz, "Jacopo de' Barbari's *View of Venice.*"

14. See Ronald Rees, "Historical Links between Cartography and Art," *Geographical Review,* no. 70 (1980), pp. 61-78.

15. Louis Marin, *Utopics: Spatial Plays,* trans. Robert A. Vollrath (New Jersey: Humanities, 1984), p. 208.

16. On prospect views as precursors of panoramic vision, see Ralph Hyde, *Panoramania!: The Art and Entertainment of the 'All-Embracing View'*, intro. Scott B. Wilcox (London: Trefoil in Association with the Barbican Art Gallery, 1988). The expression cited is the title of the book's introduction.

17. In particular, on perspective and cultural change, see Erwin Panofsky, *Perspective as Symbolic Form,* trans. Christopher S. Wood (New York: Zone Books, 1997), p. 29. Panofsky, while connecting perspectival to cultural changes, recognized the mobile gaze of film in his "Style and Medium in the Motion Pictures," *Bulletin of the Department of Art and Archeology,* Princeton University (1934), reprinted in *Film Theory and Criticism*, ed. Gerald Mast, Marshall Cohen, and Leo Braudy (New York: Oxford University Press, 1992).

18. Art historian Anne Hollander significantly refers to painterly scenic designs as "moving pictures." See Anne Hollander, *Moving Pictures* (Cambridge: Harvard University Press, 1991), especially chap. 8.

19. See Renzo Dubbini, "Views and Panoramas: Representations of Landscapes and Towns," *Lotus International*, no. 52 (1987), pp. 99–111. See also Dubbini, *Geografie dello squardo: visione e paesaggio in età moderna* (Turin: Einaudi, 1994), especially chaps. 2 and 6.

20. See Richard D. Altick, *The Shows of London* (Cambridge: Harvard University Press, 1978).

21. On moving panoramas, see Stephan Oettermann, *The Panorama: History of a Mass Medium*, trans. Deborah Lucas Schneider (New York: Zone Books, 1997); and Vanessa Schwartz, *Spectacular Realities: Early Mass Culture in Fin-de-Siècle Paris* (Los Angeles: University of California Press, 1998).

22. See, among others, Jim Bennett, Robert Brain, Simon Schaffer, Heinz Otto Sibum, and Richard Staley, *1900: The New Age* (Cambridge: Whipple Museum of the History of Science, 1994). Another moving panorama shown at the Paris Exposition was the *Trans-Siberian Express*, which simulated the celebrated railway journey in a 45-minute tour.

23. *Literary Gazette* (April 16, 1825), p. 255. Cited in Altick, *The Shows of London*, p. 395.

24. Laurence Sterne, *A Sentimental Journey Through France and Italy* (London: Penguin, 1986), first published in 1768.

25. Judith Adler, "Origins of Sightseeing," *Annals of Tourism Research*, vol. 16 (1989), pp. 7–29.

26. This is especially important given the misunderstandings surrounding the picturesque. On misconception, see Kim Ian Michasiw, "Nine Revisionist Theses on the Picturesque," *Representations*, no. 38 (Spring 1992), pp. 76–100.

27. On the picturesque as landscape aesthetics, see, among others, John Dixon Hunt, *Gardens and the Picturesque: Studies in the History of Landscape Architecture* (Cambridge: MIT Press, 1992); Malcolm Andrews, *The Search for the Picturesque: Landscape Aesthetics and Tourism in Britain, 1760–1800* (Stanford: Stanford University Press, 1989); Sidney Robinson, *Inquiry into the Picturesque* (Chicago: University of Chicago Press, 1991); David Watkin, *The English Vision: The Picturesque in Architecture, Landscape and the Garden Design* (London: Murray, 1982); and Monique Mosser and Georges Teyssot, eds., *The Architecture of Western Gardens: a Design History from the Renaissance to the Present Day* (Cambridge: MIT Press, 1991).

28. The notion was first used by Alexander Pope in relation to history painting's narrative impact and originally referred to a scene that would be apt for painting.

29. See William Gilpin, *Three Essays: On Picturesque Beauty; On Picturesque Travel; and On Sketching Landscape* (London, 1792); Uvedale Price, *Essays on the Picturesque*, 3 vols. (London, 1810); Richard Payne Knight, *The Landscape: A Didactic Poem in Three Books Addressed to Uvedale Price, Esq.* (London, 1795); and Knight, *Analytical Inquiry into the Principles of Taste* (London, 1805).

30. On this and other viewing apparatuses, see Jonathan Crary, *Techniques of the Observer* (Cambridge: MIT Press, 1990).

31. Anne Hollander, for example, prefers to highlight the filmic sublime in her discussion of "moving images." Focusing on the visual composition, rather than on moving spectatorial culture, Hollander sees the picturesque as "essentially static" and "jarringly anti-cinematic," and furthermore states that "picturesqueness remains an enemy of serious film drama; but sublime landscape can be its best servant." (Hollander, *Moving Pictures*, pp. 263–4). See also Scott Bukatman, "The Artificial Infinite," *Visual Display: Culture Beyond Appearances*, ed. Lynne Cooke and Peter Wollen (Seattle: Bay Press, 1995).

32. On the picturesque and questions of modernity, see, among others, Rosalind Krauss, *The Originality of the Avant-Garde and Other Modernist Myths* (Cambridge: MIT Press, 1985), especially pp. 162–70; Caroline Constant, "The Barcelona Pavilion as Landscape Garden: Modernity and the Picturesque," *AA Files*, no. 20 (1990), pp. 47–54; Stafford, *Voyage into Substance*; Boyer, *The City of Collective Memory*; as well as other works discussed below.

33. Yve-Alain Bois, "A Picturesque Stroll around *Clara-Clara*," in *October: The First Decade, 1976–1986*, ed. Annette Michelson, Rosalind Krauss, Douglas Crimp, and Joan Copjec (Cambridge: MIT Press, 1987), and Bois, "Introduction" to Sergei Eisenstein's "Montage and Architecture," *Assemblage*, no. 10 (December 1989), pp. 111–31.

34. Anthony Vidler, "The Explosion of Space: Architecture and the Filmic Imaginary," *Filmic Architecture: Set Designs from Metropolis to Blade Runner*, ed. Dietrich Neumann (New York: Prestel, 1996).

35. Vincent Scully, *Architecture: The Natural and the Man Made* (New York: St. Martin's Press, 1991), chap. 11.

36. Dubbini, *Geografie dello sguardo*, p. XXI.

37. See John Dixon Hunt, "Curiosities to Adorn Cabinets and Gardens," *The Origins of Museums: The Cabinet of Curiosities in Sixteenth- and Seventeenth-Century Europe*, ed. Oliver Impey and Arthur MacGregor (Oxford: Clarendon Press, 1985).

38. Scully, *Architecture*, chaps. 8 and 11.

39. Robert Smithson, "Frederick Law Olmstead and the Dialectical Landscape," *The Writings of Robert Smithson*, ed. Nancy Holt (New York: New York University Press, 1979), p. 119.

40. See Vivian Sobchack, *The Address of the Eye: A Phenomenology of the Film Experience* (Princeton: Princeton University Press, 1992).

41. See, in particular, Maurice Merleau-Ponty, *The Visible and the Invisible*, ed. Claude Lefort, trans. Alphonso Lingis (Evanston: Northwestern University Press, 1968); Merleau-Ponty, *Phenomenology of Perception*, trans. Colin Smith (London: Routledge, 1962); Merleau-Ponty, "Eye and Mind," *The Primacy of Perception*, ed. James M. Edie, trans. Carleton Dallery (Evanston: Northwestern University Press, 1964).

42. Hunt, *Gardens and the Picturesque*, p. 4.

43. The concept of heterotopia was developed by Michel Foucault in "Of Other Spaces," *Diacritics*, vol. 16, no. 1 (Spring 1986), p. 22–7.

44. See Allen S. Weiss, *Mirrors of Infinity: The French Formal Garden and 17th-century Metaphysics* (Princeton: Princeton Architectural Press, 1995). On the politics of French gardens, see also Scully, *Architecture*, chaps. 9 and 10.

45. Opened in 1661, Vauxhall Gardens was shaped in this form in the 1730s. See Hunt, *Gardens and the Picturesque*, especially chap. 2.

46. See Altick, *The Shows of London*, especially chaps. 7 and 23. The treatment of Vauxall Gardens that follows in this section of my essay is mostly based on that work, however, it is interpreted to advance and flesh out my hypothesis that the garden constitutes protofilmic space.

47. On the role of the *fête* in 18th-century French cultural life, see Thomas E. Crow, *Painters and Public Life in Eighteenth-Century Paris* (New Haven: Yale University Press, 1985), especially chap. 2.

48. These architectural entertainments were developed particularly in London's Surrey Gardens.

49. It did not open before evening until the mid-1830s, when its decline prompted the management to open during the day. This was not unrelated to the perception of Vauxhall as a "licentious" space.

50. This advertisement is dated 1817 and cited in Gilles-Antoine Langois, *Folies, Tivolis et Attractions* (Paris: Delegations a L'Action Artistique, 1990), p. 8 (my translation).

51. See Sylvia Lavin, "Sacrifice and the Garden: Watelet's *Essai sur les jardins* and the Space of the Picturesque," *Assemblage*, vol. 28 (December 1995), pp. 17–33.

52. Claude-Henri Watelet, *Essai sur les jardins* (Paris, 1770).

53. Lavin, op. cit., pp. 22–3.

54. Nicolas Duchesne, *Traité de la formation des jardins* (Paris, 1775); and Jean-Marie Morel, *Théorie des jardins* (Paris, 1776).

55. It is well known that scholarship on female spectatorship has played an important role in the very definition of feminist film theory. For an orientative map of the initial discourse, see the special issue of *Camera Obscura* on "The Spectatrix" edited by Janet Bergstrom and Mary Ann Doane, nos. 20–21 (May–September 1989). From the early bisexuality claim of feminist film theory to more recent theorizations of the "performance" of gender elaborated by queer theory, feminist scholars have been calling attention to shifting positions in the gender realm. For an array of theorizations of spectatorship, see Linda Williams, ed., *Viewing Positions: Ways of Seeing Film* (New Brunswick: Rutgers University Press, 1995).

56. There are many visual documents of female strollers and onlookers. See, as an example, the illustrations of the *History of Vauxhall Gardens*, 1890, and Paul Sandby, *Roslin Castle, Midlothian*, c.1770, where ladies in a park amuse themselves with a *camera obscura*.

57. Their recent filmic revival is interesting in this respect, as it may be read as a sign of renewed interest in the picturesque, in the context of a turn-of-the-century re-visitation of notions of the interior.

58. Jane Austen, *Pride and Prejudice*, *The Novels of Jane Austen*, ed. R. W. Chapman (Oxford: Oxford University Press, 3rd ed., 1932–34), vol. 3, chap. 1, p. 245. The novel was originally published in 1813.

59. Austen, *Emma* in *The Novels of Jane Austen*, vol. 3, chap. 6, p. 357. The novel was originally published in 1816.

60. Stafford, *Voyage into Substance*, p. 4.

61. Thomas Whately, from *Observations on Modern Gardening* (1770), anthologized in John Dixon Hunt and Peter Willis, eds., *The Genius of the Place: The English Landscape Garden 1620–1820* (Cambridge: MIT Press, 1992), pp. 306–7. The French translation of this text was influential in French visions of the garden.

62. Christopher Hussey, *The Picturesque: Studies in a Point of View* (London and New York, 1927), p. 4.

63. See Monique Mosser, "Paradox in the Garden: A Brief Account of *Fabriques*," *The Architecture of Western Gardens*.

64. Alessandra Ponte, "The Character of a Tree: From Alexander Cozens to Richard Payne Knight," *The Architecture of Western Gardens*. See also Ponte, "Architecture and Phallocentricism in Richard Payne Knight's Theory," *Sexuality & Space*, ed. Beatriz Colomina (New York: Princeton Architectural Press, 1992).

65. Barbara Stafford, *Body Criticism: Imaging the Unseen in Enlightenment Art and Medicine* (Cambridge: MIT Press, 1991), p. 413.

66. Stein, "Geography," *A Stein Reader,* p. 470.

67. Madeleine de Scudéry, *Clélie, histoire romaine*, 10 vols. (Paris: Augustin Courbé, 1654–60).

Architecture is the mother art of gardens, not because a garden needs to be (or should be) cluttered with architectural gewgaws, but because the stuff of architecture—the tension between differing volumes, the fall of light and dark, the rhythms of texture—is the essence of a garden. HENRY MITCHELL

MARGIE RUDDICK

TOM'S GARDEN

My neighbor Tom planted a vegetable garden a few years ago. I can see it from my study window, and I can also see, at very close range, the decoy owl that is planted on a stake above the garden to frighten predators. While I can't say that the owl has done a good job of repelling pests, it has become something of a personal emblem, a token that indicates to me, by the very fact that I have grown to like it, a change in the way I perceive the world around me.

Tom's house was built in the early 1960s, on a less than half-acre plot of dune overlooking the Atlantic on the eastern end of Long Island, next to the beach house my parents bought in 1957. When we moved there, ours was one of a handful of beach cottages strewn along the dune that had survived the hurricane of 1938. The original owners of Tom's house—Procter and Gamble heirs from Cincinnati—built it as their beach cabana, a place to retreat to when they wanted a vacation from their immense stucco mansion a mile away, atop the bluff that is the very end of the terminal moraine of the glacier that created Long Island. Several owners later, in the early 1980s, the house still stood peacefully, a Japanese-inspired structure on the neutral ground of beach grass and sand. Then Tom bought it.

Tom was a player in the junk bond fields of the 1980s. He bought the house as a beach house, but after a career reversal that included testifying against his boss, Tom moved out to the house full-time, making this neighborhood of small beach houses and contemporary bungalows his year-round world. Soon a young woman with a very young child moved into the house with him. Things on his land started to change.

I should have anticipated what Tom would slowly begin to do to his house and dune when he enlarged his oceanfront deck. Challenging the legality of his extension, the building department asked Tom to delineate his property, for reference. With customary bravado, he fenced off his property on all sides, and for the first time the linear swath of dune was segmented along property lines, one of which runs perilously close to my house. The dune became ours versus his, a suburban overlay on a shore landscape. Over the years the rugosa roses have grown up and the split-rail fence has weathered. Inevitably, the harsh beach climate blurred the hard lines of fence and ownership.

When my family moved to Long Island in 1957, there probably was no building department to speak of. Our house sits at the ocean's edge of a beach development started in the 1920s, laid out on a grid of two blocks parallel to the water, with eight lanes running perpendicular to the ocean. The tiny plots—most are a quarter of an acre—could be purchased with model plans for small anonymous cape houses with names like "Nantucket" and "Sconset." The scrub landscape of shad, bayberry, beach plum, scrub oak, and Japanese black pine provided a soft medium for the modest cottages that began to spring up over the low-lying back dunes. When I was small, the straight dirt roads had a wild character despite their layout: a tangle of trees, shrubs, vines, and native grasses screened the houses that nestled in the growth. Many people, however, had carved small gardens out of their back yards, and you could catch a glimpse, around the corners of the houses, of small emerald green patches, proper gardens with wisteria, hydrangea, and day lilies. While the face toward the road was often unkempt and chaotic, the small private world behind the house was often lush and well groomed; each of these gardens was different from the next.

In the 1960s, the dunes to the west of our neighborhood, which had stretched unbroken from the bluff to the ocean, were surveyed, cleared of their scrub, and built on. The roads, rather than following the grid of the 1920s development, were laid out in serpentines, winding lanes that were, by code, wider than their predecessors, and asphalted. The character of this neighborhood bore little resemblance to the older settlement: whereas that original neighborhood was organized around narrow, straight dirt roads, this new development had to conform to minimum widths for fire trucks and required more durable materials for roads; whereas the grid of the older neighborhood appeared wild and rural, this new subdivision, laid out in a pastoral, meandering plan, appeared artificial, new, and garish. This was not merely the product of road layout: new contemporary houses, each a unique architectural statement, loomed from atop sandpiles, rather than nestling in hollows. It is not coincidental that Charles Gwathmey's studio and house for his parents sits atop the bluff, overlooking this precinct. His experiment in pure geometric form on a residential scale seems to have spawned legions of offspring tumbling down the dune toward the ocean. Whereas the old neighborhood was a diverse landscape with somewhat anonymous houses tucked into it, the new neighborhood became a collection of gregarious houses, with a single remaining component of the landscape, sand, tucked under it.

Tom's house predates the new development, but in some ways, in its original form, it was similar—a lone figure on a ground of dune, sited close to other houses. What it has become is certainly a less clear and austere vision. A big blank lawn cut out from the grasses; trees jammed up against the house; a basketball hoop; the vegetable garden, slipped into a bank of scrub next to the driveway. Some people who come over to my house ask me what the landscape idea is over there at Tom's. In order to appreciate Tom's landscape, it is essential to understand what it looks like with people in it; it is necessary to see Tom, his family, and his friends in it. Without them, it is an array of unlike spaces, materials, and objects. With them, it is a gathering place; a series of gardens; a recreational place. Because Tom has added each of these features as he has seen fit, his landscape has never been conceived through the lens of an overall plan.

If Tom's landscape were drawn in plan, it would probably look more like a collage than a cohesive whole and would only start to make sense when the uses—people playing ball or sitting around a table, say—were overlaid on the plan. In the case of many of those landscapes that are studied and held up as monuments of design, it is the objects of daily life that begin to unravel the illusion of integrity. Most of the official canon of 20th-century landscape architecture consists of remarkable places photographed at times when they appear most extraordinary: a horse drinking at a 100-foot-long trough, surreal against a luminescent backdrop, in a Luis Barragán landscape; the infinite grids of Dan Kiley; the sublime organic forms of Tommy Church and Henry Moore against the more earthbound meanders of a salt marsh; the eerie grove of birches in Fletcher Steel's Blue Steps. Even Richard Haag's Gasworks Park, intended as a people's place, ends up in most photographs as an abstracted composition of industrial shapes against the curvaceous regrading of a toxic site. But the landscape of the everyday is not terribly photogenic in the abstract; to attempt to orient oneself to the everyday in the landscape, to the ways in which one experiences a landscape from day to day, in practical as well as conceptual terms, it is helpful to imagine people, and the ordinary objects that people bring with them, in these landscapes. By peopling the landscape, one can begin to introduce various conflicting uses and meanings into one landscape, as well as to imagine a landscape as occurring not over the course of one photo shoot but over many years' time.

In practice, it is relatively easy to create a landscape that, sealed off from the visual noise of people and their things, seems beautiful, arresting, of a piece. The training of most landscape architects in America often begins with the assumption that there's no one home—the work of design begins with the plan, with a few supporting sections or perspectives into which ghostly figures are inserted at a height of approximately five-foot-eight. It is more difficult, or rather goes against a traditional formalist training in a more disquieting way, to create a landscape that is accepting of the evidence of the commonplace, and accepting of more ideas or facts than can fit within an overall, unified, formal gesture. Tom's design by accretion—his insertion of the functions that he wanted into the landscape—took the opposite approach to the professional's overall strategy. Rather than being a ground onto which the objects of every day are placed, his landscape *is* the objects of every day, arrayed side-by-side. A beach ball does not merely provide atmosphere; it *is* the atmosphere. Tom's landscape admits of the present, of the facts of daily life, in a way that a professionally prepared landscape rarely does. And the reason that it admits of the present is that it is constituted by change—the things that occur over seasons, over time—and by fragments. Lacking a cohesive overall plan, the landscape can accept new additions, as there is no pure intention as to the landscape's formal integrity with which to interfere. There is no consistent whole to Tom's landscape; it resists objectification because it is composed of incidences, all unrelated except in that they result from Tom's needs.

On a recent trip to Stourhead, I was disheartened to discover that my visit coincided with the yearly *fête champêtre*, which required that many of Stourhead's lawns, lakes, and numerous follies be outfitted with soundstages, lights, ferry slips, and other festival paraphernalia, including workers scurrying around in preparation for the evening's spectacles.

These would follow an "oriental" theme. After a few attempts to avoid photographing light standards emerging from the lake, stages, and microphones, I began to appreciate what an opportunity this coincidence provided for me: while I could always buy magnificent slides of an unblemished (and almost nonexistent) Stourhead, when could I ever have captured such a demonstration of scale, of occasional use, an example in the landscape of both ends of Aldo Rossi's spectrum of propelling versus pathological permanence? I would imagine that Rossi would classify Stourhead as the latter, a monument frozen in the era of its construction, incapable of adapting to new meanings and uses. But as a monumental landscape so clearly resistant to admitting the present, it was doing a pretty good job of assuming new functions, at least for that week. By contrast a landscape that is the product of tinkering, of adding one thing, then the next, has a great advantage over the canonical monuments of landscape design created out of whole cloth, in that, as a product of accretion, it can accept new uses and meanings with less friction, less tension between an identifiable whole and the dissonant parts that are added on, shoehorned in, or laid over. The world that the designer creates, through addition, subtraction, or substitution, has as its organizing principle the will of the designer. The degree to which the landscape becomes a closed system—with a limited vocabulary and a cohesiveness that is sometimes referred to as harmony—often corresponds to the power of the designer to subsume the client's interests, and the facts of everyday life, within the overall conceptual drive. A landscape that is the product of tinkering, of adding and adjusting, can suggest the possibility that design can be the product of many confluences, in three dimensions, of many different streams of life.

I have come to see Tom as a great tinkerer. The first thing Tom built was his deck. What had been a small overlook perched above the ocean became a large outdoor living space. Tom has many friends, and the deck became a gathering spot for barbecues, cocktails at sunset, and family reunions. The house began to grow—a garage, a maid's room, an enlarged upstairs master bedroom, among other amenities, were added. The house changed from a beach bungalow, a simple bar building with a hexagonal common room, to a split-level. Tom didn't hire an architect—he and the builder designed exactly what he needed, a new room here, windows there for views. The result is what would be called a builder's house if it weren't for the quirkiness of the old cottage poking through the utilitarian additions. The rooms became bigger, the surfaces more slick, and the character moved from beach to suburb—nothing effects this shift as quickly as baseboard heating. Because there were so many people visiting Tom on a regular basis, he enlarged his parking area—from a small gravel turnaround to an ample lot. Then came the basketball hoop above the new garage door. After a few rounds of gravel dribbling, he ordered the asphalt truck to come asphalt the whole driveway. And so, incrementally, Tom's lot came to be dominated by the structures needed for the way he lives. The effect to me, next door, was that my serene baseline—the dunes, the ocean, the quiet—was receiving an increasing amount of static from the precinct of Tom's house. Literal noise intruded when his older kids would visit and pump out rock music into the salty atmosphere. But there was a lot of aesthetic noise happening too: fences, asphalt, basketball hoops. Over the next few years I watched my

unease change in character, from suspicion of Tom's every move (will he be installing a bowling alley? A giant TV screen over the deck?) to suspicion of my own training, my own expectations, and my own conception of my role in the landscape, all of which conspired to judge Tom's tinkering with his landscape as something to be suppressed.

My own set of values when it comes to my own landscape is based on an assumption, widely held in the area in which I live, at least until recently, that the highest level of art involves manufacturing the appearance that nothing has been done, acquired, or forced. To Tom, this might seem outlandish. To spend large sums of money on work that is not evident once it is completed could seem the height of perversity. In fact, my level of wariness of the signs of consumption has led me to award high value to work that eliminates all signs of consumption, in the process commodifying the look of austerity, or of casualness. But I have been raised in and have passed through educational and cultural systems that have trained me to consider my landscape as inevitable and unambitious, and, in this beach environment, to consider a landscape in which the signs of construction and acquisition are evident as jarring and unnatural. If Tom and I had passed through the same systems, I would not spend so much time thinking about his landscape, and only imagining what he must think of mine; we would probably get together once every so often for a drink, on one of our decks, overlooking the ocean.

But Tom comes from a culture different from the amalgam of cultures that my parents and environment provided me. His mother's house, down the road and away from the beach, is a modest builder's house, a two-story box that would look familiar in a suburban neighborhood. She has, over the years, adapted the house and its small landscape, sitting on the edge of the new, winding subdivision, to its seaside setting with beachy perennial plantings, gravel, buoys, and welcoming signs. Like houses along the Jersey shore, which often do not differ from houses in the suburbs in form or style, the house does not rely on architecture to tell you that it is a beach house, but rather on signs in the landscape. My house, with its diminutive size, shingled gables, and white trim, fits into the rural tradition of the eastern end of Long Island, a small farm outbuilding that happens to be a beach house. My mildly neglectful attitude toward the house and the landscape fits in with an ethic that is common in the area, an attitude of *laissez-faire* that keeps the place casual and natural-seeming. No space reads as very important: a small kitchen garden, a deck, and a terrace provide places to be out of doors, but the dominant landscape is the dune and the ocean. I was not aware that my own landscape carries with it the message of a culture until I began to try to understand Tom's next door. I did not recognize that the plantings I have put in over the years—native grasses, bayberry, thyme—are as much a sign to my visitors, a message that it is better to enhance what is already in place, as the buoys that line Tom's walkway to the beach, or the banners that have sprouted on his deck—first an American flag, then an Irish flag, and, more recently, the Scottish flag—are messages about Tom. The fact that I have spent considerable time and money to achieve the desired effect of naturalness belies my own intentions.

In the upper-middle-class culture that until recently dominated this particular area of eastern Long Island, and along the margins of which I was raised, it is considered unseemly

to make a big deal out of oneself. I don't know where Tom grew up, but I can imagine that for him, it is acceptable to let people know where you have come from and where you are going. In a suburban neighborhood, the garage and the car are not necessarily things to hide; in a rarefied summer community that had existed for a century on the eastern end of Long Island, proudly displaying one's acquisitions was traditionally perceived as a sign that one had arrived very recently, and had not yet developed a sense of humility. Once, when I attended a church service in the town at a congregation originally formed by the soap heirs who lived on the bluff, the sermon topic was humility; I heard from a friend who attended another service that that Sunday's theme was hospitality. The messages of the culture are clear: although you get to live in this place, which is heaven on earth, remember that there are people less fortunate; don't speak too loudly; don't flaunt your success. In this particular region, when people not born into this culture have reached a level of achievement that affords them a house on the ocean, they have more often than not jettisoned the landscape style of their origins, opting for the impressive, yet understated, landscape mode of hedges, scaled-down Victorian carpetbedding (that is what all that *impatiens* is, after all), and large shade trees. A client once railed at me, after I had placed plants far enough apart so that they could grow well, with earth still visible, that I had made his property "look like an *immigrant's* house," an odd choice of words, I thought, to be passed from one child of immigrants to another. But Tom has brought his landscape with him—a landscape that signals not that a very important personage lives here, but that a family lives here, a family with a specific history of enjoying being outdoors, and being together. That said, even to discuss the signals Tom is sending is to deny a major factor in Tom's makeup, one that distinguishes him from many people who aspire to have houses in this community: Tom does not really care what other people think of him.

One day I drove up to my house and noticed a wooden frame sprouting from the small patch of scrub between my driveway and Tom's. "Hey, Tom, what're you building?" I asked, trying to mask any sign of desperation in my voice, for what more could he do? "A vegetable garden," came the answer. Tom was clearing away grasses and native shrubs to make way for corn, tomatoes, and squash. His answer caught me short, and I found myself rethinking my assumptions about Tom, about his house and his land. As with the house and the driveway, Tom was carving out exactly what he needed. He had no image in mind; while neighbors down the road pulled out acres of grasses and bayberry to put down perfect lawns and long lines of *impatiens*, Tom did not seem guided by a concern for what anybody would think when driving past or to his house. The first year of the vegetable garden, Tom could not have been a more anxious parent. He cultivated, watered, coddled, staked, paced around, smoked, looked some more, adjusted a leaf here, cut back a stalk there. As his first crop matured, I began to take an interest. It didn't hurt that he would give us the odd cucumber. I noticed the snow fence less, and the height of the corn more. I enjoyed seeing the owl as I entered my study. I liked the sound of water from the hose on hot days.

So the garden came, and I assimilated it into the things that are good in my purview. Gone were the *Panicum virgatum* and the *Andropogon scoparius*, but the cabbage and rhubarb weren't dismal replacements. Tom was not finished with his landscaping, however.

One day a Bobcat appeared and began tearing up the grasses, shrubs, and other "weedy" growth in front of the house on the other side of Tom's circular driveway. This had been happening elsewhere in the neighborhood: as property values have skyrocketed to the point at which a tiny bungalow can fetch a small fortune, new homeowners have come to feel that their grounds, even if they occupy less than a quarter-acre, should appear appropriately stately. The grasses are ripped out, as are the bayberry, beach plum, and vines—the cover that is home to dove, quail, snipes, rabbits—and instant lawn is installed. The aesthetic of wild dirt roads and tangled front yards is vanishing. The inevitability of the desire for lawn—the folly of it, given the conditions of our region and the maintenance it requires—are as integral to our regional character as cold winters. In my neighborhood, despite zoning regulations that require homeowners to retain at least half of their land in its original state, lawns do seem to creep from one lot to the next, as a peculiar peer pressure seeps like runoff across property lines. The grasses that grow along the roads have their aesthetic as well as ecological merits—tender green in spring, golden in late summer, clouds of seed heads in fall, yellow against the snow in winter. But they are, to many homeowners, weeds: they look unkempt, unmanaged, and uncivilized. When I saw Tom's landscaper begin to tear out the grasses, I imagined that the lawn seepage making its way through our neighborhood had finally reached my doorstep. But he did not, in fact, clear out to the road. He left the grasses and Russian Olives that screen him from the road, and cleared a patch only about 20 feet in depth, maybe 60 feet in length. After the lawn was laid, a hammock appeared, and a huge beach ball. Once the roots had taken, I began to see the child who lives with Tom out on the lawn, sometimes with a caretaker, rolling around on the huge ball, or playing with a badminton racquet. I realized that this swath of lawn was a present from Tom to this boy—a soft, green carpet where he can play and be watched from the house. He has special needs and plays on his own mostly, so this was his own playground, replete with activities that he can do alone or with one of the adults who care for him. The lawn, far from being a symbol, as it is for people who want the look of the pastoral English park landscape at the beach, is simply a useful surface. And it is one of a series of landscape moves that have transformed Tom's dune from a cabana on a spare, neutral ground to a compound, with many activities and uses.

What Tom has done over the years has transformed the figure-ground relationship between his house and the land in ways that, despite the style or form the landscape was adopting, actually bring his house closer in line, at least in the way land is used, with the modest houses of the older neighborhood. When Tom bought it, the house stood alone amid the beach grass, but it now forms the boundary between front and back, and fits into a compound of scrub, dune, garden, and lawn. Front and back differ in their materials—lawn, scrub, and vegetables in front; deck and dune in back. But Tom's use of what should be considered his front, the approach, is actually what occurs in the backyards of the older houses—gardening, tossing a ball around—and it has occurred to me that a beach house actually has two fronts; Tom's erection of an Irish, a Scottish, and an American flag atop the dune, visible from the beach, and his installation of a figurehead atop a piece of play equipment overlooking the ocean are as much a statement about who lives there as the

things one usually sees at the entrance to a house. Tom's landscape reworking has varied, distinguished, and reclassed the parts of his landscape according to the things he likes or needs to do outdoors. His place has shifted from picturesque scene to a working landscape, from view to place. The changes that Tom has wrought have transformed the neighborhood: a summer beach colony, its faded and shingled structures blown across a dune, now has in one small corner a place that looks rooted year-round, with evergreen trees that become a light garden at Christmas. When I discovered this latter effect one December as I stopped by to check my closed-up house, I understood why Tom had planted such seemingly out-of-place spruces along the road.

By now it is fairly common for the lay person to understand that the landscape, or its components, are constituted of change: ecosystems comprise a dynamic process of competition, shifting equilibriums, of the movement of water, soil, plants, and animals across space and time. What is less easy to accept is that one's neighbors act as agents in this system, that changes in the culture of the land next door are as natural and inevitable as a change in the water table, or the death of an old oak. Although we can easily comprehend that nature "out there" is a constantly shifting mosaic of forces, it is less comfortable to acknowledge that our own backyards are engaged in this process, and that new neighbors, new modes of acting within the landscape in daily life, are what keep a place in motion, propel it, as it were, in time.

So, after understanding that the process of change is inevitable, that Tom's landscape is as natural to the area as mine, the question still remains: just what is the landscape idea over there at Tom's? What am I to make of the form it has taken? My interest in and appreciation for Tom's garden is not innocent; the fact that his landscape looks disjointed, that the building is, to my eyes, less than beautiful, feeds into a quarrel that has been taking place within me for a long time, the tug-of-war between form and content. The first thing a designer will do is attack the plan—it is to the plan that we turn in trying to organize space and program. But many landscapes that are widely held to be successful or satisfying, certain English gardens or the Ramble in Central Park for example, read as somewhat disjointed, chaotic, or awkward when viewed in plan. Often a landscape that is considered to have too much going on is dismissed by the professional as confusing. But landscapes with overlappings, shifts of direction, interruptions, and, not least of all, signs of the matter and detritus necessary for people to inhabit a place are often landscapes that are dear to the people who live with them. The impulse, after years of training, to justify, rectify, organize, and simplify often enforces one mode of action in a place; unanticipated or even subversive uses, the kinds of activities that can give a place an identity of its own beyond the way it looks, can be preempted by the overarching desire to make things work out formally, in plan. On Tom's land, things happen; the place becomes.

As the designer of his landscape, Tom has an economy of his own, with little regard for impressing his guests or appropriating a look or collecting plants. As a landscape architect, I find the whole hard to decipher, but as a neighbor I find its parts beautiful—the changing colors of the vegetable garden, the sound of a ball being bounced on asphalt, people waving hello and goodbye. And Tom's changes have not ended at his property line;

Jonelle Weaver, *Heritage Roses*, 1999. ©FPG International LLC; ©Jonelle Weaver

I have to confess to a small amount of landscape seepage that is occurring at my own house, as I have begun to interfere more seriously with our tiny plot of beach landscape. This year I put in a one-zone irrigation system so that our front walk will be green; and for next year we are planning a small vegetable garden, south of a big pine, where a huge pokeweed has grown undisturbed for the past few years, next to a bank of pink Seven Sisters roses planted by my father, a tinkerer himself, thirty-five years ago.

Reprinted with permission from *Architecture of the Everyday*, ed. Steven Harris and Deborah Berke. New York: Princeton Architectural Press, 1997.

ISBN 0-89178-082-3